Fairy Tale Fashion

To Amanda,
Thank you!
Colleen

Colleen Hill

Fairy Tale Fashion

Yale University Press New Haven and London
In association with the Fashion Institute of Technology New York

Copyright © 2016 by The Fashion Institute of Technology

All rights reserved.

This book may not be reproduced, in whole or in part, in any form (beyond that copying permitted by Sections 107 and 108 of the U.S. Copyright Law and except by reviewers for the public press), without written permission from the publishers.

Printed and bound in Italy by Conti Tipolcolor S.p.A.

Designed by Paul Sloman & Greg McCarthy / +SUBTRACT

Library of Congress Cataloging-in-Publication Data
Names: Hill, Colleen, 1982- author.
Title: Fairy tale fashion / Colleen Hill.
Description: New Haven : Yale University Press, [2016] | Includes
 bibliographical references and index.
Identifiers: LCCN 2015039619 | ISBN 9780300218022 (alk. paper)
Subjects: LCSH: Fashion design. | Costume. | Clothing and
 dress–Psychological aspects. | Fairy tales–Social aspects.
Classification: LCC TT507 .H495 2016 | DDC 746.9/2-dc23
LC record available at http://lccn.loc.gov/2015039619

Images:

Page 2: Kirsty Mitchell , "A Forgotten Tale,"
from the *Wonderland* series. Courtesy Kirsty Mitchell.

Page 6: Illustration for "Briar Rose" by Anne Anderson,
early 20th century. .

Contents

Part One: 7
Fashion and Fairy Tales
Colleen Hill 9

Part Two: 25
The Tales
Colleen Hill 27

Part Three: 211
Sleeping Beauty: A Fairy Tale's Dance with Fashion
Patricia Mears 213

Dancing, Desire, and Death: The Role of Footwear in Fairy Tales
Ellen Sampson 235

Of Bands, Bows, and Brows: Hair, the *Alice* Books, and the Emergence of a Style Icon
Kiera Vaclavik 253

Selected Bibliography 269
Acknowledgements 274

Fashion and Fairy Tales

By Colleen Hill

On a cold February day in New York, I sat entranced by a procession of beautiful princesses, castle guards, and whimsical woodland creatures. It was not a storybook, a movie, or even a magazine editorial that held my attention – it was photographs of the Fall 2014 Dolce and Gabbana collection, newly posted to Style.com. Temporarily losing all objectivity as a curator, I envisioned myself in a red fur hood, or wearing one of the design duo's flowing, chiffon gowns patterned with small golden keys. When I returned to reality, it struck me that it was time to propose an exhibition about fairy tales – a subject that had been on my mind, mostly unformed, for several months.

Valerie Steele, the director and chief curator of The Museum at FIT, was immediately enthusiastic about the concept of an exhibition on fairy tale fashion. Her 2008 show, *Gothic: Dark Glamour*, was among the first major projects I worked on at the museum, and its themes, object selection, and exhibition design have undoubtedly influenced the development of *Fairy Tale Fashion*. I quickly discovered that my topic has been largely overlooked by fashion historians and theorists, and scarcely touched upon by folklorists and fairy tale scholars. This neglect was perplexing, especially since the connections between fairy tales and numerous other creative disciplines, including film, fine art, and design, have been explored in quite some depth.

Dolce and Gabbana
Fall 2014, look 4
Courtesy Dolce and Gabbana

Fairy tales have a long history within the arts and popular culture, but in recent years they have proven more pervasive than ever. In her 2014 publication, *Once Upon a Time: A Short History of Fairy Tale*, the mythographer Marina Warner wrote that people of various professions, including couturiers, performance artists, photographers, and even therapists, "are losing themselves in the forests of fairy tale in order to come back with baskets of strawberries picked in the snow."[1] But why is this? And why have fairy tales been so important to fashion in particular? In one of the few narratives that links clothing and fairy tales, the fashion expert Gerda Buxbaum noted that while the influx of fashion information on the internet is exciting and wondrous in its own right, "Fashion has countered this high-tech functionalism by emphasizing the magical and designing clothes fit for fairies or elves."[2]

Buxbaum's theory was mirrored in a 2009 exhibition at the Victoria and Albert Museum entitled *Telling Tales: Fantasy and Fear in Contemporary Design*. Although this show excluded fashion, it did feature furniture, lighting, and ceramics that were inspired by storytelling. In the exhibition catalogue, the curator Gareth Williams wrote, "Against all evidence of an industrialized, globalized, high-tech world (or perhaps because of it) some designers retreat to pastoral idylls of fairy tales, myths and nature. In doing so, they return us to our most primitive state. No doubt their designs are escapist, even naïve, and can be quite deliberately childlike.[...] But these designers are serious about wanting to disengage us from ordinary life and to reconnect us to a state of innocence and wonder."[3] A statement like this surely indicates a desire – and perhaps a need – for fantasy in design. Such fantasy can directly derive from fairy tales.

Fashion designers often express their most fantastical and imaginative ideas through their runway collections. After his Fall 2015 menswear showing – which featured full-frontal nudity – the designer Rick Owens responded to the astonished fashion media by stating, "We all know that runway looks aren't meant to be taken literally, they illustrate an ethos," adding that his presentation was intended to portray "a utopian world of grace, free of fear and shame."[4] Owens's statement reminded me of a befitting passage from the preeminent expert on fairy tales, Jack Zipes, regarding the enduring popularity of the Grimm Brothers' stories. Zipes wrote, "[the Grimms'] 'once upon a time' keeps alive our utopian longing for a better world that can be created out of our dreams and actions."[5]

The relationship between runway shows and fantasy, however, is not limited to the actual clothing that is presented. The set for Marc Jacobs's Fall 2012 show

(top) Philipp Jean-Pierre Ndzana
Advertisement for Serpentina
clothing line, Fall/Winter 2013
Courtesy Philipp Jean-Pierre Ndzana

(bottom) Alice + Olivia
Fall 2014 presentation
Courtesy Alice + Olivia

(following) Yelena Yemchuk
"Some Enchanted Evening"
Harper's Bazaar UK, December 2012
Courtesy Yelena Yemchuk
Dress by Alexander McQueen.

was designed by the artist Rachel Feinstein, who crafted a romantic, crumbling village from layers of whitewashed wood. Bathed in moody blue light, the set looked as though it came straight from the pages of a storybook. For the Fall 2014 Alice + Olivia collection, the designer Stacey Bendet showed models in a "mystical forest wonderland,"[6] which included a model reclining in a glass coffin – an unmistakable nod to Snow White. For his Spring 2015 collection, Dries Van Noten sent his models down a runway that was covered by a lush, tufted carpet in various shades of green that resembled a forest floor. The rug was made by the artist Alexandra Kehayoglou, and while the John Everett Millais painting *Ophelia* was her specific point of inspiration, the overall effect was one of a dreamy, woodland setting. At the end of Van Noten's show, the models lounged gracefully along the length of the carpet – a leisurely gathering of beautiful, fairy tale heroines.

Fairy tale settings also make their way into fashion editorials and advertisements. Although these images often refer to well-known tales (several of which are included in this book), some take a general approach, or draw from multiple stories. A particularly remarkable example is a 2012 spread from *Harper's Bazaar* UK, photographed by Yelena Yemchuk. Entitled "Some Enchanted Evening," the astounding twenty-four-page spread featured breathtaking gowns by Alexander McQueen, Chanel, Lanvin, Louis Vuitton, and others in a misty forest. For its Fall 2014 collection, Alexander McQueen's own advertising campaign showed a model sitting in a dark, ornate castle setting, wearing Sarah Burton's gorgeous gowns. Two of the photographs from the campaign featured dresses made from bright white fabrics that stood in stark contrast to the gloomy background, while others showed black clothing that blended into the shadowy setting. In the latter images, the model posed with a black horse, her pale skin radiating the only lightness in the composition.

Analogies are often made between the plotlines of fairy tales and real-life situations, the rags-to-riches tale of Cinderella being a highly ubiquitous example. In mid-2015, fashion journalists reported on the debut of a fourteen-year-old model named Sofia Mechetner, who closed Christian Dior's Fall 2016 couture presentation wearing a long white gown with feathered cuffs. Ruth Eglash of the *Washington Post* wrote that Mechetner, who hails from just outside Tel Aviv, was "used to sleeping on a broken bed, sharing a bedroom with her two younger siblings, sweeping the floor and folding laundry to help out her single, three-job mom."[7] Certain fashion designers are likewise known for coming from humble

origins. It is well known that Gabrielle "Coco" Chanel, one of the most important designers of the twentieth century, lived a portion of her youth in an orphanage. The Jerusalem-born designer Elie Tahari, whose business now turns a profit of $500 million per year,[8] also spent his childhood in an orphanage. Later, when he moved to New York in 1971, he slept on a bench in Central Park – across the street from the high-rise building in which he currently resides.[9]

Fairy tales have also been used to characterize the very nature of certain clothing labels. One morning, while scrolling through the *Business of Fashion* website, I stumbled upon three early twentieth-century illustrations by the fairy tale artist Arthur Rackham. The images illustrated a clever article by Luca Solca, entitled "Fashion's Smaller Brands: Cinderellas, Snow Whites or Sleeping Beauties?" In the article, Solca categorized three types of fashion labels in relation to popular fairy tales. Cinderellas, he wrote, "are neglected or mismanaged brands, once the main focus of luxury players." He cited Burberry, Gucci, and Louis Vuitton as "revived Cinderellas," that is, as established luxury companies that have prospered after a decline in sales and reputation. Solca's next category, the Snow Whites, are "forgotten or small heritage brands that boast a pristine image and which have a successful CEO or creative director at the helm." The independent French label Lanvin, founded in 1889 and now overseen by the artistic director Alber Elbaz, exemplified a "Snow White" fashion company. Finally, Solca outlined the Sleeping Beauties, the "long-dormant [...] heritage brands that boast an immaculate image and unique legacy but which have been commercially dormant for decades," here referencing the attempt to revitalize the Schiaparelli label.[10]

Illustration for "Snow White" by Arthur Rackham, 1909

What Is Fairy Tale Fashion?

In fashion, the term "fairy tale" is often used to describe clothing that is particularly spectacular. While many of us have little occasion to wear fantastical, avant-garde

creations or elaborate ball gowns, seeing such designs in fashion magazines, on the runway, or in a museum setting can be awe-inspiring. A stunning, hand-painted silk ball gown by Dolce and Gabbana, for example, may be the "fairy tale" dress of our dreams. Since such magnificent clothes are inaccessible to the average person, they take on a quality of unreality.

While references to fairy tale fashion have been especially prevalent during the twenty-first century, they are far from new. A *Vogue* editorial from 1933, for example, enthused that the Paris couture collections "have opened a desire in the feminine heart for more beauty, more elegance, and more luxury. They have suddenly awakened the Sleeping Beauty slumbering in each of us, turning every woman into a fairy tale princess. It is so easy to imagine what such a princess would do!"[11]

Marina Warner explains that the term "fairy tale" is often used "as an epithet – a fairytale setting, a fairytale ending – for a work that is not in itself a fairy tale, because it depends on elements of the form's symbolic language. Fairytale is applied to evoke a quality of a scene or figure beyond a fairy tale as a distinct narrative."[12] While it is common to describe something as having a "fairy tale" quality, the ambiguity and subjectivity of this term can be problematic. In the collection of The Museum at FIT alone, there are thousands of garments that I might describe as beautiful, elegant, or luxurious. How was I to identify which of them had the strongest "fairy tale" elements? To plan this book and exhibition, I needed more clearly defined parameters for my selections.

To begin, I reacquainted myself with my favorite stories from childhood, starting with a translation of *Histoires ou contes du temps passé* (*Stories from Past Times*), a seminal book of 1697 by Charles Perrault, the French writer of fairy tales. The magnificent glass slippers from Perrault's version of "Cinderella" were entirely familiar, but his "Sleeping Beauty" had an added twist that I did not remember. When the princess awakens from her century-long slumber, Perrault writes, "she was fully dressed, and her gown was magnificent, but [the prince] took great care not to tell her that she was attired like his grandmother, who also wore stand-up collars. Still, she looked no less lovely in it."[13]

It became clear that while the importance of Cinderella's glass slippers is widely known, they are only one of a multitude of references to clothing in fairy tales. Depending on the tale, dress may be used to symbolize a character's transformation, vanity, greed, power, or privilege. In many fairy tales, readers are given little detailed knowledge beyond what is necessary to outline a plot,

Dolce and Gabbana
Hand-painted silk taffeta
evening gown, 2012
The Museum at FIT, 2013.4.1

or to portray a character as good or bad.[14] Fairy tales "represent the archetypes in their simplest, barest, and most conscious form,"[15] observed the psychologist and fairy tale scholar Marie-Louise von Franz. What is especially striking, then, is that the mention of clothing within fairy tales is often vivid. Descriptions of opulent dresses, fashionable shoes, and jewels are frequent. Therefore, although identifying fairy tale-themed fashion editorials and advertisements is fascinating, visually compelling, and important to the larger scope of my research, I based my work on primary sources – that is, the tales themselves. Numerous recurring visual motifs in these tales, such as blonde hair and red roses, can also be linked to the world of fashion. Including such motifs broadened my selection of stories, allowing me to include more than just those that made distinct references to clothing.

In many ways, this project became my own fantasy. As I examined my selected tales more closely, I began to imagine how certain fairy tale characters might have dressed in real life. This is, of course, a creative and highly subjective approach, but it was one that was necessary and justified for a number of reasons. As Warner notes, "To place fairy tales in relation to society and history is hampered from the start by the difficulty of composing any kind of firm chronology or origin."[16] Being that fairy tales are rarely set in a specific place or time, I felt free to select both historical and contemporary clothing, as long as it corresponded to the descriptions within the tales. In all but a few cases, the designers themselves had not been thinking of fairy tales when they designed the clothing I have chosen to include.

My curatorial approach was also inspired by the philosopher Roland Barthes's writing on fashion magazines, in which he observed, "It must be understood that from a practical point of view, the description of a Fashion garment serves no purpose; we could not make a garment by relying solely on its Fashion description."[17] While the descriptions of garments in fairy tales certainly serve a narrative purpose, the appearance of the clothing is entirely up to readers' imaginations. Perrault's Cinderella wears a gold and silver dress, dotted with jewels, but we will all envision this dress differently.

Another source for my curatorial selections for this book and the exhibition was the interpretations of fairy tale characters by renowned illustrators, many from the early twentieth century. Artists such as Edmund Dulac, Kay Nielsen, Arthur Rackham, and A. H. Watson created distinct visual narratives that influenced my own work. Like any of these illustrators, I simply offer my interpre-

tation of a character's dress – the only difference is that I use existing garments to tell the story.

My use of the word "fashion" in the title of this project may seem somewhat strange, being that my work originates from descriptions of garments that are entirely fictitious. Could imaginary attire really be described as fashion? In her brilliant book *Fashion-ology: An Introduction to Fashion Studies*, the fashion theorist Yuniya Kawamura answered my question. "Clothing is material production while fashion is symbolic production," she writes. "Clothing is tangible while fashion is intangible. Clothing is a necessity while fashion is an excess. Clothing has a utility function while fashion has a status function. Clothing is found in any society or culture where people clothe themselves while fashion must be institutionally constructed and culturally diffused."[18] This explanation of what constitutes fashion applies directly to fairy tales – in many cases, in fact, fairy tale garments seem to represent Kawamura's very definition of fashion.

Although filmic representations of fairy tales have determined the ways in which we envision certain characters, an in-depth discussion of this is beyond the scope of my project. Some of the earliest movies used fairy tale plots, including a charming 1899 production of "Cinderella" by the pioneering cinematographer Georges Méliès. In his 2011 book, *The Enchanted Screen: The Unknown History of Fairy-Tale Films*, Zipes compiled a thirty-seven-page filmography – and he acknowledged that it was incomplete. In spite of the sheer number of fairy tale films, the demand for them only increases. Recent examples, such as *Frozen* (2013), *Maleficent* (2014), and Disney's first live-action version of *Cinderella* (2015), have grossed hundreds of millions of dollars. Although these movies are usually loose adaptations or spin-offs of classic tales by Perrault, the Grimm Brothers, and Hans Christian Andersen, they prove that we never tire of the "glimpses of the greater things"[19] that fairy tales provide.

The enduring and universal appeal of fairy tales cannot be easily explained. The psychiatrist Bruno Bettelheim[20] postulated that their popularity is owing to the fact that they are works of art, writing, "The delight we experience when we allow ourselves to respond to a fairy tale, the enchantment we feel, comes not from the psychological meaning of a tale (although this contributes to it) but from its literary qualities – the tale itself as a work of art."[21] It is true that reading good translations of the original texts by Charles Perrault, the Brothers Grimm, and Hans Christian Andersen (in addition to numerous others) is rewarding, and I agree that they can be considered works of art. These writers

have their own distinct, often poetic voices that reflect their social and political surroundings. Their versions of the tales prove fascinating to folklorists, literary scholars, and historians, but Bettelheim's "work of art" theory does not explain why so many loose or diluted adaptations of the tales are perhaps even *more* popular than the originals. Simple storybook versions of "Cinderella" or "Sleeping Beauty" may bear little resemblance to what Perrault or the Grimms wrote, but they are loved just the same.

In a study by Samantha Holland entitled "How to be a Fairy Princess," she notes that several of her interview subjects, all of whom were adult women, "talked about the enjoyment of playing as a figure from a fairy tale – princess, fairy, mermaid – as a child – and how they still liked this image."[22] For many of us, the love of fairy tales does not end with childhood – even if we do often graduate from Disney adaptions to less sanitized versions of the stories. "If there is any single genre that has captured the imagination of people in all walks of life throughout the world, it is the fairy tale," writes Zipes, "yet we still have great difficulty in explaining its historical origins, how it evolved and spread, and why we cannot resist its appeal, no matter what form it takes."[23]

Literary Fairy Tales: A Brief History

Part of the difficulty in tracing the history of fairy tales is that they are largely rooted in oral tradition. Variants of many classic fairy tales existed for centuries before their transcription became common, beginning in the fifteenth century. The stories were modified to appeal to their new audiences, which largely consisted of the middle class and the aristocracy.[24] Fairy tales first thrived in Italy, but they had become an established part of French literary salons by the middle of the seventeenth century.[25] Both men and women attended these gatherings, but aristocratic women (known as *précieuses*) were at their center. Madame de Sévigné, a French aristocrat who wrote copious letters about life at court, referred to the tales as "the stories they amuse the ladies with at Versailles."[26] Naturally, aspects of upper-class life made their way into these fairy tales. As the scholar Dorothy R. Thelander noted, "the parade of good looks and beautiful clothes is as important in the Salon tales as it was in courtly French society."[27]

Although the *précieuses* were excluded from schools and universities because of their gender, they were highly educated women who prized witty and eloquent speech and prose. In their salons, they discussed topics such as art and

literature, in addition to more personal subjects like love and marriage. They also talked about politics, including the possibilities of relief from a patriarchal society that would result in greater independence for women.[28] Given their beliefs (as well as the thinly veiled criticism of the French court that often made its way into their tales), it comes as no surprise that the *précieuses* generally remained on the fringe of Louis XIV's court.[29] Nevertheless, fairy tale motifs were incorporated into court ballets and plays, and dressing up as a fairy tale figure, such as a nymph or a fawn, was fashionable during carnival season.[30]

Although fairy tale writing was widely recognized as the domain of women during the seventeenth century,[31] it was a man who published what is generally considered the most important fairy tale book by a French author. This was Charles Perrault's 1697 collection of tales, *Histoires ou contes du temps passé* (*Stories from Past Times*), which contained a total of eight tales, including "Cinderella," "Little Red Riding Hood," and "Sleeping Beauty." While these stories were not of Perrault's invention, his versions of them continue to be incredibly influential. In his book *Fairy Tales, Sexuality, and Gender in France*, Lewis C. Seifert writes that Perrault was but one of sixteen writers recognized for their literary fairy tales during the late seventeenth century and the start of the eighteenth[32] – yet his stories are by far the best known today.

Prior to publishing his book, Perrault was secretary to Jean-Baptiste Colbert, the minister of finances at the court of Louis XIV. Following Colbert's death, Perrault was dismissed from his position, and thus he began to focus on his literary career. As with his female counterparts, the *précieuses*, Perrault's knowledge of life at the French court was present in his stories. The French literature scholar Mary Louise Ennis notes that the clear references to Versailles in Perrault's texts "provided social commentary ranging from the necessity of appearances and the shallowness of courtiers to women's fashion and gourmet sauces."[33]

While Perrault's stories may be well known, his name is not nearly as well recognized as those of Jacob and Wilhelm Grimm. They also published versions of "Cinderella," "Little Red Riding Hood," and several other perennially popular tales, but their work was impressively comprehensive and frequently amended. Jack Zipes recently translated the original versions of the Grimms' *Children's and Household Tales* from German into English for the first time. The stories originally came in two volumes, the first published in 1812, and the second in 1815. In the introduction to his book, Zipes explains, "From 1812 to 1857 the Brothers deleted numerous tales from the first edition, replaced them with new

or different versions, added over fifty tales, withdrew the footnotes and published them in a separate volume, revised the prefaces and introductions, added illustrations in a second small edition directed more at children and families, and embellished the tales so that they became polished artistic 'gems.'"[34] The addition of illustrations, and the refinement of language in particular, attest to the growing significance of literary fairy tales during the nineteenth century. Since I had read only later versions of the Grimms' stories, I was delighted to find that, in Zipes's translation of their earliest "Cinderella," the description of her clothing was much more extensive than in subsequent editions.

Hans Christian Andersen (1805–1875) is often considered to be the "father" of modern fairy tales.[35] His lofty status stands in remarkable contrast to his humble, impoverished beginnings as the son of a cobbler and a washerwoman. Andersen's tales, though original, were heavily influenced by the work of the Grimms, in addition to German Romantic writers.[36] Aspects of his stories are often considered to be partially autobiographical. As the fashion historian Hilary Davidson notes, for example, "Andersen received his first pair of boots for his confirmation in 1819, and was so concerned with their shine and creak that he could not keep his mind on the service"[37] – an incident that clearly relates to the plot of his 1845 tale, "The Red Shoes." Zipes, however, warns against making too much of the connections between Andersen's personal life and his stories, as it dilutes the undeniable creativity and originality of his work.[38] Andersen had the ability to make the ordinary extraordinary, and his tales tend to be dark, meaningful, and expressively written.

Although a quick study of the work of Perrault, the Grimms, and Andersen provides a solid foundation for the history of literary fairy tales, this text explores also the work of several other important writers. These include Gabrielle-Suzanne Barbot de Villeneuve ("Beauty and the Beast"), Lewis Carroll (*Alice's Adventures in Wonderland*), L. Frank Baum (*The Wonderful Wizard of Oz*), and John Jacobs ("The Swan Maidens"). Selecting the fairy tales to include in this book and in the corresponding exhibition at The Museum at FIT was a challenge, but spending time poring over these familiar yet sometimes perplexing stories was hardly a mundane task. In the end, focusing on a selection of classic tales seemed wisest – not only because these stories are familiar to many readers, but also because they contain some of the most intriguing references to fashionable dress and/or important recurring visual motifs. Simply deciding that I would write about "Cinderella" or "Sleeping Beauty" was not enough,

23 Fashion and Fairy Tales

however. With rare exceptions, there are myriad versions of every fairy tale, and these vary widely between cultures, writers, time periods, and even translators. For each tale that I examine, I have noted which writer's work provides the basis for my study.

(following) "Alicia en Blanco"
Photograph: Martin Lucesole
Stylist: Doma Estudio
Hair: Estudio H
Make-up: Micky Nazar Studio.
Image courtesy Martin Lucesole

Cinderella
(Based on the tale by Charles Perrault)

Cinderella is the beautiful, sweet-tempered stepdaughter of a proud, haughty woman who has two daughters of her own. Treated terribly by her stepmother and stepsisters, Cinderella is made to undertake grueling housework. While her sisters wear stylish clothes and sleep in pretty bedrooms, Cinderella is dressed in rags, and sleeps in a garret at the top of the house.

The prince announces that he is hosting a ball, and he invites everyone of importance in the kingdom. The stepsisters receive an invitation to the party, and they plan excitedly what they will wear. Cinderella helps them prepare for the event patiently, though she is disappointed that she cannot attend. After her sisters leave for the ball, Cinderella's godmother pays her a visit. Learning that Cinderella wishes to attend the ball, the godmother taps Cinderella's rags with her wand, and they are transformed into garments of gold and silver, dotted with jewels. She then hands Cinderella a pair of glass slippers, and warns the girl that she must not stay at the ball past midnight, since the magic will come undone at that hour.

Cinderella arrives at the ball and stuns the crowd instantly with her beauty. Her own stepsisters do not recognize her, and the prince is smitten. Cinderella is invited to join the prince's festivities the next evening as well, and she arrives looking even more beautiful than before. The prince will not let her out of his sight. Losing track of time, Cinderella barely manages to leave before the clock strikes midnight. She drops one of the glass slippers during her hasty departure.

Illustration for "Cinderella" by Edmund Dulac, 1910

The prince, who is in possession of the lost slipper, proclaims that he will marry the woman whose foot fits the shoe exactly. He sends his men to try it on all the nearby princesses, then the duchesses, and so on down through the court. The men eventually arrive at Cinderella's house, where the two sisters try, and fail, to fit their feet into the shoe. Cinderella, watching their attempts, suggests that she try it on. It fits perfectly, and Cinderella pulls its mate from her pocket. While Cinderella's sisters watch in astonishment, her godmother appears and once again transforms her rags into a magnificent gown. The sisters recognize Cinderella as the beautiful princess from the ball, and throw themselves at her feet to beg for forgiveness.

Cinderella forgives her sisters graciously and leaves, dressed in her finery, to see the prince. The couple is married several days later. Cinderella confirms her kind and generous nature by giving her sisters apartments within the palace and arranging their marriages to two noblemen in the court.

Fashioning "Cinderella"

"Cinderella" is one of the oldest and most universal fairy tales, the earliest extant version having been transcribed in China during the ninth century A.D.[39] In 1893, the English folklorist Marian Roalfe Cox published a fascinating book entitled *Cinderella: Three Hundred and Forty-five Variants*, in which she identified and categorized versions of the tale from around the world (and since then, many more Cinderella stories have been discovered). In the introduction to Cox's book, Andrew Lang, a renowned collector of folk tales, summarizes the basic elements of the story, writing, "The fundamental idea of Cinderella, I suppose, is this: a person in a mean or obscure position, by means of supernatural assistance, makes a good marriage."[40] In Perrault's 1697 version of the tale (especially though not exclusively), Cinderella is a model of good breeding. Her gentility, grace, and selflessness demonstrate her aristocratic nature.[41] When these virtues are combined with her beauty, she is positioned as an ideal bride. Even while Cinderella is dressed in rags, readers are made keenly aware of her potential for greater circumstances.

The lost shoe is not part of all Cinderella-type stories, but it does characterize the most widely known versions. In his summary of the tale's storyline, Lang concluded, "One thing is plain. A naked and shoeless race could not have invented Cinderella."[42] Magnificent gowns and impossible shoes do more than

position Cinderella as a beauty who is worthy of a prince's affection – they are critical to the story's plot. Of all of the best-known fairy tales, "Cinderella" is the one most centered on sartorial display.

In some translations of the tale, Cinderella's very nickname, devised by the crueler of her stepsisters, indicates the relationship between the girl's identity and her clothing. This sister refers to Cinderella as "Cinder-slut." The term "slut" was already used during Perrault's time as it is today – that is, as a synonym for a woman of sexually loose character. Its original usage, however, can be traced back to Geoffrey Chaucer's *The Canterbury Tales* of 1386, where it referred to a man who wore dirty clothes. The English poet Thomas Hoccleve used the word in 1403 to describe an unkempt woman. Leora Tanenbaum, the author of the book *I Am Not a Slut: Slut-Shaming in the Age of the Internet*, noted that by 1450, "being sloppy in matters of cleanliness became associated with being untidy in sexuality."[43]

Since Cinderella's conduct is nothing but virtuous, one can assume that the name "Cinder-slut" refers to her dirty clothing, not to her behavior. "Heroines in fairy tales are persecuted through base clothing as much as through any other form of suffering,"[44] notes Jo Eldridge Carney in her book *Fairy Tale Queens: Representations of Early Modern Queenship*. Carney also observes that sartorial indignity often allows the heroine's important, non-physical virtues to become more apparent. In spite of her family's abusive behavior, she retains what were considered to be desirably feminine attributes of patience and kindness.[45] Furthermore, even when she is dressed in rags and covered in soot, her physical beauty remains evident. Perrault took care to note that "Cinderella looked a thousand times more beautiful in her shabby clothes than her stepsisters, no matter how magnificent their clothes were."[46]

The numerous descriptions of dress in Perrault's "Cinderella" are notably detailed for a fairy tale, reflecting the writer's own sensibility. Yet, perhaps predictably, Perrault avoids describing Cinderella's rags. It is another well-known version of "Cinderella," first published by the Brothers Grimm early in the nineteenth century, that gives a better sense of what Cinderella's tattered workwear might have looked like. The Grimms refer to an old grey smock worn with wooden shoes.[47]

Many illustrations of Cinderella show her in tattered clothes, but she is depicted only rarely wearing wooden shoes, and is shown even less often in a plain grey garment. In 1910, the illustrator Edmund Dulac dressed Cinderella

in brown clogs, a skirt assembled from large patches of checked fabric, and a mottled, stained apron. Yet her blue bodice is adorned with a clean white collar and cuffs, and none of her garments is in tatters. While her clothing does provide a strong contrast to that worn by her godmother, who looks radiant in a silvery, eighteenth-century-style gown, Dulac's Cinderella is not particularly disheveled. Arthur Rackham's illustration from 1919 portrays a more romanticized and pitiful Cinderella, showing her in a shredded, unevenly patched skirt, a faded bodice and shawl, and a scarf tied over her untidy hair. She stands barefoot on a wooden floor, gazing longingly out of the window. The rafter behind her indicates that she is in her attic living quarters. Perrault describes Cinderella sleeping on a "wretched" straw mattress in a garret at the top of the house, while her sisters dwell in rooms with parquet floors, fashionable beds, and full-length mirrors in which they can admire themselves.[48]

Perrault makes certain that readers understand exactly how demeaning Cinderella's circumstances are, particularly in regard to her appearance. Early in the story, Cinderella's sisters ask if she might also like to attend the royal fête to which they were invited. Sensing immediately that they are mocking her, Cinderella replies that the ball would be no place for her. The sisters quickly agree, reminding her, "people would laugh to see a cinder-slut in the ballroom."[49]

While Cinderella's rags are the source of her humiliation, they have provided inspiration for some designers. Giorgio di Sant'Angelo made a direct reference to Cinderella in his 1971 collection, aptly titled *The Summer of Jane and Cinderella*. "Jane" referred to an imagined, idealized customer, and the models who represented her wore simple, comfortable clothing and natural-looking makeup. The "Cinderella" portion of Sant'Angelo's collection showed a different side of the designer's work. Models danced wildly down the runway, wearing skimpy leotards and chiffon frocks that were shredded and frayed.[50] Dress bodices were made from pieces of soft, unfinished suede, attached crudely with red suede lacing. Purportedly, Sant'Angelo decided to slash the printed chiffon to pieces only the evening before his fashion show.[51] Whether or not

(facing) Giorgio di Sant'Angelo
Dress from *The Summer of Jane and Cinderella* collection, 1971
The Museum at FIT, 91.254.25

(below) Illustration for "Cinderella" by Arthur Rackham, 1919

32 Fairy Tale Fashion

this is true (Sant'Angelo had a reputation for being a great – if not entirely honest – storyteller), the results were striking.

By the 1990s, Sant'Angelo's torn-chiffon clothes would have fitted into a larger trend for "deconstructed" fashion. This term is generally used to describe garments that are coming apart, unfinished, or repurposed from other clothing or textiles. While this aesthetic seems to epitomize a modern Cinderella in her rags, there is more to making deconstructed clothing than simply shredding dresses. As the design theorist Alison Gill points out, "The garment-maker is simultaneously forming and deforming, constructing and destroying, making and undoing clothes."[52] In the designer Shelley Fox's Fall 2000 collection, she took a blowtorch to some of her garments, in certain spots reducing the gold, sequined fabric to mere threads. One of these designs, now in the collection of The Museum at FIT, consists of a ruffled, black felt top paired with a calf-length pencil skirt. In spite of the skirt's disintegration, its remaining sequins continue to glimmer. Fox's work is reminiscent of the charred, degraded state of Cinderella's clothing after she is put to work as a housemaid. (In the Grimms' version of the tale, Cinderella is forced to relinquish her beautiful clothes to her sisters, but Perrault makes no mention of this.) The fashion historian Caroline Evans describes Fox's work as "flawed beauty out of aberration" that is "not about deconstruction so much as transfiguration."[53] This perspective could also be used to describe the Cinderella tale, since her beauty remains undiminished in her transition from maiden, to housemaid, to princess.

Like Fox, the Japanese designer Yoshiki Hishinuma is also known for innovative textile treatments. His Fall 2000 "rag" dress is made from sheer black polyester coated with a matte white film. The film was first cracked and split by hand

(facing) Yoshiki Hishinuma
Dress in heat-processed polyester,
Fall 2000
The Museum at FIT, 2001.52.2

(below) Shelley Fox
Evening ensemble in felted wool
and sequins, Fall 2000
The Museum at FIT, 2008.1.1

to create a torn fringe. The garment was then shrunk and bonded using a heat process, resulting in a crimped, uneven texture. Its charred appearance and dusky palette recalls Cinderella's worn, grey smock. In an interview, Hishinuma discussed the elements of fantasy that are vital to his work, saying, "Each season I imagine a certain type of girl, but they're not real girls. Picturing an imaginary person when creating outfits gives me more energy."[54]

The Spanish fashion photographer Eugenio Recuenco also took inspiration from Cinderella's rags for a stunning editorial in *Vogue Novias* (*Vogue Brides*) in 2005. His model leans on her broom, appearing exhausted, beside a large pile of leaves. Her wedding gown is made from white fabric, but it is otherwise unconventional, having been torn and frayed along several parts of the full skirt. While an editorial for wedding gowns could have easily represented Cinderella in her finery, Recuenco's image shows that she is equally captivating – and more easily identifiable – in her tatters.

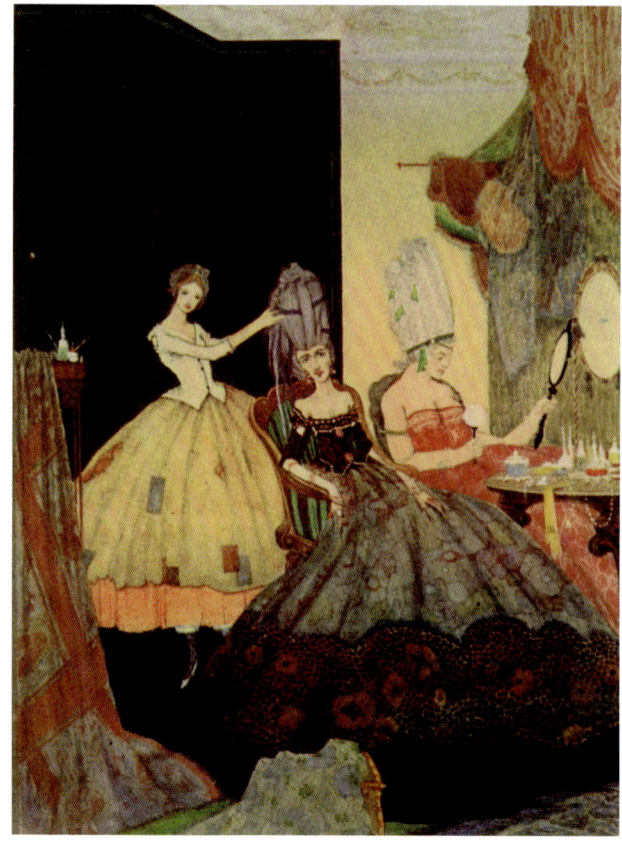

Illustration for "Cinderella" by Harry Clarke, 1922
Image courtesy Fashion Institute of Technology/SUNY, FIT Library Special Collections and FIT Archives

Cinderella's unceasingly sweet disposition is best expressed by her willingness to help her stepsisters prepare for the ball – even though this means more drudgery than usual for her, since Perrault tells us she is responsible for ironing their linens and setting their ruffles. The sisters ask for Cinderella's assistance with styling their hair, and Perrault writes that "more than a dozen [corset] laces were broken in making their waists as small as possible."[55] The sisters speak of nothing for days but what to wear to the ball, spending inordinate amounts of time in front of their mirrors. The older sister chooses to wear a red velvet dress with delicate lace trim. The younger sister, though she laments that she has only her "everyday petticoat" to wear, compensates for this ordinary garment by pairing it with a gold-flowered cloak and a diamond necklace. In some translations, the necklace is described as a diamond "stomacher," which refers to the triangular section between the neckline and waist of a woman's bodice during the seventeenth and eighteenth centuries. "Stomacher" was also used to describe a type of brooch that can be fastened to the front of a bodice, sometimes several, in rows, to create a magnificent, lattice-like effect.

35 Cinderella

Beyond these descriptions of their dress, Perrault makes little mention of the stepsisters' appearances. It is unclear whether or not they are beautiful (although it is said that they "cut a grand figure"[56]), but the ugliness of their character is impossible to ignore. Many illustrations of the sisters portray them to be elegant and fashionable, if not a little gaudy, but few drawings adhere to Perrault's description of their dress. Margaret Evans Price's work from 1921 is an exception, showing one sister in a black-and-gold gown (though not a cloak), and the other in a crimson, lace-trimmed dress.

More than 300 years after Perrault described the impressive gold-flowered cloak selected by Cinderella's stepsister, its contemporary likeness could be found in Blumarine's Fall 2014 collection, which included a dramatic navy cloak with woven bands of metallic gold flowers at the neck and the knees. It was shown with a matching mini-dress, which revealed the cape's sparkling gold lining as the model walked down the runway. The same cape was styled with a floor-length, ivory lace dress in a *Vogue* Japan fashion editorial that was aptly titled "Life as a Fairy Tale," photographed by Laura Sciacovelli. This issue of *Vogue* Japan was devoted to fairy tale-inspired fashion.

It is worth mentioning that some written adaptations of the Cinderella story, as well as a number of illustrations of the tale, portray the sisters as utterly *unfashionable* characters – they are meant to be viewed as ugly, both inside and out.

(left) Illustrations for "Cinderella" by Margaret Evans Price, 1921

(following) Eugenio Recuenco "Children's Stories," *Vogue Novias*, 2005 Courtesy Eugenio Recuenco

In the 1919 retelling of the story by C. S. Evans (illustrated by Arthur Rackham), Cinderella's sisters are named, and Evans offers quite a humorous description of their poor fashion sense:

> [Cinderella's] pretty clothes had long ago worn out, or become too small for her, and she had to dress in odds and ends that were left off by her sisters. This would not have mattered much if the clothes had been in good taste, for it is quite possible to look well even when one's clothes are shabby, but both sisters had a liking for violent colors and tasteless finery. Thus, for instance, Euphronia would come down in the evening in a gown of yellow covered in black stripes, which made her look like a zebra. You can imagine the effect of it, in contrast with her red hair and painted cheeks. Charlotte, on the other hand, loved purple and green, and would produce the most astonishing effects by mixing these two colors.[57]

Walter de la Mare's 1927 book of fairy tale adaptations, entitled *Told Again: Old Tales Told Again*, was accompanied by drawings by A. H. Watson. Although de la Mare generally transcribed Perrault's description of the sisters' dress (with a few elaborations), Watson chose to portray the sisters in a comic light. One is depicted as short and plump, and she nearly falls out of her tight, eighteenth-century-style gown. The other sister, tall and very thin, wears a dress with a massive, poufy skirt that is gathered unflatteringly into a bow at either side.

No matter what we envision the stepsisters might wear to the party, their finery cannot match that of Cinderella. There is huge variety in the ways that Cinderella's dresses are described, some of which Harold Bayley outlined in his 1912 book, *The Lost Language of Symbolism*. They include gowns woven from the stars, moonbeams, or sunbeams; a dress made from pearls with "no split or seam"; gowns covered in flowers or chains and tiny bells of gold; and – in one particularly imaginative example – a gown that looks like the sea, with fishes swimming in it.[58] There is also a description of a dress that is "blue like the sky,"[59] recalling the dresses that Cinderella wears in Disney's adaptations.

Perrault adds an element of suspense to the scene of Cinderella's sartorial transformation. When her fairy godmother appears, she first sets to work on turning a pumpkin into a gilded coach, several mice into handsome horses, and a rat into an impressively whiskered coachman. Cinderella's clothing, meanwhile, is overlooked. When her godmother asks if Cinderella is pleased with her fashionable new means of transportation, our heroine quickly responds: "Yes,

Laura Sciacovelli
Kid Plotnikova in "Life as a Fairy Tale" editorial
Vogue Japan, September 2014 issue
© 2015 Condé Nast Japan
Courtesy Laura Sciacovelli, *Vogue* Japan, and Women Management

but am I to go in these dirty clothes?"[60] It is at this point that, with a simple touch of her godmother's wand, Cinderella's rags are transformed into a magnificent gown.

It is likely that most readers are familiar with the role that Perrault's fairy godmother played in Cinderella's new wardrobe. In some versions of the tale published by the Grimms, however, the way that Cinderella obtains her resplendent clothing differs significantly. Cinderella's father takes a trip to the fair, and he asks his daughter and stepdaughters what they would like him to bring back for them. The materialistic stepsisters demand beautiful gowns, pearls, and jewels, while the humble Cinderella asks only for the first tree branch that brushes against his hat on his journey home. He returns with a hazel branch, which Cinderella plants at the grave of her mother. The branch eventually grows into a small tree, watered by Cinderella's tears. When she expresses her need for fine clothing at the tree's roots, a little bird throws down a beautiful dress. Cinderella heads to the party, where her opulent attire renders her unrecognizable – her stepsisters take her to be "the daughter of some foreign king."[61] Cinderella's dress is even more spectacular on the second night of the ball. Surprisingly, Perrault does not specify what this second gown looks like. In the initial version published by the Grimms, however, both gowns are described clearly. On the first night, Cinderella wears a "splendid dress" that is accessorized with "pearls, silk stockings, silver slippers, and everything else that belonged to her outfit."[62] The dress worn on the second night of the ball is "made out of gold and precious gems. In addition there were golden gusseted stockings and gold slippers. And after Cinderella was completely dressed, she glistened really like the sun at midday."[63] In later editions of the Grimms' story, there is a *third* night of festivities, but unfortunately the descriptions of Cinderella's gowns are not detailed in these versions.

Cinderella's magnificent ball gowns have become synonymous with the concept of "fairy tale" dress-

Illustration for "Cinderella" by A. H. Watson, 1927

ing. Although gold and silver gowns were certainly not everyday apparel during the time of Perrault or the Grimms, Cinderella's dress may have been grounded more firmly in reality than one might think. It is likely that Perrault knew of a French courtier named Madame de Sévigné, who wrote detailed letters to her daughter about life at court. These included descriptions of clothing and were considered to be so engrossing that many of them were copied and distributed even during de Sévigné's lifetime. They were later published in book format, and translated into English.

In 1676, de Sévigné wrote about a dress worn by the king's official mistress, the marquise de Montespan. The gown was so magnificent it was speculated to have some kind of magical provenance:

> M. de Langlée has made Madame de Montespan a present of a robe of gold cloth, on a gold ground, with a double gold border embroidered and worked with gold, so that it makes the finest gold stuff ever imagined by the wit of man. It was contrived by fairies in secret, for no living wight could have conceived of anything so beautiful. The manner of presenting it was equally mysterious. Madame de Montespan's mantua-maker carried home the suit she had bespoke, having it made to fit ill on purpose; you need not be told what explanations and scoldings there were upon the occasion. 'Madame,' said the mantua-maker, trembling with fear, 'as there is so little time to alter it, will you have the goodness to try whether this other dress may not fit you better?' It was produced. 'Ah!' cried the lady, 'how beautiful! What an elegant stuff is this? Pray, where did you get? It must have fallen from the clouds, for a mortal could never have executed any thing like it.' The new dress was tried on; it fitted to a hair.[64]

Part of de Montespan's public role was to act as "a triumphant beauty to display to all the ambassadors,"[65] meaning that wearing the most fashionable, French-made clothing was expected of her. De Montespan was certainly not alone in her focus on fine clothes, however. There are numerous descriptions of gold or silver cloth worn in the court of Louis XIV, especially for weddings. In 1697 – the same year that Perrault published his version of "Cinderella" – Marie-Adélaïde of Savoy wore what was surely a stunning gown of "virgin silver, embroidered with silver, with a train and a coronet of pearls,"[66] for her marriage to Louis, Dauphin of France, Duke of Burgundy. It is entirely possible that these lavish garments, worn by some of the most fashionable women of the court, had some influence on Perrault's descriptions of Cinderella's dress.

43 Cinderella

Beyond its beauty, opulent clothing played a crucial role in defining the exclusivity of the monarchy,[67] a concept of which Perrault would have been keenly aware. By attending the ball in such splendid dress, it is no wonder that Cinderella is assumed to be a princess. Furthermore, she was not dressing well simply to gain admittance to the ball – she was communicating to the prince that she was worthy of his hand in marriage. As Jo Eldridge Carney notes, "All early modern queens [...] accepted that their very identities were determined by their dazzling dresses, lessons that numerous fairy tale protagonists also well understood."[68] Notably, Perrault's text ensures that the prince never sees Cinderella in her rags. After Cinderella proves to the prince's men that is was she who lost the slipper, her godmother whisks in and provides her with a dazzling new dress. It is only then that Cinderella goes to see her prince.

"Asked to describe the dress of their dreams, most women will defer to Cinderella," asserts the fashion writer Jo Ellison. "Centuries have passed since the French folk tale first became popular but the specifications have barely changed: the fantasy gown must be lush and extravagant; it must swish across the floor with a whispering sweep; it must feature clouds of taffeta, streamers of tulle, ribbons of silk and sparkling jewels; it must make one feel like the scion of a major European royal family."[69] Perhaps a modern-day Cinderella would choose to be dressed by designers who not only make extraordinary gowns, but who have – like her – overcome challenging circumstances in order to achieve success.

Joseph Altuzarra launched his namesake label in 2008, in the midst of a global financial crisis that left parts of the fashion industry in tatters.[70] Yet this young designer – who received no formal training – persevered and prospered. "Every so often a designer comes along with enough skill to charm editors, enough charm to seduce socialites, and enough good sense – for both hemlines and bottom lines – to make you believe he just might stay a while,"[71] explained the fashion writer Rob Haskell. Altuzarra's Spring 2015 runway presentation closed with a trio of elegant, airy evening dresses that the designer referred to as his "deflated" eighteenth-century gowns[72] – a particularly interesting description, given that many illustrations of Cinderella show her in opulent, eighteenth-century-inspired dresses. The very last gown from this collection featured two hallmarks of Cinderella's ball gowns as detailed by Perrault and the Grimms: it is gold (or, more specifically, made from sheer white fabric woven with flowers in bright metallic gold thread), and its seductive neckline – which plunges almost to the navel – is highlighted by a row of delicate pearls.

Altuzarra
Spring 2015, look 37
Courtesy Altuzarra

As a young man growing up in war-torn Beirut, Elie Saab began making and selling clothing to help support his family. By the age of eighteen, he had opened his own couture house. It is not hard to imagine Saab crafting clothing that is fit for a princess – he has, in fact, received commissions from numerous European royals, including Princess Stéphanie of Luxembourg, Princess Beatrice of York, and Crown Princess Victoria of Sweden. Of his many elegant couture creations, his bridal gowns are some of his most spectacular, in many cases requiring 200 hours of work to complete.[73] It is often said that a woman's wedding is her "Cinderella moment" – and her dress is, of course, essential to her transformation. One wedding gown from Saab's Fall 2013 collection could not disappoint – constructed from layers of pearl grey tulle, it is embellished densely with rows of sparkling silver quartz, crystal, and glitter. Especially when viewed with its matching train (carried down the runway by two attendants in beautiful dresses of their own), the gown is almost inconceivably opulent.

Cinderella's Slippers

Cinderella's beautiful gowns are pivotal to her transformation from servant girl to princess. They grant her access to the ball and signify immediately her worth to the prince. Yet it is her lost shoe that is truly critical to the tale's plot. The most significant characteristic of the slipper is not its material – glass, gold, or fur, depending on the version and translation of the tale – but its size. Cinderella's feet are exceptionally small, a detail that not only connotes a desirable daintiness, but ensures no one else can fit into her shoes, and thus be misidentified as the prince's beloved.

In an early, Chinese variant of the tale, dating to the ninth century A.D., Cinderella arrives at a local festival wearing gold shoes and a cloak made from kingfisher feathers. Her footwear would have been an especially luxurious commodity during this time period in China, when wearing shoes made from bark or straw – or simply going barefoot – was commonplace.[74]

Numerous other versions of Cinderella, including those transcribed by the Grimms, also feature golden slippers. Rather than losing her shoe by accident, as she does in Perrault's tale, the Grimms write of a trick played on Cinderella by the prince. On the last night of the ball, he has the staircase covered in pitch, hoping that the sticky material will prevent Cinderella from being able to run away. She escapes from the ball anyway, of course, but her left shoe sticks in the pitch.

Elie Saab
Fall 2013 Haute Couture, look 46
Courtesy Elie Saab

46 Fairy Tale Fashion

Cinderella's gold shoes were surely stunning, but her glass slipper – seemingly the invention of Perrault – has become what Dorothy Thelander referred to aptly as the story's "talismanic piece of clothing."[75] While many elements of fairy tales require a strong suspension of disbelief, the glass slipper has sparked a special debate among fairy tale historians and enthusiasts. One frequently repeated theory is that Perrault erred in his transcription of the oral tale, writing *verre* (glass) rather than *vair* (variegated fur). Others believe that the word was simply mistranslated from French into English. A 1926 article in the *New York Times* was devoted to this supposed mistranslation, stating "When [Perrault] painted for us Cinderella's gorgeous fineries, he clothed her in bright silks and dainty lace, in rich brocades with gold and silver trimming, in tight bodices and voluminous pannier skirts. Now it was the very height of novelty for fashionable ladies in those seventeenth-century days of Perrault to wear shoes lined or edged and trimmed with soft fur of a kind which had until then been reserved for the robes of the highest in the land. This fur was known as Vair."[76]

More recently, numerous scholars have disputed the theory that Perrault had in fact intended his Cinderella to wear fur shoes. Although a glass slipper is quite inconceivable as functional footwear, fairy tale heroines rarely need to concern themselves with practicality. After all, Cinderella's wardrobe is created literally by magic. Why should she wear anything but extraordinary shoes?

One factor pointing to Perrault's intended use of glass, rather than fur, relates to the precise fit of the shoe. A fur shoe could stretch to some extent, meaning that someone with a small foot – even if not quite as small as Cinderella's – might be able to squeeze into the shoe. As glass provides no stretch, however, there is little doubt that the woman able to don the shoe has passed what folklorists refer to as "the shoe test." Furthermore, the French folklorist Paul Delarue points out that glass slippers occur not just in Cinderella, but in other fairy tales as well,[77] and that they are but one part of a larger lexicon of impossible objects in fairy tales. "All those familiar with *märchen* (folktales) know that glass, copper, gold, silver, and diamonds are the precious materials of which things in the fairytale realm

(facing) Noritaka Tatehana
Cinderella 3D-printed shoes, 2014
Courtesy Noritaka Tatehana

(below) Advertisement for "glass slippers" made from Lucite, 1950

are made, things which in our real world are made of ordinary materials," he writes, also mentioning that shoes made from gold or silver are hardly more practical than those made from glass.[78]

Furthermore, the ending of Perrault's story seems tailored to the inclusion of a glass slipper. His story ends quite simply and cheerfully – the stepsisters fail to fit the shoe, but because of Cinderella's kindness, all parties end up living happily ever after. In the short, poetic moral with which Perrault ended each of his tales, he reminds readers of the importance of graciousness above all, writing, "Beautiful ladies, it's kindness more than dress; That wins a man's heart with greater success."[79]

Things are not so simple or cheerful in the ending offered by the Brothers Grimm. Their version takes a gruesome turn, as the sisters' desperate desire to fit into the dainty gold slipper leads them to a rather appalling act: the mutilation of their own feet. At the encouragement of their mother, one sister cuts off her big toe, while the other cuts off a piece of her heel. They successfully don the slipper and manage to disguise their pain, and each sister is, in turn, taken away by the prince on his horse. It is only when the horse passes by two doves, perched in the branches of a hazel tree, that the prince realizes his mistake. "Looky look, look, at the shoe that she took," the birds call out to the prince. "There's blood all over, the shoe's too small. She's not the bride that you met at the ball."[80] The prince then glances at the sister's foot and, observing the blood that spurts from the shoe, returns his false bride-to-be to her home. This could not have been part of Perrault's story, simply for the fact that a glass slipper would have immediately revealed the sisters' bloody feet.[81] In later editions of the Grimms' story, the birds peck out the sisters' eyes, rendering them blind, while Cinderella goes off to marry the prince.

Late in the twentieth century, feminists targeted "Cinderella" (alongside numerous other fairy tales) for its promotion of a saccharine, spineless heroine. Yet as the author Jane Yolen counters, "In most of the Cinderella tales there is no forgiveness in the heroine's heart. No mercy. Just justice [...

(facing) Maison Martin Margiela, *Glass Slippers*, 2009
Photograph courtesy Dorothée Murail

(below) Nicholas Kirkwood *Cinderella* shoes, 2015
Courtesy Nicholas Kirkwood

she] doesn't tell the stepsisters that she has the matching slipper, thus allowing them to hack off their toes and heel."[82] While feminists may find some encouragement in this argument, it is almost certainly the lack of gore in Perrault's "Cinderella" that has made it the better-known version of the tale. Yet the appeal of the glass slippers has surely played a significant role in the popularity of Perrault's version as well – and these extraordinary shoes have been referenced in high fashion time and again.

Pristine white shoes, rather than glass slippers, were regularly associated with Cinderella during the early years of the twentieth century. "If Cinderella wore slippers as charming as these of white satin trimmed with oval buckles [...] then, of course, one quite understands the ending of the fairy-tale,"[83] enthused a writer for *Vogue* in 1919. An advertisement for Cinderella-brand shoe polish in kid white ran in *Vogue* during the 1920s, promising to "keep your footwear looking smart and charming for every occasion." As new materials were developed over the course of the twentieth century, however, Cinderella-style shoes came to more closely resemble glass slippers.

In the Fall 1995 issue of the fashion and art magazine *Visionaire* – devoted to "Cinderella" – the art writer Glenn O'Brien supplemented the story's plot with his own humorous additions. "Cinderella's slippers were a size 6AA," he wrote, "although shoes did not generally come in sizes in those days. They did not generally come in glass, either, and being enchanted slippers, one imagines that they were actually made of something resembling today's safety glass."[84] In fact, acrylic has been used at various times to make Cinderella-inspired "glass slippers." A boudoir slipper from 1950 was made from transparent Lucite, shaped to "sparkle like cut crystal," and was trimmed with the wearer's choice of white, black, pink, blue, or red marabou feathers.

Noritaka Tatehana's dazzling *Cinderella* shoes, designed in 2014, take the idea of acrylic "glass slippers" in a new and avant-garde direction. Their intricate form is 3D-printed, and they are faceted like gemstones to catch and reflect light. While the resin material is sturdier than glass, the towering, heel-less platforms appear as fragile – and as challenging to wear – as actual glass slippers. On his website, the designer traces his interest in Cinderella back to his childhood, and points out that the story's "shoe test" is relevant to everyday life. "Like in the Cinderella story," he writes, "women compete with one another over shoes."[85] In a nod to the story that inspired them, a pair of *Cinderella* shoes was taken to a bridal show in Japan, where a pressure sensor able to gauge fit was placed in-

side them. The woman whose feet best fitted into the shoes received a wedding gown and other prizes (alas, she did not receive the shoes themselves, which are particularly challenging and expensive to produce).

Vinyl was first popularized as a material for clothing and accessories during the 1960s, and it also came to be used for "glass slippers." Styles by Roger Vivier were featured in *Vogue* in 1966, alongside the caption, "Regardez, Cinderella: Roger Vivier has designed the lightest, most enchanting new slipper imaginable. A transparent, almost invisible, slipper in which, on a clear day – or a clear night – you can see a pretty foot forever."[86]

The 2015 release of Disney's first live-action *Cinderella* film was accompanied by contemporary designs for "glass slippers" by labels such as Salvatore Ferragamo, Charlotte Olympia, and Jimmy Choo. All of the designs included crystals by Swarovski, the company that created Cinderella's dazzling slippers for the movie. Nicholas Kirkwood's elegant yet edgy stiletto combined a crystal-encrusted heel, toe, and decorative bow with lace-covered, clear vinyl. His design, as well as those from the other featured labels, were displayed and sold via special order at Saks Fifth Avenue in New York. The interest in the promotion made it evident that, for many women, the allure of Cinderella's glass slippers does not end with childhood.

While fashionable facsimiles of Cinderella's glass slippers abound, Maison Martin Margiela made a more literal reference to the story. In 2009, the label introduced a limited-edition run of *Glass Slippers* – stiletto heels that are truly made from glass. Crafted in the midst of a trend for towering, seemingly unwearable high-heeled shoes, these slippers represented an especially dangerous – if not impossible – style. At the same time, they evoke the enduring, romantic appeal of the Cinderella tale.

Little Red Riding Hood
(Based on the tale by Charles Perrault)

Little Red Riding Hood is a pretty, charming young girl whose family members dote on her – particularly her grandmother, who fashions the girl a red cap. When her grandmother falls ill, Red Riding Hood is sent off through the forest to check on the elderly woman and deliver a basket of food to her. On her way, she meets a wolf, who instantly wishes to devour her. Instead, he asks the girl where she is headed, and she describes the location of her grandmother's house. The wolf says that he would also like to visit grandmother, and suggests that Red Riding Hood take one path while he takes another.

Red Riding Hood dawdles along her path, gathering nuts, running after butterflies, and making bouquets of flowers. The wolf, meanwhile, runs as fast as he can to grandmother's house, goes inside, and eats her. He waits in the grandmother's bed for Red Riding Hood's arrival. Disguising his voice, the wolf convinces Red Riding Hood to climb into bed with him, where he gobbles her up as well.

Fashioning "Little Red Riding Hood"

Red Riding Hood's pride in her fashionable cap (or hood, or hooded cloak) symbolizes her vanity, but it is her idleness that places her in real danger. Although Red Riding Hood is sent off to take food to her sick grandmother, she becomes distracted in the forest. This allows the wolf to reach grandmother's house long

(facing) Dolce and Gabbana
Fall 2014, look 70
Courtesy Dolce and Gabbana

(following) Eugenio Recuenco
"Children's Stories," editorial from
Vogue Novias, 2005
Courtesy Eugenio Recuenco

before Red Riding Hood does – and it also grants him the time to devour the grandmother, dress in her nightgown, and climb into her bed. In Perrault's version of the tale, there is no redemption for Red Riding Hood – the wolf eats her, too, and the tale ends there. The Grimms include an addendum to this rather gruesome conclusion, writing of a passing huntsman who rescues both the grandmother and Red Riding Hood from the wolf's belly.

There are, of course, many other versions of "Little Red Riding Hood" than those published by Perrault and the Grimms. Jack Zipes speculates that Perrault was aware of a story told in sewing societies in southern France and northern Italy. In this version, a young peasant girl must choose between the "path of pins" and "the path of needles" on her way to becoming a seamstress. She encounters a werewolf on her journey, and must demonstrate her prowess over him in order to be initiated into a sewing society.[87] In her book *The Annotated Brothers Grimm*, Maria Tatar describes a version of the tale in which Red Riding Hood tries to appease the wolf by offering him fine clothing – first her silk shirt, then her silver shoes, and in a final, desperate attempt, her golden crown. The Grimms ultimately discarded this story.[88]

In Roald Dahl's amusing, twentieth-century adaptation of the tale, Red Riding Hood is transformed into a feisty heroine – and her clothing changes accordingly. When the wolf threatens to eat her, she "whips a pistol from her knickers," and shoots him dead. Dahl's clever poem ends with the lines, "A few weeks later, in the wood, I came across Miss Riding Hood. But what a change! No cloak of red; No silly hood upon her head. She said, 'Hello, and please do note. My lovely furry WOLF-SKIN COAT.'"[89] In reference to Dahl's story, Catherine Orenstein, author of the book *Little Red Riding Hood Uncloaked: Sex, Morality, and the Evolution of a Fairy Tale*, writes, "If a wolf stole transforms the heroine, so fashion can reinvent the wolf."[90]

In spite of its many variants, "Little Red Riding Hood" is often interpreted as a story about rape, or, at the very least, loss of virginity. This analysis is not unfounded – the moral with which Perrault ends his tale includes the lines, "Wolves may lurk in every guise. Handsome they may be, and kind, Gay, or charming – never mind! Now, as then, 'tis simple truth – sweetest tongue has sharpest tooth!"[91] Some folklorists directly link the young girl's wearing of scarlet attire to her eventual fate. "Red is the color symbolizing violent emotions, very much includ-

Illustration for "Little Red Riding Hood" by Arthur Rackham, 1909
Image courtesy Fashion Institute of Technology/SUNY, FIT Library Special Collections and FIT Archives

57 Little Red Riding Hood

ing sexual ones,"[92] notes Bruno Bettelheim. Orenstein describes red as "the color of harlots, scandal and blood, symbolizing [Red Riding Hood's] sin."[93] Some folklorists and historians disagree with these interpretations, citing that the color red had both moral *and* political connotations during Perrault's time.[94] Like most fairy tales, "Little Red Riding Hood" cannot be easily or definitively interpreted.

Although the various psychological, sociological, and political analyses of "Little Red Riding Hood" are fascinating, a more straightforward understanding of her red attire is sometimes lost. Cinderella's story centers on the magical appearance of her luxurious ball gowns and spectacular shoes, but Little Red Riding Hood's sartorial identity is established with a single garment – and it is one that could have easily existed in reality. Perrault and the Grimms both describe a red hood or hat in their stories (the story is sometimes called "Little Red Cap"). The style in which Red Riding Hood is most often depicted today – the scarlet cloak with an attached hood – appears to have been modeled after the bright red, woolen cloaks worn by English countrywomen late in the eighteenth century and early in the nineteenth.

(left) Diana Sperling
"The Lord of the Manor and his family going out to a dinner party at 5 o'clock with a tremendous stile before them"
Early 19th century
Courtesy Mrs. Neville Ollerenshaw

(right) "Fashion for April, 1811," in *La Belle Assemblée*
Image courtesy Fashion Institute of Technology/SUNY, FIT Library Special Collections and FIT Archives

(facing) Cape in red felted wool, late
18th century, England
The Museum at FIT, 2002.36.1

(below left) Comme des Garçons
Spring 2015
The Museum at FIT, 2015.8.1

(below right) Giorgio di Sant'Angelo
Cape in dark red velvet, ca. 1970
The Museum at FIT, 88.29.24

(following) Kirsty Mitchell
"The Journey Home"
From the *Wonderland* series
Courtesy Kirsty Mitchell

A series of watercolors by Diana Sperling, a young English lady who painted scenes of her life in rural Essex between 1812 and 1823, documents the importance of these red, hooded cloaks as everyday garments. An especially charming example shows three women trailing after Sperling's father in a field, all wearing red cloaks over white dresses, and carrying their house shoes with them in small bags. Sperling's own caption reads, "The Lord of the Manor and his family going out to a dinner party at 5 o'clock with a tremendous stile before them." Many of Sperling's paintings feature red cloaks, sometimes worn on horseback or traversing the countryside, and at other times strewn casually over a bedroom table or hanging on a hook.

Although Sperling's drawings of the cloaks are not detailed, other sources give us a better sense of what they may have looked like. A cloak in the collection of The Museum at FIT, dating to late in the eighteenth century, is made from bright red, felted wool. Its functional design includes a quilted, satin-lined collar (visible when the hood is down), and a button-front vest that is built into the cloak's interior to allow for additional stability and warmth. One can imagine that this attractive yet practical garment would have been like the one worn by Sperling herself. Similar cloaks exist in the collections of the Costume Institute at the Metropolitan Museum of Art, the Manchester Galleries, and the Museum of Fine Arts, Boston, among others. All of these resemble the cloaks depicted in innumerable illustrations of Little Red Riding Hood.

There were various high-fashion versions of red cloaks in Sperling's time. One example was featured in the English fashion magazine *La Belle Assemblée* in 1811, and, like Sperling's illustration, it is paired with a white walking dress. Rather than a hood, the cloak has a deep, pointed "cape" that ends with a tassel. The magazine describes the garment as made from red cashmere wool, lined with purple silk, and embroidered around the neck, cape, and sides with a "purple fancy border." The coordinating "little red cap" is a bonnet with a turban front, fashioned from red velvet with purple trim.[95]

It is clear that red riding hoods were commonly worn as outerwear late in the eighteenth and early in the nineteenth centuries, but an adaptation of "Little Red Riding Hood" by Walter de la Mare, published in 1927, shows that they were considered quaint and old-fashioned by the early years of the twentieth century. De la Mare begins:

> In the old days when countrywomen wore riding-hoods to keep themselves warm and dry as they rode to market, there was a child living in a little vil-

lage near the Low Forest who was very vain. She was so vain she couldn't even pass a puddle without looking down into it at her apple cheeks and yellow hair. She could be happy for hours together with nothing but a comb and a glass; and then would sit at the window for people to see her. Nothing pleased her better than fine clothes, and when she was seven, having seen a strange woman riding by on horseback, she suddenly had a violent longing for such a riding-hood as hers, and that was of a scarlet cloth with strings.[96]

Red capes have long fallen out of use as everyday clothing, but they continue to influence high fashion. Seeing any variation of a red cape on the fashion runways (particularly if it has a hood) immediately evokes this popular tale. A cape by Giorgio di Sant'Angelo, dating to early in the 1970s, exemplifies how this style was adapted to suit a modern fairy tale heroine. Made from deep red velvet, it features an oversize hood that comes to a long point, topped with a large tassel – much like in the 1811 illustration from *La Belle Assemblée*. The cape also features intricate, multicolored embroidery that underscores the fanciful and folkloric look of many fashions from the start of the 1970s, a style for which Sant'Angelo was especially well known.

A more recent example, designed by Rei Kawakubo for her label, Comme des Garçons, takes the red riding hood in a provocative new direction. Her Spring 2015 collection consisted entirely of garments rendered in shades of bright red, a color the designer associates with roses and blood. One ensemble included a long, loose gown made from shreds of red patent leather, coupled with an enormous, peaked hood – also in patent leather, but quilted. From the side, the wide hood entirely obscures the wearer's face (a fact that inevitably led to quips from the fashion media about a "Big Red Riding Hood"). Of the many unusual and spectacular clothes from this collection, this particular ensemble received a special amount of attention, particularly when the musician and fashion maverick Björk wore it in the Spring 2015 issue of *T* magazine, devoted to women's fashion.

The image of Red Riding Hood has become so pervasive that she sometimes does not even need to wear a red cloak to be identified. The March 15, 1935 issue of *Vogue* featured an illustration of an elegant, floor-length evening gown, with a caption that reads, "Mainbocher puts a fetching Red Riding-Hood of black tulle on the billowing tulle cape [...] Throw off the cape and there's a tulle-shrouded black satin slip."[97] As this description implies, the dress was made entirely of black fabric. The use of the term "Red Riding-Hood" was only meant

64 Fairy Tale Fashion

to describe the style of the hood, which was loose and round with a ruffle that framed the face.

In a similar vein, Alexander McQueen's Fall 2002 presentation featured a model in a lilac leather cape with a large, billowy hood, who led two wolf-like dogs down the runway. Even in this unusual color, the ensemble's reference to "Little Red Riding Hood" was plain. More recently, the artist Kirsty Mitchell created a Red Riding Hood-inspired piece for *Wonderland*, a captivating series of photographs made in honor of her late mother, a teacher and lover of literature and artwork. In this photograph, entitled "The Journey Home," Mitchell chose not to dress her model in red. Instead, she wears a hooded cloak fashioned from bright yellow leaves, and stands at the end of a winding woodland path made from the same material. This haunting image – like all of Mitchell's work – was crafted entirely by hand, and is not digitally altered. Mitchell is a trained fashion designer who once interned for Alexander McQueen, and it is clear that she too has an otherworldly sensibility.

Perhaps because of its unmistakable visual identity, "Little Red Riding Hood" is also a popular reference in advertisements and magazine editorials. Elsa Schiaparelli based various ads for her *Shocking* perfume on fairy tales, including an example from 1943 that shows a woman in a red cap and a short red dress. She carries a basket that holds a large bottle of the perfume. In the right corner, a wolf dressed in dapper attire lusts after her – or perhaps her basket. In 1954, Max Factor launched a new shade of vibrant red lipstick, called "Riding Hood Red," and an advertising campaign to match. A model in a red, hooded cape holds a tube of the lipstick to her mouth, while she glances sideways toward a group of eager men who peek out from the trees behind her. "Wear Riding Hood Red at your own sweet risk," reads the ad's tagline, "we warn you, you're going to be followed! It's a rich, succulent red that turns the most innocent look into a tantalizing invitation [...]"[98]

In fashion editorials, red clothing worn in woodland settings and shown with certain props, such as a basket of apples, are all that seem necessary to evoke the tale. In a 2009 *Vogue* editorial entitled, "Into the Woods," Mert Alas and Marcus Piggott photographed a variety of "capes and coats,

Advertisement for Schiaparelli's *Shocking* perfume, 1943
Illustration by Vertès
Private Collection

65 Little Red Riding Hood

dresses and suits of scarlet, rose, ruby and crimson,"[99] selected by the fashion editor Grace Coddington. Natalia Vodianova modeled garments from Chanel, John Galliano, Marc Jacobs, and Yohji Yamamoto – among many others – in a beautifully saturated, woodland setting. One especially striking image shows Vodianova reclining among the yellowed leaves of the forest floor, a basket of red apples beside her. She wears a coat by Moschino in red wool, black leather Lanvin gloves, and black Louis Vuitton platform boots. "A proper riding coat (in the hue of a shiny Red Delicious apple) delivers a lot of polish in just one piece," read the photo's caption.[100] Red Riding Hood's role as a style icon appears to be everlasting.

(below) Max Factor advertisement for "Riding Hood Red" lipstick, 1954
Private collection

(following) Mert Alas and Marcus Piggott "Into the Woods," *Vogue*, September 2009
Courtesy Mert Alas and Marcus Piggott/ Art Partner

The Fairies
(Based on the tale by Charles Perrault)

A widow lives with her two daughters, one of whom takes after her disagreeable, haughty mother in both looks and manners, the other of whom is as sweet-natured and attractive as her deceased father. The mother, naturally, favors the daughter who resembles herself and treats the other one poorly. As part of her daily chores, the mistreated daughter must fetch water from a spring that is a mile away. One day, in the midst of this task, a poor woman approaches her, and asks for a jug of water. The kind girl assists readily. The woman then reveals that she is a fairy in disguise, and as a reward for the girl's goodness and beauty, the fairy bestows upon her a strange and marvelous gift: each time she speaks, flowers and precious stones will fall from her mouth.

The girl returns home, where her mother is thrilled by the valuable gift. She quickly sends her mean daughter, Fanchon, to the spring, hoping that she will receive the same reward. This time, however, the fairy disguises herself as a magnificently dressed lady, and Fanchon refuses the seemingly wealthy woman's request for water. The fairy then reveals herself once again, and curses Fanchon for her meanness. Each time she speaks, snakes and toads will fall from her mouth.

When Fanchon returns home, her sister is blamed for her ailment. To avoid a beating by her mother, the kind girl escapes to the forest. It is there that she meets a prince, who takes her to the king's palace to marry her. The story concludes with the hateful Fanchon being driven from the house by her mother, and she eventually dies in the forest.

Illustration for "The Fairies" by Gustave Doré, 1867

Fashioning "The Fairies"

There is only a single reference to clothing in this story – that of the fairy changing her disguise – yet it is crucial to the plotline. Perrault writes that the fairy first "assumed the form of a poor peasant in order to discover just how kind this young girl was,"[101] an act that would have required her to adopt a peasant's simple, shabby clothing. Later, when the fairy prepared to meet the nasty sister, she "put on the airs and the garments of a princess just to see how rude [Fanchon] could be."[102] The fairy's disguise tricks the girl, since she expects to see the same humble, poor woman whom her sister aided. When Fanchon instead sees a woman in opulent dress, she haughtily refuses to assist someone she assumes could afford to keep a servant.

That the fairy in this tale takes human form may seem puzzling, being that we typically imagine fairies as tiny, winged creatures that live among the flowers. In examining Perrault's collection of tales, however, we see that he represents fairies in a number of ways. There is Cinderella's godmother, who exists to provide Cinderella with unimaginable finery and fashionable modes of transportation. In "The Fairies," she is a shape shifter who is capable of both good and bad deeds (even if the injurious deeds are justified). Finally, as we will see in the forthcoming entry on "Sleeping Beauty," Perrault presents these fairies as *either* good or bad. The good fairies bestow the baby princess with gifts, while the bad fairy curses (or at least attempts to curse) the girl to an early death. Dorothy Thelander explains these various representations neatly, writing, "The only two prerequisites for the French fairy are that she be a woman and that she work magic."[103]

Further adding to the confusion of the fairies is that their appearance remains undefined. We get no sense of what the fairy in "The Fairies" looked like in her undisguised state. As mythological creatures, the depictions of fairies that do exist in texts and illustrations are, of course, subject to their various creators' whims, but they are nonetheless intriguing. A particularly charm-

Prada
Printed silk pajamas, Spring 2008
The Museum at FIT, 2008.45.1

ing description of fairies' dress is included in Michael Page and Robert Ingpen's *Encyclopedia of Things That Never Were*, in which he says, "Fairy queens and their attendants are very fashion-conscious and they dress in elaborate costumes of fabrics woven from the finest spider-silk with dewdrop sequins. A peculiarity of these garments is that, whenever a queen appears to a mortal, they cannot be touched or even felt by human hands."[104] In a similar text, *The Book of Imaginary Beings*, it is noted that fairies are particularly fond of the color green.[105]

Indulgence in whimsical books aside, a prevailing "fairy look" can be traced to nineteenth-century England, where the tales of the Grimm Brothers and Hans Christian Andersen, in particular, contributed to an expansive enthusiasm for fairy stories.[106] Fairies were not only the subjects of book illustrations, but also of paintings, ballets, theater productions, and poetry. Christopher Wood, the author of *Fairies in Victorian Art*, notes that artists "tried to paint fairies realistically and accurately, with the greatest attention to detail […] Such a combination of reality and fantasy may seem an impossibility, yet the Victorians attempted it, and this is what gives their fairy paintings their strange, and at times, disturbing intensity."[107]

Fairies in Victorian art were often – though certainly not always – dressed in sheer white, classically styled gowns or drapery, with gossamer wings. In his 1906 book, *Puck of Pook's Hill*, Rudyard Kipling despaired of what he thought to be the "prettification" of fairies during this time period, describing them as "little buzzflies with butterfly wings and gauze petticoats and shiny stars in their hair and a wand […] pointy-winged and wand-waving sugar-and-shake-your-head set of impostors."[108]

Perhaps Kipling would have approved of a recent representation of fairies, created by the artist James Jean for Miuccia Prada's Spring 2008 collection. Among his many projects, Jean has illustrated elaborate, provocative covers for the comic book series *Fables*, a number of which featured well-known fairy tale characters. For Prada, Jean created what the designer described as a series of "whimsical illustrations

Illustration for "Toads and Diamonds" (a tale similar to "The Fairies") by G.P. Jacomb-Hood, 1889

72 Fairy Tale Fashion

[...] of dragons, eerie fairies, hybrid creatures, and man-eating flowers that were part Aubrey Beardsley and part Hieronymus Bosch," adding that "the whole collection had a sort of sci-fi, romantic sensibility."[109] The first ensemble shown on the runway, now in the collection of The Museum at FIT, was a pair of emerald-green silk pajamas with one of Jean's prints in shades of purple, green, cream, and gold. The fairies are elegantly depicted, with long, graceful limbs and flowing hair, perched on leaves and clutching flowers. At first glance, they simply appear beautiful, but a closer look at the print reveals flowers with partially defined faces and leaves in the shape of human hands, bestowing the print with a strongly sinister quality. Susannah Frankel noted that Prada's fantasy was "far from simple or indeed steeped in anything as nice as sugar and spice [...] there is a dark romance to this vision also."[110] Regardless, the collection was a commercial success, with the limited edition fairy-print handbags being touted as one of the most covetable – and elusive – fashion must-haves of 2008.[111]

Perrault did not include any description of the clothing worn by the sisters in "The Fairies." This may be because they would likely be dressed in the humble clothing of a peasant or a countrywoman – and as we learned from "Cinderella," Perrault did not seem inclined to describe anything but fine fashions. The artist Gustave Doré illustrates the kind sister retrieving water for the fairy, who wears her crone's disguise in the background. While the sister's headscarf and apron are indicative of her humble station, she is shown with a pronounced hourglass figure – firmly placing her within the beauty ideal of the 1860s, when the illustration was created. G. P. Jacomb-Hood's 1889 illustration takes a similar approach. Fanchon, wearing a simple dress with a lace-front bodice, is shown scowling at the fairy, who is enviously fashionable in her short cape and full-sleeved bodice.

In contrast to stories such as "Cinderella" and "Furrypelts," in which the characters prove their worth by donning magnificent clothing, the heroine in "The Fairies" experiences no sartorial transformation. While it is made clear that the prince is first attracted to the kind sister's beauty, he is won over by her unique gift. Perrault writes, "Seeing five or six

(facing) Armani
Evening gown embellished with Swarovski crystals, Fall 2007
The Museum at FIT, 2008.67.1

(below) Holly Fowler
English Princess collection
Photograph by Christina Smith, courtesy Holly Fowler

74 Fairy Tale Fashion

pearls and as many diamonds fall from her mouth, the king's son asked her to tell him where they came from. She told him the entire story, and the king's son fell in love with her. When he considered that such a gift was worth more than a dowry anyone else could bring, he took her to the palace of his father, where he married her."[112]

This statement makes the prince seem more avaricious than caring, but consideration of dowries – which often included clothing – was of great importance during and around Perrault's time. As Kimberly Chrisman-Campbell explains in her book *Fashion Victims: Dress at the Court of Louis XVI and Marie-Antoinette*, "Marriage usually marked a young woman's entrance into the world of fashion. At all levels of French society, clothes functioned as currency in marriage negotiations. Depending on her social status, a bride's wedding clothes could consist of anything from a new hat to a lavish trousseau intended to last for years. Clothes often formed part of the bride's dowry and the groom's wedding gifts to his bride. Whatever her financial circumstances, a bride was expected to wear the proverbial 'something new.'"[113]

With her endless supply of precious jewels, the kind sister would have the means for a truly spectacular wardrobe. She could, of course, simply use the wealth provided by her jewels to purchase fine clothing. Yet she may have also chosen to affix the brilliant gems directly to her garments – another practice that was certainly known within the French court. Among a wide array of jewels, Perrault's version of this tale specifically mentions diamonds and pearls. Like many motifs that appear within fairy tales and elsewhere, the symbolic meaning of this selection is subject to a number of interpretations. Perhaps these were simply the most precious or fashionable gems at the time of Perrault's writing. Nevertheless, a 1913 book by George Frederick Kunz, *The Mystical Lore of Precious Stones*, offers a compelling explanation that is worth consideration. "The diamond is to the pearl as the sun is to the moon, and we might call one the 'king gem' and the other the 'queen gem,'" he writes. "The diamond, like a knight of old – brilliant and resistant, is the emblem of fearlessness and invincibility; the pearl, like a lady of old – pure and fair to look upon, is the emblem of modesty and purity."[114] Kunz further notes that, according to an old superstition, the talismanic power thought to be held by diamonds is lost if the jewels are purchased. In order to take full advantage of their charms, diamonds must be received as a gift. The kind sister, therefore, would be able to make full use of the diamonds gifted to her by the fairy.[115]

Yoshiki Hishinuma
Dress in heat-processed polyester, 2001
The Museum at FIT, 2001.52.2

77 The Fairies

While covering a dress in pearls and diamonds may be common in the realm of fairy tales, the concept still resonates in fashion. In 2007, Giorgio Armani collaborated with Swarovski on a new cut of crystal, made exclusively for the designer's use. Approximately 100,000 of the resulting *Diamond Leaf* stones were used to completely cover a floor-length evening dress, placed in graduated sizes from neckline to hem. Whereas Armani quite literally covered this evening gown with sparkling gems, the English born, New York-based designer Holly Fowler takes a different approach to twenty-first-century opulence. Fowler explores the line between reality and fiction in her work, hand-painting her streamlined clothing styles with *trompe l'oeil* motifs that often include animals, flowers, jewels, and satin bows. A dress from her *English Princess* collection, made from gold fabric, is covered with swags of multicolor roses, chains of diamonds and gold, diamond pendants, and oversize tassels. The designer's muse is a fictional, modern-day princess named Pamela, whom Fowler dreamed up as a child. Fittingly, Pamela wears gold and flowers every day.[116] The true opulence of Fowler's designs relies not on surface embellishment, but on her painstakingly detailed, hand-painted motifs, which ensure that each garment is one-of-a-kind.

Whereas the kind sister in "The Fairies" is easily imagined in beautiful, jewel-encrusted clothing, Fanchon's wardrobe might be envisioned in relation to the creatures that cursed her. Fanchon's fate bears some resemblance to the ancient Greek mythological character Medusa. After endeavoring to rival the goddess Athena in beauty, Athena changed Medusa's long ringlets into hissing snakes, transforming her into a monster whose gaze turned anyone who looked at her into stone. Whereas Fanchon was never meant to be beautiful, the snakes and toads that fall from her mouth consign her to a monstrous state, and she is exiled from her own home.

Toads were associated with evil in European superstition, and were linked to witches.[117] While this makes sense in relation to Fanchon's fate in "The Fairies," toads are rarely represented in fashion. Snakes, however, tend to be more compelling creatures. They embody an intriguing duality – we might fear the snake's sly, cold-blooded, and venomous nature, but it is also a symbol of strength and rejuvenation. The snake's beautiful skin – either real or fabricated – has long proved an alluring material for fashion. "Since the birth of haute couture in the mid-nineteenth century designers have looked to the animal kingdom as a source of raw materials as a catalyst for inspiration, and as a conduit for their

Alexander McQueen
Digitally printed silk dress from the *Plato's Atlantis* collection, Spring 2010
The Museum at FIT, 2012.36.2

79 The Fairies

artistic expression,"[118] observes the fashion curator Andrew Bolton. Several contemporary fashions demonstrate how designers have incorporated faux snakeskin or snakeskin prints into their collections. In 2001, Yoshiki Hishinuma crafted a simple sheath dress from sheer white polyester. The coating applied to the ground fabric underwent heat processing, resulting in a subtle flaking that gave the garment a snake-like texture. Alexander McQueen's darkly beautiful Spring 2010 collection, *Plato's Atlantis*, featured dresses in digitally printed, multicolor reptile designs that were engineered to follow the silhouette of each dress. In Spring 2015, Giles presented a gown with an oversize print of undulating snakes that overlap and curl around the dress. While this motif may be unusual for a billowing evening dress, the looped forms of the snake print elegantly mirror the curving silhouette of the gown.

Giles
Spring 2015, look 49
Photograph courtesy Giles

Sleeping Beauty
(Based on the tale by Charles Perrault)

Aking and queen yearn to have a child, but struggle to conceive. The eventual birth of a daughter brings them great joy, and they plan a christening celebration for her. All of the fairies in the land are invited and, according to custom, each fairy provides the infant with a gift fit for a princess: unrivaled beauty, a sweet temperament, and grace, as well as skills in dancing, singing, and playing music. Unfortunately, the king and queen neglect to invite one old, cantankerous, and reclusive fairy, and she arrives at the party in a disgruntled state. When it is time for her to bestow her gift upon the young princess, she maliciously condemns her to death by the prick of a spindle. The curse cannot be reversed, but another fairy manages to counteract it, so that the girl will fall into a deep sleep rather than die. A prince will wake her in a hundred years.

The king attempts to keep his daughter alive by banishing all spinning wheels and spindles from the kingdom. Fifteen or sixteen years pass before the girl meets an elderly woman who, having failed to hear the king's decree, sits in a remote tower, spinning thread. The cruel fairy's prophecy is fulfilled, and the sleeping princess is carried off to the finest apartment in the palace. The benevolent fairy then puts the palace staff into the same, deep sleep, ensuring that when the princess wakes, her servants will be at the ready.

One hundred years go by, and Sleeping Beauty awakens to the admiring stare of her prophetic prince, who has made his way through the treacherous briars

Illustration for "Sleeping Beauty" by Arthur Rackham, 1916

meant to prevent unwanted visitors from entering the castle. The couple is married and have two children, but they keep their relationship secret. The prince's frequent absences from his family's home arouse suspicion in his mother, who eventually uncovers what he is hiding. The prince's furtive behavior is necessary, since his mother, who is part ogre, may desire to cook and eat her daughter-in-law and grandchildren. Sure enough, she demands to do just that – but the steward she assigns to slay Sleeping Beauty and her children cannot follow through on the act. He tricks the bloodthirsty, part-ogre woman by cooking and serving forest animals instead. Although his deception is eventually uncovered, the story ends with the mother falling into a vat of toads and snakes she had intended for Sleeping Beauty, her grandchildren, the deceptive steward, and his wife.

Fashioning "Sleeping Beauty"

Charles Perrault's version of this famous tale is once again rife with references to fashionable, aristocratic life, starting with the gifts that are bestowed upon Sleeping Beauty by the fairies. She is given all the desired assets of a female in her high social position: good looks, excellent manners, and talent. Other, more specific details are also scattered throughout the text. Shortly after the prince wakes Sleeping Beauty, for example, Perrault describes the couple passing through a "salon of mirrors" on their way to dinner. This is undoubtedly a nod to Versailles' famous "Hall of Mirrors," with which Perrault would have been familiar. He also provides numerous descriptions of luxurious home furnishings, such as tapestry wall hangings, gold flatware encrusted with jewels, and bed linens embroidered with gold and silver threads, some of which have made their way into illustrations of the story.

While objects of splendor communicate the wealth, power, and privilege that were intrinsic to court life, it is the presence of the spindle – a decidedly humble object – that is pivotal to "Sleeping Beauty." Its inclusion highlights the historical importance of fabric and clothing manufacture. Prior to major textile manufacturing developments that began to take place over the course of the eighteenth century, the production of fashion – from yarn, to cloth, to finished product – was performed entirely by hand. Spinning was a crucial task, carried out primarily by women; it was both labor intensive and notoriously underpaid. Catherine Orenstein writes, "In the countryside, [spinning] was the incessant and deforming labor of the peasant woman, who sought distraction and relief

in conversation, gossip, and stories. Women told tales to the repetitive rhythm of work, weaving in the signs of their labor, until telling a tale and spinning a yarn became one and the same."[119] It comes as no surprise, then, that spinning and spinning wheels are part of so many fairy tales.

The inclusion of the old woman in the tower in "Sleeping Beauty" points to the fact that, by the seventeenth century, some courts had begun to establish what Jack Zipes describes as a "primitive factory system," housing spinners to provide courtiers with thread, yarn, cloth, and clothing.[120] Spinners working specifically for the courts would be especially focused on the production of luxury fabrics, including silks, silk brocades, velvets, and gilded textiles, as well as embroidered cloths. While Sleeping Beauty would have surely worn finery fit for a princess, we are given few precise details about her clothing choices. Notably – and amusingly – Perrault pointedly remarks that over the course of the princess's long sleep, her gown goes out of fashion. When Sleeping Beauty rises from her slumber, Perrault describes her as "fully dressed, and her gown was magnificent, but [the prince] took great care not to tell her that she was attired like his grandmother, who also wore stand-up collars. Still, she looked no less lovely in it."[121] Some translations refer to this as a "square collar," but the prince's observation of his love's outmoded appearance remains the same. It is possible that Perrault envisioned Sleeping Beauty in a ruff, a style of collar that was fashionable during the latter half of the sixteenth century and that began to fall out of favor early in the seventeenth. The ruff had luxurious connotations that were certainly suitable for a princess such as Sleeping Beauty. In her book *The Anatomy of Fashion: Dressing the Body from the Renaissance to Today*, Susan J. Vincent writes that wearing a starched neck cloth or ruff "asserted disassociation from labor," continuing:

> Those who wore these fashions of privilege did not need to spend their lives tilling the fields or relentlessly at work in a factory. Instead, they had money, time and servants in abundance, enough to satisfy the requirements of these most demanding items of dress. For demanding they were: time consuming to arrange, labour intensive to maintain, and expensive to make. A ruff, for example, had to be laundered and restarched after every wearing, and then its pleats reset into shape with heated "poking sticks."[122]

A 1916 illustration by Arthur Rackham shows Sleeping Beauty wearing a ruff, along with an elegant, rose-printed gown[123] with slashed sleeves. (This style of

sleeve was also used in Gustave Doré's 1867 illustrations of "Sleeping Beauty," and both make reference to a style of dress worn in Europe during the sixteenth century.) Rackham's illustrations are esteemed for their richness and beauty, but this example is especially detailed. Sleeping Beauty lies on a bed covered with lavish textiles with what looks to be a tapestry at her head, and a tiny dog sleeps at her side.

While Rackham's work portrays a specific, historically inspired fashion, many more illustrations of Sleeping Beauty show her in bed wearing long, sheer, pale gowns, with her hair loose and flowing. These garments are evocative of sleepwear, which seems fitting for this tale, but they often also include lavish details. *The Sleeping Princess*, a painting by the Scottish artist John Duncan, exemplifies this style. Sleeping Beauty reclines on a bed covered in ivory sheets with gold patterning, positioned in a room decorated with colorful tapestries or rugs. She wears a long, white gown with gold trim and embroidery, and a gold belt is fastened just above her waist. Duncan depicts what appears to be a chemise (visible at the bottom hem) worn under a long-sleeved overdress made from a gauzy fabric. The princess also wears a gold and red bejeweled crown, with flat-heeled

(left) John Duncan
The Sleeping Princess, 1915
Tempera on canvas
Image courtesy Perth and Kinross District Council, Perth, Scotland

(facing) Barry Lategan
Model Tree Allen in a dress by Bill Gibb
British *Vogue*, March 15, 1977
Barry Lategan/*Vogue* © The Condé Nast Publications, Ltd.

slippers to match. Her wavy hair, adorned with gems or flowers, tumbles over the edge of the bed and onto the floor.

A 1977 editorial in British *Vogue* by Barry Lategan is unmistakably similar to Duncan's work, although there is no evidence that the photographer was aware of the aforementioned painting. Lategan's spread consists of a series of photographs featuring the model Tree Allen in various stages of sleep, as she rests on a small sofa upholstered with an ornate, antique tapestry. One of these photographs is staged almost like a mirror image of Duncan's painting – Allen's wavy red hair cascades over the arm of the sofa while her left arm falls gracefully to the floor. She wears a dress by Bill Gibb made from "frosted lilac silk organza," paired with metallic gold Manolo Blahnik shoes.[124] "British designers are storytellers, dreamers. This was really the essence of the romance behind Bill Gibb," remembers John Galliano.[125] Gibb was a Scottish designer who became famous during the 1970s for his imaginative, escapist designs, and his work was perfectly suited to fairy tale-like settings.

Georgina Chapman and Keren Craig, the designers behind the contemporary luxury label Marchesa, are also well known for making gowns that look like they have come straight from the pages of a fairy tale. While they are no strangers to pale, sweeping gowns or opulent embellishment, a dress from the Spring 2012 collection seems ideally suited to the Sleeping Beauty princess. It is made from swaths of pearl-grey tulle that are looped and tucked around the body in a nearly continuous piece. Full sleeves, gathered at the wrist, emphasize the sheerness of the fabric. Perhaps one of the most stunning elements of the dress is the embellishment at its neckline: an incredibly intricate, silver latticework design with subtle rhinestone embellishments.

Marchesa
Spring 2012, look 21
Courtesy Marchesa
Photograph © The Museum at FIT

Beauty and the Beast
(Based on the tale by Madame de Villeneuve)

Beauty is the youngest of the twelve children of a prosperous merchant, who loses his home and its splendid possessions in a house fire. Shortly thereafter, he learns that he has also lost all of his ships, and the family is forced into poverty, moving to a house in the country. Beauty remains cheerful in spite of her newly difficult life, but her siblings struggle to find happiness.

The merchant learns that one of his ships, carrying expensive cargo, has been found. He makes plans for the journey into town to retrieve its goods. His children are delighted, and imagining that they will soon be wealthy again, they ask their father to bring exceptionally fine clothing and jewels back for them. Beauty, meanwhile, asks for nothing but a rose.

By the time the merchant reaches town, the cargo has been dispersed among his colleagues, who believed him to be dead. He must return home penniless, and his journey is beset by terrible weather. He stops to rest at a magnificent castle. Although the castle appears to be empty, he finds a meal waiting for him. After spending the night, he leaves through a beautiful garden. When he pauses to pick a rose for Beauty, he is confronted by the Beast. Furious over the man's theft from his garden, the Beast demands that the merchant give him one of his daughters as payment.

Returning home, the merchant reluctantly tells Beauty and his other children what has happened. Beauty concedes selflessly to the Beast's request, and goes with her father to the castle. She is respectful to the Beast, and is provided

"Belle et la Bête," in *Gazette du bon ton*, April 1913
Illustration by Charles Martin
Image courtesy Fashion Institute of Technology/SUNY, FIT Library Special Collections and FIT Archives

with beautiful living quarters and many amusements. Each evening, the Beast asks Beauty if she will marry him, but she politely declines. When Beauty begins to feel lonely, she is allowed to leave the castle to visit her family, but the Beast warns her that she must return to him in two months' time. Near the end of her stay at home, she dreams that the Beast is dying. As soon as she wakes, she returns to the castle, where she finds the Beast lying in the garden, very ill. She revives him, and he again asks her to marry him. This time she consents, both revealing and breaking the Beast's long, terrible enchantment. He is returned to his former state: a handsome prince.

Fashioning "Beauty and the Beast"

Gabrielle-Suzanne Barbot de Villeneuve published her long, winding, and descriptive "Beauty and the Beast" tale in 1740. Although this story is still in print, most readers are likely to be more familiar with an abridged version, written in 1756 by Madame Leprince de Beaumont. She adapted the story for the *Magasin des enfants*, a publication that was intended to advise children on how to behave properly in social situations. Leprince de Beaumont's version of the tale, therefore, is focused on morality, and emphasizes Beauty's qualities of domesticity and self-sacrifice.[126] "Beauty and the Beast" was further popularized in 1757, when it was translated into English.

Like most fairy tales, "Beauty and the Beast" was not entirely the invention of its author, but rather an adaptation of another, older tale. Folklorists have traced this story's origins to "Cupid and Psyche," a second-century Latin tale by the Roman rhetorician and Platonic philosopher Lucius Apuleius. This story was printed in the fifteenth century, and spread throughout Europe over the course of the following two centuries. The basic storyline was changed to suit each new language and culture it reached, eventually evolving into a group of "Beauty and the Beast" tales.[127] As of 1997, folklorists had identified more than 1,500 variants of this story.[128]

The scholar Ruth B. Bottigheimer observes that the premise of the European "Beauty and the Beast" narratives highlights the fact that they were written in the modern era. Specifically, their "plots arise from a narrative requirement that characterizes modern but not medieval stories; namely, that a beautiful woman accept and love an ugly husband."[129] While the love between Beauty and the Beast is obviously essential to the story, the importance of the class system also plays

an important role in shaping the plotline. Even though Beauty's father acquires great wealth, he is a still only a merchant, rather than an aristocrat. He may be able to afford the fine clothing and jewels that his children desire, but such luxurious items are not considered appropriate for his family's position. When their father loses his wealth and possessions, Beauty's siblings hope to rely on the kindness of their friends – but these friends reject them. "From the hour they became poor, every one, without exception, ceased to know them. Some were even cruel enough to impute their misfortunes to their own acts […] they reported that all [the merchant's] calamities were brought on by his own bad conduct, his prodigality, and the foolish extravagance of himself and his children."[130]

Once the merchant's children are reduced to meager means, they must take on the household chores themselves, and are thus forced to adapt their wardrobes:

> The daughters, on their part, had sufficient employment. Like the poor peasant girls, they found themselves obliged to employ their delicate hands in all the labours of a rural life. Wearing nothing but woollen dresses, having nothing to gratify their vanity, existing upon what the land could give them, limited to common necessaries, yet still retaining a refined and dainty taste, these girls incessantly regretted the city and its attractions.[131]

Beauty, however, manages to sustain a positive outlook. Seemingly never one for grand possessions, she dresses her hair with fresh flowers and enjoys her new, rural life, imagining herself as a quaint shepherdess from the past.

Beyond the description of woolen dresses, there is surprisingly little detail of clothing in this story. We know that Beauty's greedy sisters demand "jewellery, attire, and headdresses"[132] when they believe their father's fortune to be recovered, and beautiful gowns are mentioned among the possessions that the Beast offers to Beauty's family. (She chooses to send her father home with pieces of gold, instead, which she considers to be more versatile.) Although we are not given specifics on Beauty's dress, there are many indications that she is leading a fashionable, aristocratic life. Andrew Bolton observes that, during the eighteenth century, "the most powerful way to demonstrate social superiority was to pursue a life of leisure, luxury, and refinement."[133] While this of course included one's fashion choices, it also extended to daily activities and the spaces in which those activities took place.

When Beauty arrives at the castle, she is first supplied with "a toilet table covered with everything necessary for a lady,"[134] which she uses to prepare her-

self for dinner. Later, as she begins to explore her apartments within the castle, she discovers many amusements: a room filled with musical instruments (it is mentioned that Beauty can play nearly all of them), a gallery of paintings, and an impressive library. Later, she finds a cabinet with "purses, and shuttles for knotting, scissors for cutting out, and fitted up for all sorts of ladies' work; in fact, everything was to be found there."[135] She is also treated to a private aviary full of rare birds, a troop of pet monkeys, and plays put on solely for her amusement (and that are, rather unnervingly, acted out by the monkeys). All of these elements underscore that although Beauty is not materialistic, she is genteel and in possession of good taste – in other words, she is in every way worthy of a prince's affection and life within his castle.

Although descriptions of Beauty's dress are lacking, there are frequent references to her dressing and undressing, implying that this was a considerable part of her daily routine. In fact, it is indicated that her *toilette* – the French ritual of dressing and undressing during the eighteenth century – is performed by the female apes in the castle.[136] Given that she is living in the home of a prince – even if he is in the guise of a beast – it is likely that Beauty would don court dress. This might have looked something like the *robe à la française* from 1755–60, now part of the collection of The Museum at FIT. This gown is made from silk brocade – one of the most difficult and expensive fabrics to produce during the eighteenth century. The fabric is intricately woven to form a striped, ribbed ground, with motifs of feathers and flowers tied into bouquets. The most interesting element of the fabric – and perhaps the most unexpected – is the inclusion of meandering bands of leopard spots, interspersed among the flowers. Leopard prints were, in fact, fashionable in eighteenth-century France, where they were most often used for trimmings and accessories.[137] With its subtle reference to rococo exoticism and its lush lace and ribbon *passementerie*, this dress seems an ideal choice for Beauty. Furthermore, her ability to wear such a garment, in place of the simple, woolen dress she would have worn at her father's home, again highlights Beauty's sophistication. Graceful movement in lavish clothing was a hallmark of the aristocracy.

As we saw in drawings for "Cinderella," in particular, fairy tale illustrations that feature clothing occasionally make direct reference to the text they are depicting. Beyond a few basic details or recognizable motifs, however, these illustrations are largely the products of the artists' imaginations. Late in the nineteenth century and into the early years of the twentieth century – the Golden

Robe à la française in brocaded silk, 1755–60
The Museum at FIT, P82.27.1

Age of fairy tale illustration – many artists chose to depict historical dress. Styles that were intended to portray medieval or eighteenth-century-style fashions were particularly common. Perhaps illustrators thought that medieval dress would emphasize the long history of the tales, while eighteenth-century fashion is often considered to be especially lavish and beautiful. In the case of "Beauty and the Beast," however, it seems that Beauty is more frequently shown wearing the fashionable dress of the era during which the illustration was published. An excellent example of this can be found in an 1811 book entitled *Beauty and the Beast, or, A Rough Outside with a Gentle Heart*, belonging to the collection of The Morgan Library and Museum in New York City. Several of the beautiful, full-color illustrations included in it are reminiscent of fashion plates created early

(left) "Beauty in Her Prosperous State," in *Beauty and the Beast*, or, *A Rough Outside with a Gentle Heart*, 1811.
The Pierpoint Morgan Library, New York. PML 16547. Purchase; 1909.

(below) "Fashions for March, 1810," in *La Belle Assemblée*
Image courtesy Fashion Institute of Technology/SUNY, FIT Library Special Collections and FIT Archives

95 Beauty and the Beast

in the nineteenth century. One example from this book shows "Beauty in her prosperous state": she sits in a parlor, reading, while wearing the high-waisted, white gown and flat-soled slippers that were fashionable at the start of the nineteenth century. Two of Beauty's sisters stand in the background, wearing similar gowns and feathered hats. The family's stylish parlor is complete with a small piano. This image bears a strong likeness to a fashion plate printed the previous year in *La Belle Assemblée*, which showed similar fashions in a comparable setting. Nearly 200 years later, the actress Drew Barrymore was photographed for

(left) Illustration for "Beauty and the Beast" by Edmund Dulac, 1910

(below) Paul Poiret
Fancy dress harem costume, 1919
The Museum at FIT, 74.36.29

a "Beauty and the Beast"-themed fashion editorial by Annie Leibovitz for *Vogue*. In one image, Barrymore leans against a piano in an opulent room, listening to a small orchestra that is assembled in front of her. She wears a white, high-waisted gown by John Galliano that is clearly based on styles of the early nineteenth century; it also resembles the aforementioned illustrations.

Edmund Dulac created some of the most beautiful and sartorially interesting illustrations of "Beauty and the Beast" for the 1910 book *The Sleeping Beauty and Other Tales from the Old French*, which featured Sir Arthur Quiller-Couch's adaptations of well-known stories. For "Beauty and the Beast," Dulac depicts all of the characters, including the Beast, wearing long robes, Turkish trousers, feathered turbans, and Arabian-style slippers that turn up at the toe. These illustrations resemble Dulac's work for *The Arabian Nights*, published three years earlier, yet they can also be compared to the world of high fashion. In 1909, Serge Diaghilev founded his groundbreaking Ballets Russes, and Léon Bakst designed costumes and sets for the company's production of *Schéhérazade* the following year. Bakst's Orientalist costumes had a profound impact on fashion early in the twentieth century, with similar designs by the famous French couturier Paul Poiret first appearing in 1911.[138] It appears that Dulac's Beauty was just ahead of the fashion curve.

It is tempting to think about what Beauty might find in the castle's wardrobes today. Her fondness for roses was acknowledged by the Beast and, as a well-known symbol of love, these flowers seem to be especially appropriate in this tale. A contemporary version of the white sheath dress, made by Rodarte for its

(below) Rodarte
Dress in white organza, silk tulle, and feathers, Spring 2007
The Museum at FIT, 2007.13.1

(facing) Giles
Spring 2015, look 25
Photograph courtesy Giles

Spring 2007 collection, is embellished with a cascade of oversize, three-dimensional blooms, handcrafted from layers of pink, white, and black organza. In a more direct tribute to the Beast, a slinky, floor-length slip dress from Giles's Spring 2015 collection is printed with a motif of enormous paws, complete with sharp nails. "Some very cool predators stalked the runway at Giles today," wrote Maya Singer for Style.com. "Most memorably, though, there were the cat claws – oversize, multicolored, and glittering under a finish of sequins. Deacon's sense of pop has rarely if ever served him better than it did here."[139]

Christian Louboutin's *Alex* pumps truly embody the dynamic of beauty and beastliness. The designer pairs a strass-covered stiletto with a uniquely shaped pump, designed to resemble a lion's paw. The suede is embroidered over the toes to create a dense, fur-like texture. The shoe is completed with four "claws" made from clusters of dark rhinestones. "Designers have drawn on animal symbolism, with its folkloric, mythological, and magic-religious associations, to imbue their work with an arresting and sometimes alarming sensuality," writes Bolton. "Straddling the ideologies of nature and artifice, designers have sought to shape ideals of femininity that evoke and invoke the physical and symbolic characteristics of animals, ideals that have resonance in both the past and the present."[140]

The appearance of many male characters in fairy tales is rarely detailed beyond a simple description of their handsomeness or ugliness. "Beauty and the Beast" provides no exception, yet the elusiveness of the Beast's appearance makes him somewhat more intriguing. We know nothing of his looks, beyond the fact that he is ugly. But is he truly ugly, or only considered to be so because he has human traits without human form? De Villeneuve's tale portrays the Beast as both hideous and stupid, but in Beaumont's version, he is rather more gentlemanly, if not more physically appealing.

Illustrators have drawn the Beast in a wide and creative array of forms; he has been portrayed as a boar, a dog, a lion, and a warthog, among other creatures. Most of these illustrations express his beastliness only through his head and his hands, often with an animal-like visage (either realistic or imagined), and paws or talons. The prince-cum-Beast cannot change anything about his appearance, but he is still a nobleman. Illustrations usually show the Beast stand-

Christian Louboutin
Alex pumps, Fall/Winter 2011–12
Courtesy Christian Louboutin

99 Beauty and the Beast

ing upright, no matter what animal he is intended to be, and he is often dressed in lavish, fashionable clothing. In their own bizarre way, these images help to make the story more convincing. They suggest the Beast's human origins as well as his nobility, and it is easier to imagine Beauty's daily interactions with a creature that can walk on two legs and converse with her. Walter Crane's 1874 illustrations envision the Beast as a wild boar, whose coarse black fur and long tusks are offset by his modish attire and excellent manners. In the book's frontispiece, he is shown with hat in hand, bowing deeply to Beauty. Her dress is informed by the Aesthetic Movement (the artistic group to which Crane belonged), whereas the Beast's finely embroidered suit, lace cravat, and buckled shoes show the influence of both seventeenth- and eighteenth-century court attire. The curse put on the Beast may have robbed him of his identity as a prince, but his sartorial choices allow him to retain his dignity.

Illustration for "Beauty and the Beast"
by Walter Crane, 1874
General Research Division,
The New York Public Library,
Astor, Lenox and Tilden Foundations

Snow White
(Based on the tale by the Grimm Brothers)

In the middle of Winter, a queen sews beside her ebony-framed window. She pricks her finger, and three drops of blood fall into the snow. Admiring the contrast of the crimson blood against the bright snow, she thinks, "If only I had a child as white as snow, as red as blood, and as black as the wood of the window frame!"[141] She soon has a daughter who looks just she wished, but the queen dies shortly after giving birth.[142]

The king remarries a year later. Snow White's stepmother is very beautiful, but she is also proud and vain. She owns a magic mirror, and daily she asks of it: "Mirror, mirror, on the wall, Who is the fairest one of all?" The mirror responds that the queen is the fairest, and because it always tells the truth, the queen is satisfied.

Yet with each passing day, Snow White becomes more beautiful. When she is seven years of age, the mirror tells the queen that Snow White has grown to be a thousand times fairer than she. The queen is enraged, and eventually calls upon a hunter to kill Snow White. She tells him to bring back her lungs and liver, which she plans to eat. The huntsman cannot bear to kill such a beautiful child, however, and leaves her in the forest. He takes the lungs and liver of a young boar to the queen, hoping to fool her into thinking he completed his task.

Snow White wanders through the forest, where she eventually finds a small cottage. She falls asleep inside, but is awakened by seven dwarfs who live there. After hearing her plight, the dwarfs allow Snow White to stay with them, provided that she keep house. Meanwhile, the magic mirror reveals that Snow

Illustration from "Snowdrop" by Jennie Harbour, 1921

White is still alive. The queen devises a plan to trick Snow White to her death. Dressing as an old peddler woman, she finds the cottage, and tempts Snow White with new, silk stay laces in many colors. She laces Snow White too tightly, cutting off her breath, and the girl falls down as though she were dead.

The dwarfs revive Snow White when they arrive home, but her stepmother again dresses up in the disguise of the old woman. This time, Snow White is offered a pretty but poisoned comb, and after the wicked queen brushes her hair, she once again loses consciousness. The dwarfs revive her a second time and warn her against talking to strangers, but the naïve young girl falls for her stepmother's trickery a third and final time. In this instance, Snow White cannot resist a poisoned apple. A piece becomes lodged in her throat, and she cannot be revived.

The dwarfs put Snow White in a glass coffin that can be seen from all sides, and place it at the top of a mountain, one of them keeping guard at all times. As times passes, Snow White remains as beautiful as ever, looking as though she is only sleeping.

One day, a prince comes through the forest and sees the coffin. Enraptured by Snow White's beauty, he begs the dwarfs to allow him to take the coffin away with him. While the prince's servants are carrying it through the forest, one of them stumbles over a shrub. The bit of poisoned apple is dislodged from Snow White's throat, and she awakens. She agrees to marry the prince, and they plan their wedding. The stepmother is invited to the event, and before attending the ceremony, she dresses in her finest clothes and consults her mirror. The mirror replies coyly that the "young queen" is a thousand times fairer than she. When the stepmother arrives at the feast, Snow White recognizes her instantly, and the wicked stepmother is condemned to wear red-hot, iron slippers and dance to her death.

Fashioning "Snow White"

Snow White's stepmother is an unusual character within the fairy tale genre, and she deserves as much attention as Snow White herself. In most fairy tales, inner and outer beauty are inextricably linked. This stepmother, however, is both extremely wicked and very beautiful. Bruno Bettelheim ponders, "We do not know why the queen in 'Snow White' cannot age gracefully and feign satisfaction from vicariously enjoying her daughter's blooming into a lovely girl,

but something must have happened in her past to make her vulnerable so that she hates the child she should love."[143] The stepmother's mysterious past and unexplained wickedness position her as a character who is in many ways more interesting than the sweet – but rather stupid – Snow White. It seems only natural that the queen would harbor some jealousy toward her beautiful, young stepdaughter, but her hatred of the girl is powerful and frightening. Her cruelty is made evident in her request to have her stepdaughter killed, but her madness is emphasized by her eagerness to eat the girl's lungs and liver. This gruesome detail implies that the queen believes that by ingesting Snow White's body, the girl's beauty will be transferred to her.

Even before we are made aware of the stepmother's capacity for evil, we learn of her extreme, consuming vanity, evidenced by the magical looking-glass that she consults so regularly. Joyce Thomas notes that although it is not made explicit in the tale, the possession of this magic mirror indicates the queen's identity as a witch long before she crafts her poisoned apple.[144] That the queen is not solely a wicked, beautiful woman – but rather a wicked, beautiful *witch* – further defies stereotypes regarding the appearance of fairy tale characters. Many illustrators of the tale have quite logically chosen to first portray the queen consulting her cherished mirror. One such image by John D. Batten, published in the 1916 edition of *European Folk and Fairy Tales*, shows her gazing haughtily into the looking glass, her hair elaborately braided and coiled around a comb and a small crown.

Illustration for "Snow White" by John D. Batten, 1916

Because of her sinister beauty, the wicked queen serves as an unlikely style icon. In an analysis of a study entitled "How to be a Fairy Princess," Samantha Holland found that several of her participants "preferred the evil stepmother in Snow White because she was strong, intelligent, wicked, had black hair and looked like a goth with her white face, red lips and black clothes – that is, someone who looked more like them."[145]

Rick Owens's Spring 2011 collection featured models in angular, monochromatic clothes accessorized with sharp, two-pronged hair combs. One of these ensembles, now in the collection of The Museum at FIT, comprises a floor-length dress with train and a sleeveless coat, both in pearl-grey cotton faille. The coat's high, stiff collar casts the wearer's

face into shadow, and makes the protrusion of the comb appear even more sinister. "[Owens] presented an impeccably orchestrated show, which felt straight out of a dark fairy tale," described the fashion journalist Alice Pfeiffer. "Seemingly inspired by Snow White's wicked stepmother, the models marched down the catwalk with grave faces, hair pulled back into spiked combs."[146]

An ensemble from Undercover's Fall 2014 collection makes a more overt reference to the story's wicked queen – this time with a twist. The model's white mini-dress and matching cape are both printed with a motif that, from a distance, resembles blue-and-white porcelain. Upon closer inspection, the images depicted turn out to be UFOs. The ensemble is paired with an elaborate, openwork crown made from loops of tiny hair braids, and the model's eerie red contact lenses complement the glowing apple in her hand. The wicked stepmother is portrayed as part-queen, part-alien, and part-witch, but the reference to "Snow White" is unmistakable.

While the stepmother's combination of evil and beauty marks her as an atypical character, Snow White is distinctive in her own right. In the land of fairy tales, goodness is strongly linked to golden hair. (In the tales explored within this book, Rapunzel and Furrypelts are specifically identified as blondes, while others, including Cinderella, Sleeping Beauty, and the Little Mermaid, are often depicted in illustrations with fair hair.) Like her stepmother, Snow White embodies a peculiar dichotomy: whereas her stepmother is bad but beautiful, Snow White is good, but raven-haired. In addition to her dark tresses, her alabaster skin and scarlet lips are meaningful. Cristina Bacchilega writes, "when Snow White's mother gives birth to the image of woman she has internalized, what appears in the heroine are the beauty and purity of white, the transformative powers of red or gold, the ritual – and sexual – death of black."[147]

It is the poisoned apple that appears to kill Snow White, and because of its integral part in the plot, this object has become the most closely associated with the

(facing) Rick Owens
Evening ensemble in cotton faille and polished cotton, Spring 2011
The Museum at FIT, 2011.3.1

(below) Undercover (Jun Takahashi)
Fall 2014, look 37
Courtesy Undercover

(following) Philipp Jean-Pierre Ndzana
Campaign for Serpentina clothing line
Fall/Winter 2013
Courtesy Philipp Jean-Pierre Ndzana

story. The importance of the apple is furthered by the fact that the queen's other attempts to kill her stepdaughter – first with the stay laces, then with the poisoned comb – are left out of many reworked or simplified versions of the tale. This includes Disney's animation of *Snow White and the Seven Dwarfs*, first released in 1939, and still exceedingly popular. The exclusion of the laces and the comb from the narrative is unfortunate, given the depth that they add to Snow White's character. The girl's desire for these two objects of fashion exposes more of her personality – in particular, her own vanities and insecurities – and thus links Snow White to her stepmother in an intriguing way.

We can perhaps forgive Snow White for being tempted by the stay laces. After all, this is the stepmother's first attempt to trick the girl. Poor Snow White is also living in the middle of the woods, with only seven dwarfs for company. If we can indulge in a consideration of the story from a somewhat realistic standpoint, Snow White was raised as a princess. She would have likely relied on servants to dress her, and would scarcely know how to care for herself. "Oh, my child, what a sight you are," exclaims the stepmother-in-disguise when Snow White opens the door for her. "Come, let me lace you up properly."[148] Bruno Bettelheim posits that Snow White's interest in the stay laces highlights her desire to be sexually attractive, and that this outweighs any anxiety she might feel about the stranger at her door.[149] Yet he overlooks the fact that corsetry had other connotations as well, such as beauty, social rank, and morality. Snow White's stepmother-in-disguise, therefore, seems to be preying not only on the girl's vanity, but also on her vulnerability and her sense of propriety.

Numerous illustrations depict Snow White wearing dresses with lace-front bodices. A spectacular line drawing by A. H. Watson shows the wicked stepmother, hunched over and dressed in a dark, hooded cloak. She reaches out to Snow White with the stay laces extended be-

Illustration for "Snow White" by A.H. Watson, 1927

tween her fingers. The girl observes her shyly, with one hand to her mouth in contemplation. Snow White wears a dress with a full skirt and a tightly laced bodice, and is obviously considering how her dress would look with the multicolored silk laces that are on offer. The Fall 2014 Dolce and Gabbana collection, devoted entirely to a fairy tale theme, included a contemporary likeness of this dress style. Constructed primarily from sheer, red-violet fabric, the dress also features an intricate bodice made from interwoven strips of fabric and bands of lacing. The figure-hugging silhouette is further emphasized by the laces, which are positioned to form an hourglass shape.

Dolce and Gabbana
Fall 2014, look 12
Courtesy Dolce and Gabbana

When the disguised stepmother approaches Snow White for the second time, carrying with her the poisoned comb, the girl is again unable to resist the temptation of her "pretty wares." Snow White's desire for the comb can be understood in multiple ways. We know that her hair is her most distinguishing feature, and one of which she must be proud, if not vain. As she spends more time with the dwarfs in the woods, she surely yearns for the adornments and luxuries that were part of her past life as a princess. We already know of Snow White's desire for a neat appearance, as she so readily accepted the offer of stay laces. (Her fastidious nature is echoed in the tidy house she keeps for the dwarfs.)

Some folklorists link Snow White's poisoned apple to Eve's acceptance of the forbidden fruit in the Garden of Eden, identifying the apple as a symbol of sin. Whatever its meaning, the apple is clearly not an object of fashion – yet the queen knows that if she can make it aesthetically pleasing, it will nonetheless serve to entice Snow White. The Grimms describe the apple to be "white with red cheeks," a detail that mirrors Snow White's own appearance and subtly plays into the girl's narcissism.[150] Luckily for her, the beauty she is so conscious of is also that which makes her irresistible to the prince, who eventually (albeit unintentionally) wakes her from her coma.

Snow White's beauty has inspired numerous fashion editorials, but she is (unfortunately) most recognizable in her vegetative state. In a 1946 photograph by Irving Penn, a young Carmen dell'Orefice – known for exquisite looks and her dark hair – makes for an ideal Snow White. She lies on a low bed covered in white tulle, wearing a long, strapless dress by the label Junior Formals. Her attending "dwarfs" are a group consisting of popular entertainers, a club owner, a baseball player, and a cartoonist.[151] "Thanks to the American standard of living and pure glandular luck, the dwarfs are unusually large,"[152] explained the corresponding text. Penn's image was part of a spread entitled "Fables Retold," which also featured portrayals of "Cinderella" and "Little Red Riding Hood."

There is more than enough magic and enchantment in "Snow White" to place the story firmly in the realm of fantasy, yet, as in many fairy tales, there are probable references to historical events woven into the story. The vanities of Snow White and her wicked stepmother take very different forms, but both are better understood in light of the importance placed on the appearance of noblewomen. Jo Eldridge Carney writes, "The dichotomous perceptions and descriptions of early modern queens and their fairy tale counterparts uncover the high social and political value placed on beauty. Queens or would-be queens could be sharply critiqued for the flaws in their appearances but they could also be found guilty of vanity, superficiality, and rivalry for trying to fulfill the beauty mandate."[153] Finding the balance between beauty and modesty seems to be a challenge that Snow White's stepmother has simply renounced, and with which Snow White struggles.

"Snow White" may have more basis in real life than the physical expectations of the monarchy. Both Carney and Marina Warner write about historical occurrences with similarities to this tale, including an attempt by the queen Catherine de' Medici to eliminate her political enemy, Louis de Condé, with a poisoned apple (he purportedly fed it to his dog). "The story may be apocryphal," Carney recognizes, "but it points to an overlap between the annals of history and the fairy tale genre."[154] Furthermore, Warner writes of a visit to a 2012 British Museum exhibition entitled *Treasures of Heaven*, in which she learned that St. Ludmila, the grandmother of King Wenceslas, was strangled with a veil by her mother-in-law. The woman was jealous of Ludmila's goodness and beauty.[155] (Note that not all "Snow White" tales include the stay laces – the princess sometimes loses consciousness after being wrapped too tightly in other garments, such as a shirt or a cloak.[156]) Evil queens, it seems, are not so improbable after all.

Model Carmen dell'Orefice as Snow White, wearing a dress by Junior Formals
Vogue December 15, 1946
Photograph by Irving Penn
Irving Penn/*Vogue* © The Condé Nast Publications, Ltd.

Rapunzel
(Based on the tale by the Grimm Brothers)

A sinister enchantress[157] maintains a bed of the rapunzel plant in her garden. When a pregnant woman sees the leafy vegetable, she claims she will die if she does not get some of it, which leads her husband to scale the enchantress's wall to steal it for her. The enchantress catches the thief, and demands that his unborn child be promised to her as payment for his crime. As soon as the child is born, the enchantress appears, names the girl Rapunzel, and whisks her away.

Rapunzel grows up to be the most beautiful child on earth, with "long hair, as fine and as beautiful as spun gold."[158] When Rapunzel is twelve years of age, the enchantress becomes concerned that the girl is too lovely for her own good. She locks Rapunzel in a tower, which has neither stairs nor a door, in the middle of a forest. Rapunzel must uncoil her lengthy braids and drop them to the ground when the enchantress wants to pay her a visit, allowing her hair to act as a ladder for the old woman to climb.

Several years pass before a young prince, riding through the forest, hears Rapunzel singing from her tower. He is captivated by her voice, but does not know how to gain entrance to the tower. He continues to visit the forest until he hears the enchantress say "Rapunzel, Rapunzel, let down your hair," and sees her climb up the girl's hair and into the tower. The next day, he gives the command and climbs the braids. Rapunzel is stunned to meet a man for the first time, but the two soon fall in love, and devise a plan. Each time the prince visits Rapunzel,

(previous spread) Eugenio Recuenco, "Children's Stories," *Vogue Novias*, 2005
Courtesy Eugenio Recuenco

(facing) Illustration for "Rapunzel" by Arthur Rackham, 1909

he brings with him a skein of silk, which she will braid into a ladder. In due time, they will be able to leave the tower together.

Their plan is foiled when Rapunzel carelessly informs the enchantress that she is much heavier to pull into the tower than the spry young prince. Deceived and insulted, the enchantress cuts off the young woman's braids and banishes her to the wilderness. She then tricks the prince into entering the tower, only to inform him that he will never see his beautiful Rapunzel again. In an act of sorrow, he jumps off the top of the tower. He lives, but he falls upon thorny brambles that blind him. He takes to roaming through the forest, grief stricken.

In spite of this rather dismal storyline, the tale ends happily. In his wanderings, the prince once again hears Rapunzel singing, and he finds her living in the forest with their twin children. Rapunzel cries tears of joy at being reunited with her prince, and when the tears fall into his eyes, his blindness is cured. The family returns to his kingdom and lives happily ever after.

Fashioning "Rapunzel"

The maiden with the long, golden hair has become such a well-known fairy tale character that the significance of her unusual moniker is often overlooked. The rapunzel plant – also known as rampion – is autogamous, meaning that it can fertilize itself. If it remains unfertilized, it contains a column that will split in two, and curl "like braids or coils on a maiden's head."[159] The cravings felt by Rapunzel's mother during her pregnancy, therefore, relate directly to her daughter's singular defining characteristic.

Readers are given little description of Rapunzel beyond her splendid hair. This attribute was so precious that many versions of the tale include an unusually pragmatic detail: before the enchantress (or later, the prince) climbs up Rapunzel's braid, the girl fastens her hair to a latch outside the window, thus relieving her scalp from some of the weight. Rapunzel's behavior indicates that she is complacent and naïve, but there are no direct references to her personality traits (as there are in "Cinderella" or "The Fairies," for example), nor do we know anything of her manner of dress. It is only in some versions of the tale that clothing is mentioned at all. In those stories (which include the Grimms' original version), Rapunzel innocently questions why her gown has become too tight. This leads the enchantress to realize that the girl is pregnant, and the tale unfolds from there.[160]

Joyce Thomas outlines the enchantress's attempt to preserve Rapunzel's girlhood by confining her to a nearly inaccessible tower, describing the structure as "less any sort of protective cocoon than a coffin, though what the witch overlooks is the fact that the body is alive and will, therefore, find its own means of exit."¹⁶¹ Rather than making her planned escape with the prince, however, Rapunzel's freedom from the tower comes with a heavy price: her beautiful braids are lopped off, and she is banished to the forest.

Although the story contains a mere sentence (or sometimes two) devoted to the cutting of Rapunzel's hair, the significance of this action is much greater. In *Ambiguous Locks: An Iconology of Hair in Medieval Art and Literature*, Roberta Milliken writes that her study of hair from the fourth century to 1525 "is particularly helpful in understanding the important role women's hair continues to play in, not only the identification of women, but also in the general value assigned to them, for it is during these times that the idea of woman that becomes one cornerstone of western thought congeals."¹⁶² Long – especially *blonde* – hair acted as a particularly potent symbol of feminine beauty. The loss of Rapunzel's braids compromises her attractiveness severely.

While the enchantress strips Rapunzel of her most beautiful asset, the cutting of the braids undoubtedly holds deeper meaning as well. There are many, sometimes conflicting, notions about the symbolism of hair. Some sociologists believe that the ways in which individuals dress or modify their hair is a revealing expression of their identities. Unlike clothing, hair is quite literally part of us, and seems to grow magically from our heads. In Rapunzel's case, her long tresses are a critical part of her identity, meaning that the loss of hair also represents a loss of self. Furthermore, hair is thought by some theorists to be a symbol of the genital organs, and its cutting signifies castration or the attempt to control one's sexuality. Hair cutting could also be used as means to make oneself unattractive purposefully. Milliken points out that numerous female saints cut their hair to ensure that men considered them "hideous oddities," in order to more easily protect their virginity.¹⁶³

Illustration for "Rapunzel" by Kay Nielsen, 1925
General Research Division,
The New York Public Library,
Astor, Lenox and Tilden
Foundations

mORE DASH
THAN CASH

Rapunzel

While hair signifies a woman's beauty and desirability, it may also be indicative of her worth. This is why Rapunzel's blondeness is of such importance. Blonde hair is often linked to gold – a notion that is related to its color, of course, but to other characteristics as well. Marina Warner writes:

> Blonde hair shares with gold certain mythopoeic properties: gold does not tarnish, it can be beaten and hammered, annealed and spun and still will not diminish or fade; its brightness survives time, burial, and the forces of decay, as does hair, more than any other residue of the flesh. It is hair's imperviousness as a natural substance that yields the deeper symbolic meanings and warrants the high place hair plays in the motif repertory of fairy tales and other legends.[164]

Because of its invulnerability, golden hair is symbolic of power – a power that Rapunzel is deprived of when her hair is shorn. Blonde hair has also been associated with riches. In William Morris's 1858 poem based on the tale, the prince refers to Rapunzel's beautiful, yellow hair numerous times, and mentions specifically that his beloved does not wear gold or gems.[165] Rapunzel does not need such flashy apparel – it is clear that her magnificent golden tresses are of greater value.

Part of the appeal of golden hair was its rarity. In centuries past, women could not color their hair easily to any hue they desired, as we can today. This ensures that fairy tale blondes are *natural* blondes – yet in spite of its real-life rareness, golden hair is anything but unusual in these stories. It is sometimes mentioned casually as an obvious signifier of a character's beauty or, as is the case in "Furrypelts" and "Rapunzel," it can be central to the story's plot.

In spite of the relative simplicity of becoming a blonde in the modern era, long, golden tresses continue to conjure images of Rapunzel. A 1970 *Vogue* editorial features Twiggy playing "the princess in the tower in a long languorous white dress with long narrow sleeves," with "long, golden Rapunzel hair."[166] Her lengthy tresses were fashioned by the hairdresser Ara Gallant, using synthetic hairpieces by Helene Curtis. Twiggy emphasized the style by standing in profile and slanting her body backward, so that the heavy hairpieces fall to her knees, nearly overwhelming her thin frame.

Alexander McQueen's Fall 2007 collection is also evocative of Rapunzel, even if the tale was not the designer's actual point of reference. Entitled *In Memory of Elizabeth Howe, Salem, 1692*, the collection featured clothing based on Mc-

"More Dash Than Cash"
Vogue, April 15, 1970
Model: Twiggy
Photograph by Justin de Villeneuve
Justin de Villeneuve/Vogue
© The Condé Nast Publications, Ltd.

120 Fairy Tale Fashion

Queen's newly discovered family relationship to several women who had been persecuted during the Salem Witch Trials.¹⁶⁷ One of the dresses is made from deep green velvet that envelops much of the body, covering the neck, arms, and legs, and trailing into a short train at the floor. The fabric is embellished richly with thick, hair-shaped strands of copper-colored beads. While McQueen was likely thinking of the use of human hair in rituals of witchcraft, the tumbling effect of the beads, which shimmer past the wearer's knees, makes it hard not to think of "Rapunzel." This was not the only time McQueen experimented with hair motifs in his work; for the Fall 2000 *Eshu* collection, the designer crafted a long coat made from loops of dense, black, synthetic hair.

(facing) Alexander McQueen
Dress in dark green velvet with gold beading, Fall 2007
The Museum at FIT, 2013.2.1

(below) Nicolette Brunklaus
Blond curtains (on view in the 2005 Museum at FIT exhibition *Dutch at the Edge of Design*)
Digitally printed silk, 2003
Collection of The Museum at FIT, 2005.24.1

For the blog (IN)DECOROUS TASTE, Lauren Tennenbaum and Lydia Koch fashioned a dress from long, blonde, human hair. "Inspiration can come from many places; in this case it was in the form of a weave [...] I wondered why designers haven't explored this medium more thoroughly. I realize it's remotely disgusting, but really, is it?"[168] they questioned. The designers embellished a sheath dress with two tiers of human hair, one affixed to the dress's neckline, and the other at the waist. In a photograph of the garment by Daniel Lehenbauer, the model's hair is also long, straight, and light blonde, and blends seamlessly into her unusual gown.

Although this book focuses on clothing and its relation to fairy tales, it would be remiss not to include the Amsterdam-based interior designer Nicolette Brunklaus. The notion of storytelling is central to Brunklaus's work, and her textile designs often combine her passion for photography with her love for the natural world. Yet even her most realistic subject matter is infused with an imaginative, ethereal quality. A set of curtains from 2003 – aptly titled *Blond* – features a photograph of golden hair, digitally printed on silk fabric. The tresses tumble down each of the panels, in mirror image, and pool into soft curls at the bottom hems. While the imagery itself is enchanting, it is the scale of the curtains that recalls Rapunzel's story. Together, the panels measure nearly ten feet high by more than nine feet wide. Whether installed in a gallery or in a home, they are simultaneously beautiful and imposing, and elicit the sense of solitude a woman can affect when she covers her face with her hair.[169] Undoubtedly, they also recall the romance of "Rapunzel."

Dress made from human hair
Dress and headwear:
(IN)DECOROUS TASTE (Lauren Tennenbaum and Lydia Koch)
Photograph by Daniel Lehenbauer
Courtesy Lauren Tennenbaum

Furrypelts
(Based on the tale by the Grimm Brothers)

When a king's exceptionally beautiful, blonde wife falls gravely ill, she asks him not to remarry unless he can find someone as beautiful as she is. After her death, the king sends messengers to search for a suitable new wife, but none can be found. Meanwhile, the king's daughter grows into a young woman, who is as beautiful and blonde as her mother. When the king notices this, he decides he must marry her. Understandably horrified, the princess tries to deter him by making seemingly impossible demands. She tells him that he must commission three dresses for her: "one as golden as the sun, a second as silvery as the moon, and a third as bright as the stars." She also demands "a cloak made of thousands of kinds of pelts and furs," taking a bit from every animal in the kingdom.[170]

The king hires the most skilled women in the land, who successfully craft the three dresses and the cloak of many furs. He presents the magnificent garments triumphantly to his daughter, announcing, "Tomorrow our wedding will be celebrated."[171] That evening, the princess sneaks out of the castle, taking with her the extraordinary gowns, as well as three of her most treasured possessions: a gold ring, a little golden spinning wheel, and a golden bobbin. All of these items are packed into a nutshell. She wears the cloak of many furs, and covers her face and hands with soot. She walks through the forest until she becomes exhausted, and then crawls into a hollow tree and falls asleep.

(facing) Illustration for "The True Sweetheart" (a tale similar to "Furrypelts") by Arthur Rackham, 1917 General Research Division, The New York Public Library, Astor, Lenox and Tilden Foundations

(following) Emma Summerton "Into the Woods" editorial, *Vogue* Japan, October 2014 Photograph courtesy Emma Summerton/Trunk Archive

The princess is soon discovered by a huntsman, who takes her to a castle in another kingdom. Her disheveled appearance disguises her royalty, and she is sent to work in the castle's kitchen. The princess never removes her matted fur cloak while she works, but she does sneak off to attend balls held at the castle, unrecognizable as the kitchen maid in her beautiful dresses. She also begins to send subtle yet purposeful signals of her presence to the king, first by dropping her gold ring into his soup, then her small golden spinning wheel, and finally her golden bobbin. The king wonders where these treasures have come from, and realizes eventually that Furrypelts must be their owner. He calls her to his chambers and pushes aside her cloak, revealing her golden hair and her starry dress (which she had not had time to take off after leaving the final ball). Furrypelts wipes the soot from her face, revealing her full beauty, and she and the king are soon married.

Fashioning "Furrypelts"

The Grimms' "Furrypelts" is related to the somewhat better known tale "Donkeyskin," a version of which was published by Charles Perrault in 1697. Jacques Demy's 1971 film based on the latter tale, starring Catherine Deneuve, may be familiar to some readers, but both "Donkeyskin" and "Furrypelts" have been excluded from many anthologies of fairy tales. Much of the reason for this is the tales' reference to incest – in both stories, the king wants to marry his beautiful daughter. When fairy tales became firmly settled in their role as children's literature, such a shocking plotline would have been unsuitable. For this book, however, including "Furrypelts" was an absolute necessity, since within the fairy tale genre, only "Cinderella" rivals this story in its descriptions of spectacular fashions. Also like "Cinderella," clothing is integral to both the princess's identity and to the unfolding of the story's plot.

References to nature and the heavens are plentiful in fairy tales. Maria Tatar attributes this in large part to the stories' roots "in the pagan world, one that is oriented toward fire, water, wind, the sun, the moon, and the stars. These cosmic forces are central to the fate of the hero, and they often shape the course of events in ways that escape our attention."[172] In asking for gowns that look like the sun, the moon, and the stars, Furrypelts calls upon the cosmic forces of which Tatar writes, hoping that they will provide her with a means of escape from her father's lascivious intentions. Furrypelts next shifts her focus from

129 Furrypelts

heaven to earth – although it is not stated explicitly, she is requiring the king's men to trap and skin every animal in the kingdom. It seems improbable that the king will be able to produce the fine clothing and the unusual cloak that his daughter demands. When he does so, however, Furrypelts must take refuge in the very forest from which the material for her cloak originated.

Since dazzling gowns are common in the realm of fairy tales, Furrypelts's demands do not seem out of place. It is curious, however, that the princess asks for special clothing that will seemingly make her appear even *more* attractive to the man she is trying to discourage.[173] Attempting to discern the logic in many fairy tales can be a fruitless and frustrating endeavor, but Furrypelts's demands seem to be based on her personal desire for fashion. After all, she is sure to pack her three magnificent dresses with her when she flees from the kingdom. While it is true that the dresses (and her trinkets) are useful to her at the end of the tale, she had no way of knowing such an outcome when she left for the forest. Fur-

(left) Illustration for "Furball" (A tale similar to "Furrypelts") by Margaret Evans Price, 1921

(right) Illustration for "Donkeyskin" (a tale similar to "Furrypelts") by H.J. Ford, 1900

thermore, Furrypelts embodies other key characteristics of a fairy tale princess, such as great beauty, golden hair, and good manners. In some other fairy tales, these traits are enough to indicate a character's noble status.

The beautiful gowns are undoubtedly significant to this story, but the cloak made from thousands of pieces of fur is a more intriguing object. There are many fairy tales that feature beautiful dresses, but fewer that portray heroines in fur cloaks, particularly those of the "Furrypelts" variety. Much of the cloak's role in the tale is centered on its ability to disguise both the beauty and the noble birth of its wearer. It is regarded as a garment worn for protection (both physical and emotional), rather than fashion. A huntsman mistakes the cloak-wearing princess for an animal in the woods, and she continues to wear the cloak while she works in the palace as a kitchen maid – presumably making the fur dirtier and more bedraggled each day, and thus enhancing her disguise.

Yet in its initial, unsullied state, the cloak must have been a remarkable sight. In granting his daughter's request for a piece of fur from every animal in the forest, the king knowingly and quickly depletes an integral part of his kingdom's resources. Fur fashion has historically been – and still is – viewed as an elite and exclusive commodity.[174] During the age of sumptuary laws (from the fourteenth through the seventeenth centuries), certain rare and valuable furs could *only* be worn by nobility, while other, lesser-valued pelts were designated for the clergy or peasantry. The princess's demand to wear a bit of every type of fur in the kingdom is sheer excess. It speaks not only to her high position, but also to the king's madness and desperation in meeting his daughter's requirements. This plotline is echoed in "Donkeyskin," in which the princess requests that her father provide her with the skin of a donkey that produces gold and provides great wealth for his kingdom. When the king kills this valuable animal

Diane von Furstenberg
Fall 2014, look 21
Courtesy Diane von Furstenberg

in order to marry his daughter, she dons the donkey's pelt and flees to the forest.

Of all of the garments described in "Furrypelts," the cloak seems the most tangible. We need only to look at the contemporary fashion for multicolor, patchwork fur coats – exemplified by Diane von Furstenberg's Fall 2014 collection – to get a sense of what Furrypelts's cloak might have looked like. Thinking more closely about the depictions of the three ethereal dresses, however, their potential as actual garments becomes clearer. In many cultures, the sun is associated with gold, and the moon with silver. This recalls Cinderella's beautiful gold and silver gowns, and their possible link to clothing worn by the monarchy. More specifically, in her comprehensive study of Marie Antoinette's wardrobe, the French history scholar Caroline Weber describes the queen's selection of a gown for a momentous political meeting: "Marie Antoinette planned her outfits for the event with tremendous care, abandoning her more personal whims of style for the time-honored conventions of queenly pomp," she writes. "For the formal procession and the religious services on May 4, 1789, she settled on a lustrous cloth-of-silver gown, which, viewed beside Louis XVI's resplendent cloth-of-gold jacket, would cast her as 'the moon to the King's sun.'"[175]

We can imagine Furrypelts shedding her ragged, furry cloak to reveal something like Zandra Rhodes's ensemble made from bright gold lamé. Its rounded, ruffled sleeves and flared, handkerchief hem are sunburst pleated, adding to the ensemble's radiance. Rhodes intended her design to be a reinterpretation of English court costume, and it was specifically inspired by Diana Spencer's wedding to Prince Charles in 1981. More recently, the Indian-born, New York-based designer Bibhu Mohapatra presented a floor-length, ivory chiffon gown as the final piece in his Spring 2015 collection. The fabric was embellished with shimmering silver roundels and delicate webs that suggest the textured surface of the moon. While

(below) Bibhu Mohapatra
Spring 2015, look 43
Courtesy Bibhu Mohapatra

(page 132) Zandra Rhodes
Evening ensemble in gold lamé, 1981
The Museum at FIT, 91.158.1

(page 133) Mary Liotta
Evening dress in ivory silk chiffon with beaded and sequined silver stars, early 1930s
The Museum at FIT, 78.237.10

the dress is fitted at the front waist, it falls loosely from the shoulders at the back of the dress and extends into a train, recalling the silhouette of an eighteenth-century *robe à la Française*.

The star carries myriad symbolic meanings across cultures, but two of its most widely known significations are those of guidance and destiny – making it an appropriate feature for the gown Furrypelts wears when she is unveiled and begins her new life with the king. A beautiful 1917 illustration by Arthur Rackham portrays the golden-haired heroine standing in her humble living quarters, fastening a long, silvery gown covered in stars over her chemise. Beside her, a small case containing her golden trinkets rests open on a chair.[176] The caption for the illustration reads, "The third time she wore the star dress which sparkled at every step."[177] A gown dating to the early 1930s, by the designer Mary Liotta, provides a sense of what the shimmering, star gown might have looked like in actuality. Made from layers of ivory silk chiffon, the bias-cut dress is embellished densely with silver stars crafted from glittering silver beads and sequins.

The number three is significant in numerous fairy tales, but it is especially prevalent in "Furrypelts." The princess has three magical dresses, there are three primary settings (the father's palace, the woods, and the second king's palace), and Furrypelts uses three golden trinkets to make the king aware of her presence. There are seemingly innumerable associations with "the power of three." For example, it is believed to represent human life (the mind, body, and spirit); the world as a whole (the earth, sea, and air); and the kingdoms of nature (animal, vegetable, and mineral). In the case of Furrypelts's dresses, of course, the sun, moon, and stars form a triad. The belief of the Greek philosopher and mathematician Pythagoras provides one of the most pervasive theories, and his is the one that is most easily applied to storytelling in general. He thought three to be the perfect number in that it represents a beginning, middle, and end.[178]

Furrypelts's trinkets act as the third reference to gold in the tale, following the references to golden hair and the golden dress. Beyond their role as precious objects that alert the king to Furrypelts's presence, the ring, bobbin, and tiny spinning wheel carry their own meanings. The most straightforward ornament that Furrypelts employs is the ring, a universal token of relationships and love – gold rings being particularly significant. As Joyce Thomas explains, the indestructible nature of gold has been linked to "the permanency, incorruptibility, purity and high value accorded love."[179]

The inclusion of the tiny spinning wheel and bobbin are slightly more ambiguous in meaning. Being made from gold rather than the typical wood, both are obvious luxury items – more so even than the gold ring, which is a common token of affection. Spinning wheels are recurrent objects in fairy tales – such as in "Sleeping Beauty" – but this precious, diminutive example highlights that spinning was viewed not solely as a laborious task for working women, but also as a pastime for well-bred ladies. The bobbin is the object over which the thread, once spun, is wound. As the use of the bobbin marks the end of the spinning process, it makes sense that this is the third and final trinket to be placed in the king's soup, since it leads to the story's conclusion.

Although "Furrypelts" resembles "Cinderella" in several ways, a closer examination of this story shows that it is not quite as far removed from reality as many other fairy tales. If we can believe that the beautiful dresses and the cloak could have actually existed, there is, in fact, very little magic in the story at all (the exception to this is that Furrypelts manages to pack all of her gowns and her trinkets into a nutshell before she travels into the forest). Furrypelts is a princess whose father – and by extension, the people of his kingdom – concede to her wishes. She does not need a fairy godmother, or a wishing tree. It is unfortunate that this story is relatively unknown, since Furrypelts is not a typical blonde, fairy tale heroine. She is plucky, clever, and not afraid to get her hands dirty – even if she cannot resist having beautiful clothes.

The Little Mermaid
(Based on the tale by Hans Christian Andersen)

The youngest of a family of six mermaid princesses longs to reach the age of fifteen, when she will be allowed to rise up from the depths of the sea and sit on the rocks in the moonlight. When she at last reaches her fifteenth birthday, she makes her way to the top of the water just as the sun is setting. She peers into a ship where a handsome young prince is enjoying his own birthday celebration. Soon, a terrible storm rolls in, the prince's ship begins to rock violently, and he falls into the sea. The Little Mermaid rescues him, taking him to dry land and watching over him until morning. A human maiden comes along, and seeing the prince lying on the beach, wakes him. The prince has no idea that it is the mermaid princess who truly rescued him.

Upon returning to her home deep in the sea, the Little Mermaid can think only of the prince. Her sisters eventually learn of her fascination with him, and show her the location of his castle. The Little Mermaid makes many trips to observe him and those around him, becoming more and more entranced by the human world.

Desperate to be with her prince, the Little Mermaid visits a frightening sea-witch who says she can turn the princess's tail into legs – at a steep price. It will feel to the mermaid as if she is walking on knives, though she will appear exceptionally graceful to others. There are other conditions, too: once she takes human form, she can never be a mermaid again, and she must win the prince's hand in marriage. If she fails to do so, her heart will break, and she will be

Illustration for "The Little Mermaid" by Jennie Harbour, 1932

turned into sea foam. Finally, the sea-witch will take the mermaid's beautiful voice as her payment (by cutting off her tongue), rendering her mute. The mermaid agrees to these terms, and makes her way to the shore by the prince's castle. She wakes in the morning to find that her tail has been replaced by legs, and the prince is standing over her. Though she cannot speak and explain why she is there, he takes her to his castle.

They live happily for some time, until the prince is reintroduced to the maiden he believes to have rescued him from the shipwreck, and asks for her hand in marriage. The Little Mermaid knows that this signals her death, but her sisters barter with the sea-witch in the hope of saving her. They hand their sister a knife with which to kill the prince, which will transform her back into a mermaid, but she does not have the heart to murder him. She accepts her fate, and dissolves into sea foam.

Fashioning "The Little Mermaid"

"The Little Mermaid" is one of Hans Christian Andersen's most famous and beloved tales. This is due in part to its beautiful and dramatic prose. The story's poetic descriptions of cornflower-blue water, underwater plants, and castles made from mussel shells and coral are quintessential Andersen, but the plot is actually based on a novella entitled *Undine*, published in 1811 by the German writer Friedrich de la Motte Fouqué.[180] The history of mermaids in folklore, however, is much older. "Few items of marine folklore are more widespread, go back further in history, are more fascinating, or pose more problems for the scholar attempting to arrive at workable conclusions than the belief in merfolk,"[181] notes the sea folklorist Horace Beck.

Since mermaids are half-human, we can in some ways relate to them, but we also remain captivated by their fantastical qualities. In her book *The Mermaid and the Minotaur*, the feminist writer Dorothy Dinnerstein observed:

> Myth-images of half-human half-beast like the mermaid and the Minotaur express an old, fundamental, very slowly clarifying communal insight: that our species' nature is internally inconsistent, that our continuities with, and our differences from, the earth's other animals are mysterious and profound; and in these continuities, and these differences, lie both a sense of strangeness on earth and the possible key to a way of feeling at home here.[182]

139 The Little Mermaid

Mermaids are akin to other mythical sea beings, such as sirens and water nymphs, but they tend to be portrayed as less sinister and vampish than their peers. The greatest appeal of all of these sea-dwelling characters is their beauty, which they sometimes use to lure men. Of the merman king's six lovely daughters, the Little Mermaid is described as "the prettiest of all, her skin was soft and delicate as a rose leaf, her eyes as blue as the deepest sea, but like all the others she had no feet, and instead of legs had a fish's tail."[183]

Descriptions of mermaids vary surprisingly little. They have pretty faces, long, beautiful hair (typically blonde or red, dressed carefully with a comb and mirror), and human torsos above fish-like tails (purportedly similar to the tail of a cod more than a mackerel, a porpoise, or a shark[184]). If mermaids wear any type of adornment, it is, quite naturally, gleaned from the sea. On her fifteenth birthday – when the Little Mermaid is finally allowed to swim to the water's sur-

(left) Illustration for "The Little Mermaid" by Elenore Abbott, 1920

(right) *Harper's Bazaar* cover with "mermaid" dress form, July 1936
Courtesy Hearst Publications

face – her grandmother dresses her in what Andersen describes as "a wreath of white lilies round her hair, but every petal of the flowers was half a pearl,"[185] and she also fixes eight oysters onto the princess's tail. The Little Mermaid protests the weight and discomfort of her finery, but her grandmother insists that she wear it to indicate her high rank within the ocean kingdom. Some illustrations of mermaids show them wearing seashell bras – an idea that is charming, if somewhat puritanical. Illustrators may also draw mermaids so that their bare breasts are not visible, or simply arrange their long hair to disguise their nakedness (as the Little Mermaid herself is said to do when the prince discovers her, in human form, on the sea shore).

The Little Mermaid's quest to become human is not based entirely on her desire to be with the prince, though that does play a crucial part in her decision. Early in the story, she asks her grandmother what will happen to her when she dies. She learns that mermaids do not have immortal souls, as humans do, and therefore they are destined to "become mere foam on the water," with no future beyond their 300-year lifespan.[186] The Little Mermaid comes to realize that she must be loved by a human in order to have a place in heaven. Her grandmother warns her that such a thing is impossible, exclaiming, "That which is your greatest beauty in the sea, your fish's tail, is thought hideous up on earth, so little do they understand about it; to be pretty there you must have two clumsy supports called legs!"[187]

Based on the countless representations of mermaids in artwork, film, and fashion, the Little Mermaid's grandmother was clearly misinformed. While it is incorrect to say that humans are interested in *looking like* mermaids, many women have a desire to *dress as* mermaids. By the 1930s, slinky, floor-length dresses were sometimes described as "mermaid" gowns. An editorial in the October 1933 issue of *Vogue*, devoted to dressing a woman like a "fairy tale princess," included a "mermaid" halter dress in black silk by Jean Patou, with a long train that extended from sunburst-pleating at the back waist. Mermaid imagery was also used more literally in clothing. For his

Charles James
La Sirène evening gown in taupe silk crepe, 1956–57
The Museum at FIT, 91.241.131

141 The Little Mermaid

Spring 1936 collection, Marcel Rochas introduced a dress with mermaid-shaped buttons and a large mermaid adornment at the front waist, which *Vogue* praised for its charm. Elsa Schiaparelli also took inspiration from mermaids during this era. Her Summer 1940 collection included a "mermaid" silhouette that "curved in at the waist, rounded out over the hips, and drew in again at the knees, a shape helped along by an eight-ounce girdle she had designed with the American corset company Formfit,"[188] explains the curator and Schiaparelli expert Dilys Blum.

Charles James crafted his first *La Sirène* (*The Mermaid*) gown in 1937. Silk fabric was draped over a full-length, molded dress form that widened into a fishtail shape at the bottom. His technique was similar to that of blocking felt when making a hat, a process with which James, a trained milliner, would have been keenly familiar.[189] Unlike the rigidity of a hat, however, James's dress is soft, with no interior support or construction. An example of this style from 1957 demonstrates how the fabric was tucked and stitched expertly to create a form-fitted silhouette, its precise tucks ending at the wearer's knees to allow for ease of movement.

Whereas the effect of James's *La Sirène* is created entirely by the manipulation of fabric, Norman Norell's series of "mermaid" gowns is distinguished by its use of sequins. The first example of what was to become a signature of the designer's work appears to be from 1949, and he continued to make variations on the mermaid gown until his death in 1972. Norell's early style comprised a slinky, black sequined dress that ended just above the knee, with an attached silk skirt that flared out dramatically and ended at mid-calf. Later examples tend to be floor length, body skimming, and fully sequined. "Fashion, to Norell, wasn't a mad rush from one style to the next, rejecting today what had seemed marvelous yesterday. It was a logical progression, a search for perfection. And so his best styles endured. Women could pull them from their closets ten years after they were purchased and wear them to applause, with great delight," recalled the fashion writer Bernadine Morris. "This was as true of his understated jersey dresses, the basis of his daytime look, as it was of his spectacular sequin-studded

Norman Norell
"Mermaid" evening gown in sequined silk jersey, ca. 1972
The Museum at FIT, P86.43.3

styles, which made everyone who wore them glow like a mermaid."[190] A mermaid dress from the end of Norell's career consists of a beige top and a slightly flared, blue-green skirt that recalls a mermaid's bare torso and shimmering tail. Like all of his "mermaids," each sequin has been individually sewn to the jersey fabric.

In 1988, Thierry Mugler created a "fairy tale kingdom" for his presentation of a collection devoted to the lost city of Atlantis. Marine monsters, sea nymphs, sharks, and starfish graced the catwalk.[191] One of Mugler's provocative "mermaid" dresses consists of a strapless, winged bustier and matching skirt, both made from shimmering Lurex in a shade of pale violet. One of Mugler's greatest talents was combining fantasy with adept craftsmanship, visible here in the precise, figure-enhancing tucks along the bustier and skirt. The "fishtail" effect is emphasized by the silhouette of the skirt, which sweeps dramatically from the knees into a short train at the back.

In the May 2012 issue of *Vogue* India, a two-page spread highlighted that a "fascination with the ocean depths surged through the Summer collections," and featured items such as a mermaid- and seahorse-printed skirt from Versace, an elaborately beaded "siren" gown by Giorgio Armani, and a pearl-encrusted, conch-shell-shaped clutch by Chanel.[192] This trend piece was accompanied by a mermaid-inspired editorial photographed by Luis Monteiro and styled by Anaita Shroff Adajania. Entitled "Water Sign," the series of vibrant photographs was shot both underwater and on the seashore. In one image, the model stands on the beach, wearing a flowing, black-and-white gown by Anthony Vaccarello and a shell bangle by Pebble London. Her dancer's pose – one leg arched behind her, arms extending overhead – is reminiscent of the Little Mermaid's ability to move with exceptional grace after she obtains human form, in spite of the pain it causes her.

More recently, Kate and Laura Mulleavy, the sister designers behind the label Rodarte, channeled the romance of mermaids for their Spring 2015 collection. The Mulleavys created a group of richly layered, iridescent dresses in hues of blue, green, white, and black,

(facing) Thierry Mugler
Evening set in lilac polyester and Lurex blend, 1988
The Museum at FIT, 2011.13.1

(below) Luis Monteiro
"Water Sign," *Vogue* India, May 2012
Courtesy Luis Monteiro

some complete with a delicate, openwork material that was unmistakably evocative of fishing net. The fashion writer Mhairi Graham noted that the glittering embroidery on some of the dresses was reminiscent of sea foam.[193] "Mermaids poignantly remind us of all the great mysteries of the ocean, all of its beauty and melancholy," explained the Mulleavy sisters. "We were inspired by tide pools and the ocean: its undulating and delicate textures and colors. As the collection evolved, it seemed fitting to have a series of dresses that were inspired by the fantasy of mermaids, as they poetically capture the spirit of the sea."[194]

Rodarte
"Mermaid" evening gown, Spring 2015
The Museum at FIT, 2015.35.1

The Snow Queen
(Based on the tale by Hans Christian Andersen)

A demon is delighted by his creation of a special mirror that shrinks and distorts good and pretty things, while magnifying bad things. When the mirror is accidentally dropped, it shatters into "hundreds of millions and billions of bits."[195] The mirror's minuscule fragments cause great harm, as they get stuck in people's eyes and puncture hearts around the world, distorting vision and turning hearts to ice.

 Readers are introduced to two young friends and neighbors, a boy named Kay and a girl called Gerda. They live in a crowded city, but beautiful roses and other plants grow outside their adjacent apartment windows. One snowy evening, Kay looks out of the window, and the figure of a woman appears before his eyes. Kay is frightened and jumps away, later convincing himself that what he saw was only a large bird. Sometime afterward, Kay and Gerda sit reading a book when Kay feels something strike his heart and something else get stuck in his eye. Fragments of the wicked mirror have become lodged in his body, and he soon turns nasty, teasing Gerda mercilessly and mocking people on the street. One afternoon, Kay carries his sledge (a type of sled) to the town square. When he arrives, it gets hooked onto a larger, white sledge and Kay is swiftly carried away behind it. When the sledges finally stop, the other driver reveals herself to be the Snow Queen, the same figure who had appeared at Kay's window. She endears herself to him, and the boy stays with her.

Illustration for "The Snow Queen" by Edmund Dulac, 1911

Gerda is distraught over the disappearance of her best friend. She asks the nearby river if it has seen Kay, offering her new red shoes in exchange for information. She takes off the shoes and throws them in the river, but they are quickly returned to shore – the river has not taken Kay, so it cannot accept Gerda's offering. Thinking she had simply not thrown the shoes hard enough, Gerda climbs into a boat to reach the center of the river, and is carried away in a current. Finally, a kindly old woman walks out into the water to stop the boat, and Gerda is saved.

The old woman is a witch, but a benevolent one who simply wants Gerda's company. She hides all the roses in her garden using a magic stick, knowing that the flowers will remind Gerda of her lost playmate, but she forgets about a rose that is painted on one of her hats. When Gerda sees the flower, she remembers her mission, and sets out again to find Kay. She encounters a crow, who leads her to believe that Kay has married a local princess. When Gerda arrives at the royal castle, however, she discovers that the new prince is not Kay. After hearing her story, the prince and princess send Gerda back on her way in a golden chariot so luxurious that it attracts the attention of a group of robbers. Although they initially intend to kill her and eat her, Gerda is saved by a young robber-girl who wants a playmate. The robber-girl keeps pigeons and a reindeer as pets, and

Andreia Chaves
Invisible shoes in glass, leather, and 3D-printed nylon, 2011
The Museum at FIT, 2013.47.1

overhearing Gerda's plight, the pigeons provide her with information regarding Kay's whereabouts. The reindeer then takes Gerda to a place called Lapland.

In Lapland, Gerda and the reindeer meet with a woman who sends them on to Finnmark. There, a Finnish woman takes the reindeer aside and tells him that Kay has been struck with evil glass in his eye and his heart, and the shards must be removed before he can overcome the spell of the Snow Queen. She assures him that Gerda has the strength to do this. The reindeer carries Gerda to the Snow Queen's icy gardens, but the girl must enter the palace alone.

Gerda ventures through the vast, empty ice castle in search of Kay. Fortunately, the Snow Queen is out, wreaking havoc on warmer countries, and Kay has been left alone. Gerda discovers her friend – who is blue with cold – and begins to cry when he does not respond. When her tears fall upon his breast, they penetrate to his heart and melt a bit of the mirror. Kay begins to sing, and then bursts into tears, washing the grain of glass from his eye. He returns to his normal self, releasing him from the Snow Queen's hold, and he and Gerda return home.

Tom Ford
Spring 2014, look 28
Courtesy Tom Ford

Fashioning "The Snow Queen"

"The Snow Queen" is one of Andersen's longest stories, and it is written in seven parts. In its initial conception, however, the tale existed as a short, ballad-style poem that told of a young woman and her lover, a miller boy who is abducted by the Snow Queen.[196] In the poem, the Snow Queen's role is that of a sexual predator – quite different from the cautionary children's tale that is so well known today, in which Kay and Gerda are introduced as children.

Unlike in "Snow White," where the wicked stepmother's mirror is nothing but truthful, the demon's mirror in this tale is deceptive. "The most beautiful landscapes reflected in it looked like boiled spinach, and the best people became hideous, or else they were upside down or had no bodies," Andersen writes. "Their faces were distorted beyond recognition, and if they had even one

150 Fairy Tale Fashion

freckle it appeared to spread all over their nose and mouth."¹⁹⁷ The demon considers this mirror to be so amusing that he sends his disciples to carry it around the world, allowing everyone to see their hideous reflections in its glass. The mirror is intended to mock even the angels in heaven before it is dropped and shattered. That the mirror's fragments can become lodged in innocent people's hearts and eyes, rendering them cold and heartless, relates to the belief that mirrors can steal part of one's soul.¹⁹⁸

In both "The Snow Queen" and "Snow White," mirrors are strongly linked to notions of vanity. While this concept is especially evident in "Snow White," it can also be perceived in Andersen's tale – after all, the demon's followers would be unable to take pleasure in their sinister, mocking mirror if their victims did not want to see themselves in the first place. Mirrors as symbols of vanity, self-love, and frivolity originate in the tale of Narcissus, who falls in love with his reflection in a pool of water. Unable to cease gazing at himself, he eventually drowns. Yet Narcissus is hardly the only one absorbed by his own appearance. In his essay, "A Gift of Mirrors: An Essay on Psychologic Evolution," the psychologist William F. Fry, Jr. writes:

> The degree of fascination with mirrors is testified to not only by their long and widespread use, but also by the persistence of human ingenuity at find-

Shoes in red Morocco
leather, 1800–10
The Museum at FIT, 2015.34.1

ing substances which can be turned to reflective function. Stone surfaces have been polished, especially jade and obsidian. Mirrors have been created of burnished iron ore, native copper, silver, gold, bronze, steel, and of course glass […] That mirrors are especially prized is suggested by the extensive and elaborate decorations applied to them, and by the decorative uses made of them.[199]

The decorative uses to which Fry refers include beautiful stands and mounts, inlays of jewels and other opulent materials, and artistic inscriptions on the mirrors themselves. Fry's words could also be extended to some less conventional applications, such as the use of mirrors in fashion. Tom Ford's Spring 2014 collection featured a mini-dress strikingly embellished with an intricate pattern of mirrored fragments. Ford is not the only designer who has embraced the aberrant beauty of a fractured mirror. Andreia Chaves's aptly named *Invisible* shoes from 2011 are crafted into an unusual silhouette using 3D printing, then covered with a mirrored façade that was laser cut to create precise, form-fitting shapes. The shoes mirror the wearer's surroundings in a fascinating, slightly disorienting manner that is the result of their fragmented surface. While Ford's dress and Chaves's shoes may bring to mind Andersen's description of the sinister mirror in "The Snow Queen," they also suggest a well-known superstition: that breaking a mirror begets seven years of bad luck. That said, mirrors also carry many positive connotations, as objects of luck, good health, success in love, and protection from evil.[200]

Footwear plays a small but vital role in "The Snow Queen." When Winter turns to Spring, Gerda decides to begin her search for Kay. "I will put on my new red shoes," she says, "those Kay never saw; and then I will go down to the river and ask it about him!"[201] When she reaches the river, she throws her shoes in the water, attempting to sacrifice her cherished possessions in exchange for information on her friend's whereabouts. When the shoes are quickly returned to her, Andersen explains, "it seemed as if the river would not accept her offering, as it had not taken little Kay."[202]

This reference to red footwear is brief, but it is certainly notable. "The Snow Queen" was written just four months before another of Andersen's best-known tales, "The Red Shoes."[203] The latter story centers on a girl's desire to wear red footwear, even when she knows it is inappropriate. "The Red Shoes" stars a young, impoverished girl named Karen who must go barefoot in the Summer, and has only heavy wooden shoes to wear in the Winter. Her obsession with

red shoes begins when an old shoemaker fashions Karen a pair of clumsy shoes made from strips of red cloth. Later, after having been adopted by a wealthy, elderly woman, Karen encounters a young princess, who wore "neither a train nor a golden crown, but she was dressed all in white with a beautiful pair of red morocco shoes [...] Nothing in the world could be compared to those red shoes."[204] Karen fools the old woman, who has poor eyesight, into buying her a similar pair. Against all measures of decorum, the girl wears the red shoes to her confirmation. After the ceremony, Karen performs a little dance in the shoes, and finds that it is difficult to cease. She later sneaks off to a ball wearing the red shoes, even though her kind, elderly caretaker is on her deathbed. At the ball, Karen finds that she still cannot stop dancing. The shoes have grown onto her feet, and she must carry on dancing day and night, through all weather. Eventually, she finds an executioner to chop off her feet, and he makes her a pair of wooden legs and crutches. Karen repents, and is welcomed back into the church.

In both "The Red Shoes" and "The Snow Queen," the shoes are objects of pride. Gerda plans to wear her red shoes on her journey to find her friend – specifically, shoes that Kay has never seen – telling readers that she hopes to impress him with her new footwear. That she is willing to give up these shoes, however, is a gesture of self-sacrifice that differs from Karen's prideful and sinful ways.

(facing) Alexander McQueen
Evening dress in tulle and black and white laser-cut vinyl, Fall 2008
The Museum at FIT, 2010.61.1

(far left) Illustration for "The Snow Queen" by Katharine Beverley and Elizabeth Ellender, 1929

(left) Illustration for "The Snow Queen" by Milo Winter, 1916

According to the fashion historian Hilary Davidson, through "The Red Shoes," Andersen established a "template for the way in which red shoes were appreciated and comprehended in the twentieth century,"[205] especially as objects representative of female sexuality.

The significance of red shoes at the time of Andersen's writing during the nineteenth century is easily understood. In "The Red Shoes," he specifically notes that the little princess's footwear is made from Morocco leather, a thin, supple material often used for fashion accessories and book bindings. According to the 1885 publication *The Manufacture of Leather*, Morocco leather produced from goatskin was "extensively manufactured" for use as women's shoe uppers, but that these skins were commonly tanned black.[206] Until the emergence of chemical dyes during the 1850s and 1860s, "splendid" red leather was more difficult and expensive to achieve.[207] The Museum at FIT owns a pair of flat-heeled slippers in red Morocco leather from early in the nineteenth century, whose simplicity of design belies their probable role as status objects.

Beyond little Gerda's red shoes, Andersen makes several other references to dress in this tale, beginning with a description of the Snow Queen when she first appears at Kay's window: "A few snowflakes were falling, and one of these, the biggest, remained on the edge of the window-box. It grew bigger and bigger, till it became the figure of a woman, dressed in the finest white gauze, which appeared to be made of millions of starry flakes." Andersen also gives an account of her physical appearance, explaining, "She was delicately lovely, but all ice, glittering, dazzling ice. Still she was alive, her eyes shone like two bright stars, but there was no rest or peace in them."[208] In just a few sentences, Andersen has eloquently depicted the Snow Queen's alluring beauty, but also her forbidding coldness, which at first frightens Kay and causes him to leap away from his window.

The comparative literature scholar Erica Weitzman notes that two recurring motifs in "The Snow Queen" – snowflakes and roses – stand at aesthetic odds, a point that Andersen makes clear several times. The snowflake's symmetry is associated with the "frigid mathematical perfection" of the Snow Queen's world.[209] The beautiful but imperfect rose, meanwhile, was once a favorite flower of both children, but Kay deems a rosebush to be "horrid" after the mirror fragments become lodged in his body. He specifically mentions a rose that is "quite crooked," a detail Weitzman interprets to mark "the unbridgeable gap between actuality and ideality and, by extension, the intolerable crookedness of all creation."[210]

J. Mendel
White fur cape (2011) and
silk dress (Spring 2008)
Courtesy J. Mendel
Photograph © The Museum at FIT

Alexander McQueen crafted a dress from a cascade of intricate, symmetrical snowflakes that would have pleased the Snow Queen. Yet McQueen's dress lacked the fine white gauze Andersen describes; instead, black silk netting lends the dress a slightly ominous quality. It was part of a Fall 2008 collection entitled *The Girl Who Lived in a Tree*, and McQueen invented a fairy tale of his own to accompany the clothes. Inspired by a six-hundred-year-old tree in his garden, the designer imagined "a feral creature living in the tree. When she decided to descend to earth, she was transformed into a princess."[211] The collection was presented on a runway that circled around an enormous tree wrapped in silk tulle. The fashion historian Judith Watt links McQueen's interest in fairy tale-inspired fashions to a story from his childhood, in which he drew Cinderella, wearing a full-skirted ball gown, on his bedroom wall.[212]

When the Snow Queen appears in the tale driving her sledge, she is wearing a coat and cap made from white fur (sometimes translated as bearskin). In 1929, Katharine Beverley and Elizabeth Ellender illustrated one of the most intriguing depictions of the Snow Queen in this attire, showing her as a tall, featureless figure in white who rises out of the snow and leans over little Kay in a threatening embrace. In a 1916 illustration by Milo Winter, she is shown wearing a more typically fashionable ensemble, including a full-length, white fur coat and a cap complete with earflaps and a peaked brim.

The Snow Queen's pristine white coat speaks not only to her sense of perfection, but also indicates her queenly status. The fashion journalist Chioma Nnadi surmises, "There are few things in this world more unapologetically luxurious than a snow-white fur coat."[213] Nnadi was referring specifically to the J. Mendel Fall 2012 collection, which opened with a series of stunning fur and fur-trimmed garments. J. Mendel was founded as a furrier in 1870, and the company is currently under the leadership of Gilles Mendel, its fifth-

Henrik Halvarsson
"The Ice Queen"
Glamour Russia, December 2012
Courtesy Henrik Halvarsson

generation designer.[214] A stunning hooded cape from 2011 is crafted expertly from a variety of white furs, including raccoon, goat, Mongolian lamb, shadow fox, natural Chinese lamb, and alpaca. Layered over a floor-length ivory dress in hand-pleated silk and tulle, this lavish ensemble appears to come straight from the pages of "The Snow Queen."

When Gerda finally enters the Snow Queen's palace to rescue Kay, Andersen provides readers with a characteristically poetic description of the Queen's lair. "All the rooms were immensely big and empty, and glittering in their iciness," he explains. Gerda encounters a frozen lake in the midst of the palace's never-ending halls, which is "broken up on the surface into a thousand bits, but each piece was so exactly like the others that the whole formed a perfect work of art. The Snow Queen sat in the very middle of it when she sat at home. She then said that she was sitting on 'The Mirror of Reason,' and that it was the best and only one in the world."[215]

The image of the Snow Queen seated in the center of her lake is one that has often intrigued illustrators of the tale, exemplified by Edmund Dulac's haunting image from 1911. He shows the Snow Queen wearing a long, gauzy white dress, cinched at the waist, and upon her head a tall crown in the shape of a snowflake. A similar image can be found in a *Glamour* Russia editorial from 2012. Photographed by Henrik Halvarsson, the model Masha Kirsanova poses in what appears to be a cavern made from ice, its walls lit by an eerie blue light. In one photograph, Kirsanova wears a towering metal crown by Pebble London with an intricately embellished Marchesa gown. As in Dulac's illustration, she stares straight at the viewer, with the faint hint of a smirk. The image is simultaneously chilling and beautiful – much like the story of "The Snow Queen" itself.

The Swan Maidens
(Based on the tale by Joseph Jacobs)

A huntsman observes seven swan-maiden sisters as they alight on the banks of a river. They remove their feathered robes to bathe and play in the water. He thinks them all beautiful, but the youngest maiden is especially enchanting, and the hunter steals her robe from the river's shore. Since the maidens cannot fly without their feathered garments, the six elder sisters must leave the youngest behind. The huntsman comes forward from his hiding place, and reveals to the maiden that he has her robe. He refuses to return it to her, and makes her promise to marry him. When they arrive at his home, he hides her feathered garment. She settles into life with the huntsman, and they have two children.

When the children are playing hide-and-seek one day, one of them discovers the feathered robe, and takes it to her mother. The woman puts the garment on, and explains that if the children's father wants to find her, he must journey to the land east of the sun and west of the moon. With that, she flies away.

The hunter sets out to find his wife. He consults the King of the Beasts, the King of the Birds, and the King of the Fishes about his wife's whereabouts. A dolphin tells him finally that the land east of the sun and west of the moon lies at the top of the Crystal Mountain. He tricks two men and steals their valuable possessions: a cap of invisibility, and shoes that swiftly carry their wearer through the air to any location. Using these objects to reach his destination, he tells the king of the land (who is also his wife's father) that he has come to retrieve his

The Swan Princess by Mikhail Vrubel, 1900
The State Tretyakov Gallery, Moscow
© The State Tretyakov Gallery

bride. The king challenges the hunter to identify her, since she looks exactly like her sisters when dressed in her feathered robe. The huntsman touches the hand of each sister. He recognizes his wife by the indentation of a needle on her right forefinger, caused by making clothing for their children. The king happily releases his daughter, and the couple lives happily ever after.

Fashioning "The Swan Maidens"

"The basic story of capturing a bride by stealing her feather robe is likely a very old one [...] perhaps even Paleolithic, before agriculture,"[216] writes Elizabeth Wayland Barber in her book *The Dancing Goddesses*. The tale of "The Swan Maidens" summarized above appeared in Joseph Jacobs's 1916 *European Folk and Fairy Tales*, and, as Barber suggests, is but one of innumerable variants of this story. Jacobs was a collector of folklore as well as a writer and historian, and he made notes on the history of each of the tales he included in his publication. In his entry on "The Swan Maidens," he writes that another folklorist, E. S. Hartland, claimed that the "feathery robe" in the tale was a euphemism – that the story was, in fact, about actual swans. Jacobs disputes this belief, writing, "the whole story as a *story* depends on the seizure of a separate dress involving the capture of the swan bride."[217] The feathered dress is the tale's critical element.

Several well-known fairy tales center on swans, clothing, and metamorphosis. The Grimm Brothers' tale "The Six Swans" tells of a king's marriage to a wicked woman from whom he conceals the existence of his seven children (six boys and one girl) from a previous marriage. When the queen discovers her six stepsons, she throws an enchanted white shirt over each of their bodies, turning them into swans. The evil queen does not realize she also has a stepdaughter, and the girl spends years working on six shirts, painstakingly made from starflowers,

Illustration for "The Six Swans" by Anne Anderson, early 20th century

which she eventually uses to reverse her brothers' metamorphoses. In one of the few studies of dress in fairy tales, the children's literature scholar Carole Scott notes that the use of fabric made from starflowers is entirely metaphorical, and that it adds a "celestial aspect" to the sister's task.[218] Overall, Scott designates "The Six Swans" to be "the most complex tale involving the painstaking fabrication of clothes to effect the reclamation of a young man from his animal covering."[219]

Hans Christian Andersen also wrote a story about a young maiden and her brothers. Entitled "The Wild Swans," it bears many similarities to "The Six Swans." In this story, too, a king has many children (this time, eleven sons and one daughter), and is remarried to a cruel woman. This queen, however, is aware of these children and is unkind to them. She sends the girl, Elisa, to be raised by peasants in the countryside. She later manages to turn the king against his sons, transforms them into swans, and banishes them from the palace. Many years later, Elisa locates her brothers and vows to end their enchantment. In order to do so, she must make yarn from stinging nettles, and then weave the yarn into eleven long-sleeved shirts (sometimes described as "coats of mail") for her brothers. As in "The Six Swans," Elisa labors over her arduous task and eventually restores her brothers to (mostly) human form. (In both "The Six Swans" and "The Wild Swans," the final shirt is complete but for one sleeve, meaning that the youngest brother's arm remains a wing.)

The storyline of a stolen garment and its owner's resulting transformation is not exclusive to swan tales. There is, in fact, a similar tale in mermaid lore. These sea beings are sometimes said to have a cap (usually red), veil (one is mentioned briefly in Andersen's "The Little Mermaid"[220]), or shawl that is essential to their existence as mermaids. If a mermaid is caught and her magical garment is taken from her, she will take human form. Similar to the Swan Maiden, she is usually obliged to live as a wife and mother. Also like her feathered counterpart, the mermaid spends her time searching for the lost garment, hoping to resume her life at sea.[221] Unlike the mermaid, the Swan Maiden's metamorphosis is uncomplicated – there is no awkward, painful transition from fish tail to human legs. As Jacobs noted, the way that the maidens are described indicates that they have human bodies. It is their magical, feathery robes that bestow them with the attributes of a swan. The Swan Maiden fits seamlessly into the human world, and bears human children, but she longs for the freedom of her previous life. In *A Dictionary of Literary Symbols*, Michael Ferber writes, "As swans are migratory,

163 The Swan Maidens

and are frequently seen alone, they can be imagined as exiles from their homelands,"[222] a notion that also relates to the Swan Maiden's plight.

Like many animals, swans are laden with symbolism. Jack Tresidder describes the swan as "a romantic and ambiguous symbol of light, death, transformation, poetry, beauty, and melancholy passion," noting the swan has been particularly prominent in western literature, music, and ballet.[223] Its association with metamorphosis can be traced to classical mythology, in which Zeus disguises himself as a swan in order to seduce Leda. Part of the appeal of the swan is, of course, its physical grace – the bird's long, curving neck, gliding gracefully across the water, is undeniably romantic. Beyond literature, music, and ballet, the swan has inspired the visual arts, including fine art and fashion. Mikhail Vrubel's 1900 painting *The Swan Princess*, in the collection of the State Tretyakov Gallery in Moscow, Russia, shows a lovely, doe-eyed maiden glancing over her shoulder, her gaze meeting that of the viewer directly. Her white swan's gown is complete with large wings that curve out beside her, but she also has human limbs. She lifts one hand to reveal fingers adorned with large, jeweled wings. She also wears a sheer veil, trimmed with elaborate silver embellishments, and an ornate crown in gold, silver, and jewels over her dark hair. Tales of swan maidens are particularly prevalent in Russian folklore, and Vrubel's captivating work highlights their allure.

Swans have been represented in fashion in myriad ways. The simple shape of a 1960s Valentino dress acts as a canvas for a bold motif of white swans on a black ground, for example. The fabric is reversed on the sleeves, revealing black swans on a white ground. While Valentino's use of the swan motif is literal, Charles James's *Swan* dress is named not for its motifs, but for its silhouette. This design is one of the couturier's greatest masterpieces, and has been the object of careful study by fashion historians. The intricate, sculptural dress is made from thirty-nine different pattern pieces.[224] Its remarkably full skirt comprises alternating layers of nylon and silk that gather in fullness and fan out at the back hem, like the extended wings of a bird. Although James crafted this gown in multiple color-ways, an example of the *Swan* from the collection of The Museum at FIT is made from black chiffon over white satin, once again evoking imagery of both black and white swans.

The black swan is most often associated with the ballet *Swan Lake*, composed by Pyotr Ilyich Tchaikovsky in 1875. *Swan Lake* is an original story, but one based on elements of swan folk tales, and it is often regarded as a "fairy

Valentino Boutique
Dress in black-and-white double-faced cotton, ca. 1966
The Museum at FIT, 74.117.70

tale" ballet. It tells the story of Odette, a princess who is transformed into a swan by an evil sorcerer. Odette is the White Swan, while the sorcerer's wicked daughter, Odile, is known today as the Black Swan. It was not until an American production of the ballet in 1941 that Odile was costumed in black, however, and thus earned her current title. Prior to that time, Odile dressed in various colors, including "Aurora Borealis" hues, reds, golds, and greens. Odile's newfound identity as the Black Swan would also come to inspire fashion designers – Christian Dior designed a stunning evening gown that he titled *Black Swan* for his Fall 1949 collection.[225]

Undercover's Spring 2015 collection included multiple ensembles with tutu-style skirts and swan motifs printed onto fabrics, but it was a combination of these ideas that resulted in some of the most enchanting garments. One ensemble, now in The Museum at FIT's collection, is extraordinarily detailed. It consists of a feather-printed mini skirt worn with a beaded and fringed hem, worn beneath a stiff "pancake"-style tutu. The tutu is made from layers of silk net, hand-painted in shades of blue, white, and black to resemble plumage. A top in beige leather is styled over the torso like a classic motorcycle jacket, but its three-quarter-length sleeves are fashioned from laser-cut, blue-and-white silk "feathers" atop sheer black chiffon. At once romantic and edgy, this is an ensemble fit for a twenty-first-century swan maiden.

Swans were an even greater focal point in Giles Deacon's Spring 2012 collection. Debuting less than a year after the release of Darren Aronofsky's ballet film *Black Swan*, Deacon was quick to point out that his collection had a wholly different point of reference: a breathtaking automaton of a silver swan from 1774, now in the collection of The Bowes Museum in northern England. Deacon was inspired further by Cecil Beaton's photographs of "society swans," including the 1925 portrait of Beaton's sister, Baba, seated against a metallic silver backdrop and wearing a dress to match. The photograph is aptly titled *Symphony in Silver*, and this artwork was, in turn, related to Andy Warhol's *Silver Clouds*.[226] The first ensemble to grace Deacon's runway presentation was a crisp white pantsuit, worn with a white, feathered mask and a formidable headdress in the shape of a swan. Other garments were made from fabrics printed with swans or woven with shimmering silver feather motifs. One outstanding evening dress featured a sheer bodice, embellished with the figure of a swan that wrapped elegantly around the torso. A voluminous skirt in sheer, pale lavender fabric was worn over a short satin skirt, and ended in a wide hem of matching

Charles James
Swan evening dress in black chiffon and white satin, 1954–55
The Museum at FIT, 91.241.136

167 The Swan Maidens

feathers. More feathers, this time dyed red, were attached at the neckline. Kadia Blagrove wrote that the collection "interpreted the essence of the swan," which she described as "beautiful yet savage."[227] The Swan Maiden is beloved for her beauty and her spirit, but she is not a kind heroine – and her willingness to abandon her children may be unfathomable to many readers. Like so many fairy tale characters, she is simultaneously difficult and beguiling.

(facing) Undercover (Jun Takahashi)
Spring 2015 ensemble
The Museum at FIT, 2015.38.1

(left) Giles
Spring 2012, look 41
Courtesy Giles

Alice's Adventures in Wonderland

(Based on the tale by Lewis Carroll)

One hot Summer's day, seven-year-old Alice is sitting by a riverbank when she sees a white rabbit rush past her. Muttering to himself that he will be late, he checks a pocket watch that he has tucked into his waistcoat. It is the rabbit's clothing, specifically, that catches Alice's eye, and she follows the creature into his rabbit hole. She falls a very great depth and lands in long hallway lined with locked doors. Alice notices a glass table with a tiny gold key, which unlocks a small door. There is a beautiful garden beyond the doorway, but she is too large to get through. Alice drinks the liquid in a bottle marked "DRINK ME," which shrinks her, but realizes she has become too small to reach the key, which she has left on the table. The girl then notices a cake marked "EAT ME," which makes her grow. This time, she becomes larger even than her normal size. She begins to cry, and ends up shrinking herself again using a small fan left behind by the rabbit. Her own sea of tears eventually carries her away down the hallway. While she treads water, Alice meets a mouse, and he accompanies her to shore. A number of other animals are there as well, but Alice accidentally frightens them away by telling stories about her cat.

Alice sees the White Rabbit again. He mistakes her for his servant and asks her to retrieve some gloves and a fan from his house. While Alice is there, she drinks an unmarked bottle of liquid that again makes her grow, this time to the size of the room. When the rabbit returns to his home and sees her, he and his servants try to get Alice out of the house, but she swats them away. They begin

The Queen of Hearts with Alice, by Sir John Tenniel, 1865

to throw pebbles at her, which turn into little cakes when they reach the floor. Alice eats one of the cakes, which shrinks her, and she runs out of the door.

Alice comes across a large, hookah-smoking caterpillar, who bewilders her with questions about her identity. Before he crawls away, the caterpillar tells her that different parts of the mushroom he is sitting on will allow her to grow or shrink. She nibbles on a bit of one part, which makes her neck grow very long. She then tries another part, and shrinks back to her normal height.

Alice next finds the Duchess's house. Inside the house is a grinning Cheshire Cat, a cook making soup, and the Duchess nursing a howling baby. The Duchess is rather rude to Alice before leaving to play croquet with the Queen. She hands over her baby to the girl, who discovers the infant has turned into a pig. Alice releases the pig into the forest.

Outside, Alice meets the Cheshire Cat again, and asks him which way she should go. He tells her that she will find a Hatter in one direction, a March Hare in another, and that both are mad. He then says that everyone in Wonderland is mad, including her, before fading to nothing but a smile.

Alice proceeds to the March Hare's house, and finds him having tea with the Hatter and a Dormouse. They do not invite Alice to join them, but rather engage in an insulting, puzzling conversation with her. Alice leaves them and continues on in the forest, finding a tree with a door in its side. Going through the door, she ends up back in the long hallway where her journey began. This time, she remembers to take the key from the table, eats a bit of leftover mushroom to decrease her size, and makes it through the door to the garden.

Alice meets three playing cards working as gardeners, hastily painting a bush of white roses red. They are fearful of the Queen of Hearts, who has a terrible temper and expects red roses only. After saving the gardeners from the Queen's wrath, Alice joins a game of croquet, played with live flamingos as mallets and hedgehogs as balls.

The Duchess approaches Alice, and this time attempts to befriend the girl before being chased off by the Queen. Realizing that Alice has not met the Mock Turtle, the Queen summons a Gryphon to take her to him. Alice listens to the Mock Turtle talk about his life, and then she tells her new companions about her adventures in Wonderland. They hear an announcement that a trial is about to begin, and the Gryphon takes Alice back to the croquet field.

The Knave of Hearts is being prosecuted for stealing the Queen's tarts. The testimony against him, including that of the Hatter and the Duchess's cook, is

nonsensical. Meanwhile, Alice feels herself growing larger as the trial goes on. She is called to the stand, and the White Rabbit, acting as a herald, submits new evidence. It is a set of verses written by the Knave, which is interpreted wrongly by the King to be an admission of guilt. When Alice proclaims the King's explanation of the text to be nonsense, the enraged Queen orders the girl's beheading. By this time, Alice has grown very large, and upends the Queen's army of playing cards. She then awakens quite suddenly and finds her head in her sister's lap. Alice tells her sister about her curious dream before going inside for tea.

Fashioning *Alice's Adventures in Wonderland*

Alice's Adventures in Wonderland has never been out of print since its first publication in 1865. The story celebrated its 150th anniversary in 2015 to great fanfare, with museum exhibitions, innumerable news articles, and new editions of the book translated into Egyptian hieroglyphs, Cockney rhyming slang, and the Afghan languages Dari and Pashto – to name only a few.[228] In the midst of this widespread interest in all things *Alice* was a discussion of its protagonist's enduring role as a style icon. Kiera Vaclavik, whose essay "Of Bands, Bows and Brows: Hair, the *Alice* Books and the Emergence of a Style Icon" is included in this book, was the curator of an exhibition at the Victoria and Albert Museum of Childhood in London entitled *The Alice Look*. This wonderful show traced how Alice has been admired and interpreted across time and cultures, and how her image has appeared in everything from shoe advertisements to Japanese anime. Vaclavik observes that Alice has become "something of a blank canvas, able to absorb a huge range and combination of emphases and directions. Although a much more fixed sense of her image has emerged than in the nineteenth century, she continues to multiply in a constant stream of new editions and interpretations."[229]

In the opening paragraph of *Alice's Adventures in Wonderland*, the girl famously asks, "[w]hat is the use of a book without pictures or conversations?"[230] Alice's story was to have plenty of both. The 1972 book *The Illustrators of Alice in Wonderland* noted that more than a hundred artists had tried their hand at depicting

Illustration of Alice by Sir John Tenniel (1890), from *The Nursery Alice*

Alice – a number that is doubtless much larger today.[231] Alice is usually portrayed as a young girl (she is only seven years old in the story, after all), but her look is never static – she had a fashionable bob in the 1920s, for example, and a Marcel wave early in the 1930s. There have also been numerous film versions of the story, including a 1903 production directed by Cecil Hepworth and Percy Stowe, and Jan Švankmajer's fascinating, although disturbing, adaptation from 1988. Of these countless portrayals of Alice, however, John Tenniel's forty-two original illustrations for the book remain the most closely associated with the story. Many of these iconic images were based on Lewis Carroll's own preliminary drawings for the tale, and the author was exceptionally particular – not only in regard to how Tenniel's final illustrations looked, but also to how they were placed on the book's pages. Carolyn Vega, the curator of the exhibition *Alice: 150 Years of Wonderland* at the Morgan Library and Museum in 2015, wrote, "the overall design of the book – the way in which the witty and inventive text interacts with Tenniel's beautiful drawings – influenced the book's brilliant and lasting success."[232] After the book's first printing, the British newspaper the *Guardian* reported that while Carroll's tale was highly enjoyable, Tenniel's illustrations were even better.[233]

The original *Alice* illustrations are so unmistakable – and so beloved by readers – that they have occasionally become a part of fashion themselves. The Museum at FIT has two examples of this: a 1946 scarf by Brooke Cadwallader that featured excerpts from *Alice* and several of Tenniel's illustrations, and a man's waistcoat by Audrey Buckner from Fall 1992, made from a silk jacquard woven with images of Tenniel's Alice, the White Rabbit, the Hatter, and the Queen of Hearts.

Although Carroll's sample sketches for *Alice's Adventures in Wonderland* reveal a distinct vision for Alice's appearance – including her dress – she is described little in the tale. That is what makes Tenniel's work, as approved by Carroll, so important. Vaclavik writes that Tenniel's Alice was "shown consistently as a smartly but not too fussily dressed Victorian child,"[234] but also notes that Tenniel himself made changes to Alice's clothing to keep up with fashion. By the time the story's sequel, *Through the Looking-Glass*, was published in 1871, Alice wore a

Audrey Buckner
"Go Ask Alice" waistcoat in black silk jacquard, Fall 1992
The Museum at FIT, 93.62.1

new style of dress with a narrower skirt, as well as her soon-to-be signature hairband and striped stockings.

It was not until 1874 that Alice and her companions were shown in color. These illustrations, made for the cover of a book of piano music, gave her a red dress with a white pinafore. Better-known color illustrations of Alice originate from *The Nursery Alice*, an abridged version of the story from 1890, intended for young children. In these images, also by Tenniel, she wears a yellow dress under a white pinafore. The pinafore is trimmed in blue, matching her stockings and the hair bow that pulls back her long, loosely waved blonde hair. In 1899, Tenniel drew Alice wearing a blue dress that is much like the one she is most closely associated with today. This garment can be seen in a satirical illustration titled *Alice in Bumbleland*, which Tenniel drew for *Punch* magazine (the publication for which he was a leading cartoonist for five decades).

The archetype of a blonde Alice in a blue dress and white pinafore was firmly established by Disney in its 1951 animation of the story. Yet since Alice had already undergone numerous transformations – many of which strayed entirely from Tenniel's illustrations – Disney's *Alice* can in fact be viewed as somewhat of a return to the original illustrator's work. The company based its color choices and costumes for the movie on drawings by Mary Blair, whose own drawings took inspiration from Tenniel. Alice's dress, fitted tightly at the waist with a full skirt, was suited to Christian Dior's 1950s "New Look" silhouette. Alice was, yet again, keeping up with fashion.[235]

Alice's role as a style icon is somewhat ironic, since her appearance was intentionally nondescript.[236] Although fashionable, her clothing was otherwise unremarkable. Tenniel may have chosen to alter her look over time so that children could easily identify with her character, rather than be distracted (or even amused) by her out-of-date apparel. Another noteworthy paradox of Alice's status as a fashion arbiter is that although she is a young girl, she has inspired countless women's fashion editorials and clothing. The Argentinian photographer Martin Lucesole shot a charming feature for *La Nación* magazine that showed "Alice" posing with a white rabbit in a variety of youthful, white ensembles (often looking pale blue as a result of the lighting; see page 24 above), her signature headband represented by a large bow made of hair. A 2003 feature for *Vogue*, organized by the inimitable fashion editor Grace Coddington and photographed by Annie Leibovitz, featured the fresh-faced model Natalia Vodianova (then twenty-one years old) as Alice. "Lewis Carroll described her as an innocent in

174 Fairy Tale Fashion

satin and ribbons. Disney made her flaxen-haired and saucer-eyed. In the pages of *Vogue* the land of merry unbirthdays and late-running rabbits shine to life again – as the world's most influential designers dress the original little lost girl in their own visions,"[237] writes Hamish Bowles. Vodianova wore a variety of gowns in shades of blue by designers that included John Galliano (for Dior), Jean Paul Gaultier, and Marc Jacobs. Many of the designers themselves were also styled and photographed as characters from the book – Galliano, Gaultier, and Jacobs played the Queen of Hearts, the Cheshire Cat, and the Caterpillar, respectively. Only one of the dresses featured in the editorial, created by Nicolas Ghesquiere for Balenciaga, included a white pinafore (unfortunately, none of these images was available for reproduction in this book).

Since Alice's dress is purposefully nondescript, many "Alice" dresses lose their connotation outside of Wonderland-inspired settings. For this reason, I looked for clothing that might make a different connection to Alice and her story, using some of the many visual motifs that occur throughout the tale. As Vaclavik writes, there is an "unmistakable 'Wonderland aesthetic' (think rabbits, playing cards, teacups, pocket watches)"[238] that can be observed not only in imagery that has been inspired by the story, but in clothing design itself. Among the myriad fairy tale references in Dolce and Gabbana's Fall 2014 collection, for example, there were a number of garments that featured ornate motifs of flowers and golden keys. One such dress, in a shade of dark greenish-blue, was reminiscent of Alice's first adventures in Wonderland, when she resolutely endeavors to access the beautiful garden with a small, golden key.

Alice's story was referenced by a number of high-fashion designers in 2010, coinciding with the release of Tim Burton's live-action version of *Alice in Wonderland* for Disney. The Parisian department store Printemps celebrated the occasion by asking several prestigious designers to create garments inspired by the story. The results were featured in elaborate displays in the store's windows. They included pieces from Christopher Kane, Maison Martin Margiela, Alexander McQueen, and several others. One of the most distinctive designs was by Manish Arora, whose structured, bright blue mini-dress, later remade for The Museum at FIT collection, features playing-card-printed sleeves crafted into sculptural, starburst shapes. Individual "playing cards" in various sizes are scattered over the bodice, attached to springs that allow them to quiver playfully, bringing to mind Alice's upending of the Queen of Heart's playing-card army. In the Printemps display, this design was styled with black-and-white checkered

Dolce and Gabbana
Fall 2014, look 23
Courtesy Dolce and Gabbana

stockings, a long white wig, and a white rabbit's mask, but even without these accoutrements, the connection between the dress and the story is evident.

Nicholas Kirkwood also created a design for the Printemps display. His charming Alice shoes are sling-back stilettos that combine myriad motifs from the story, including vibrant, red silk roses, a metal key, a pocket watch, and a tiny porcelain tea set. The heels themselves are black-and-white checkered – a frequently seen Alice feature that originates from Tenniel's depiction of the Mad Hatter's suit, as well as from the game of chess. Kirkwood has designed the shoes so that the left and right are distinctly different, and this lack of uniformity is well suited to a story that was intentionally fanciful and nonsensical.

Alice is the story's protagonist, of course, but each of the many characters in Wonderland is fascinating in both nature and appearance. I have always enjoyed that, in the very beginning of the story, Alice is not much alarmed by the fact that the White Rabbit can speak, but rather by his clothing and jewelry:

> Alice [did not] think it was so *very* much out of the way to hear the Rabbit say to itself 'Oh dear! Oh dear! I shall be too late!' (when she thought it over afterwards it occurred to her that she ought to have wondered at this, but at the time it all seemed quite natural); but when the Rabbit actually *took a watch out of its waistcoat-pocket*, and looked at it, and then hurried on, Alice started to her feet.[239]

It is no wonder that Alice noticed the Rabbit's attire, if he looked as Tenniel depicted him. He is dressed immaculately in a solid-colored waistcoat, checkered coat, standing collar, and what appears to be a tartan ascot, and he carries a tightly rolled umbrella under his arm. He further confirms his dandyism by dropping a pair of white kid gloves and a fan. When the White Rabbit makes his appearance as a herald in the court of the King and Queen of Hearts, he abandons his suit for a heart-printed tunic with a ruff at the neck.

The White Rabbit is second in importance only to Alice in this story – after all, without having noticed him, she never would have made her way into Wonderland. The Rabbit is also the subject of two of the best-known *Alice*-related expressions: "down the

(facing) Manish Arora
"Alice in Wonderland" dress
The Museum at FIT, 2015.10.1

(below) Nicholas Kirkwood
Alice shoes, 2011
Courtesy Nicholas Kirkwood

rabbit hole" and "follow the white rabbit," both of which imply journeying into the unknown. The latter phrase was a title of a dapper menswear collection presented in 2014 by the Romanian designer Florin Dobre, but the white rabbit has also made its way into women's clothing. A nineteen-year-old Candice Bergen famously wore a "white rabbit" ensemble to Truman Capote's legendary Black-and-White Ball in 1966. This consisted of a furry white mask with tall, pert rabbit ears, and a black velvet dress with white mink trim to match. The outfit was made specially for the young actress by Halston, and is currently in the collection of The Museum of the City of New York. More recently, Undercover's Fall 2013 runway presentation included several models wearing white rabbit masks. Some of these masks were paired with slightly off-kilter, menswear-inspired styles, such as a double-breasted tuxedo jacket fashioned into a mini-dress, complete with layered satin lapels.

The White Rabbit's pocket watch is his most important accessory (he frequently checks it and frets that he will be late to his appointment with the Queen of Hearts), and it has also become one of the most important elements of Wonderland iconography. When The Museum at FIT acquired a 1980s "pouf" evening dress by Louis Féraud that featured a large appliqué of a watch attached to a gold chain, I was reminded instantly of *Alice*. The dress also features a black-and-white checkerboard motif over the left breast, a detail that is reminiscent of another important Wonderland fashion arbiter – the Mad Hatter.

Tenniel's illustrations of the Hatter (as he is referred to in Carroll's text) are among his most amusing. The Hatter is rather small in stature, but he has a large head that is emphasized by an equally oversize top hat. Tucked inside the hat's band is a sign that reads "In this style 10/6." This indicates that he is wearing one of his own samples, available at the price of ten shillings and six pence. The Hatter's style of dress is natty but slightly eccentric, and includes a three-piece suit consisting of a plain jacket and a waistcoat and trousers in oversize checks. His ensemble is completed by striped socks and a bow tie with large polka dots. In one

The White Rabbit by Sir John Tenniel, 1865

image, he is shown stepping out of his lace-front shoes. Since the *Alice* illustrations were not originally printed in color, black-and-white checked fabric is often used to represent the Hatter (his suit was later depicted in colored illustrations in various vibrant hues).

The Hatter's behavior in Carroll's text is obviously erratic – but that can be said of most of the book's characters. Much has been made of his particular strangeness, however, especially in relation to his profession. Nineteenth-century hat makers faced significant health risks, due to the chemicals used on the animal furs used to make felt hats. "Quite apart from the damage to the lungs, constant inhaling of the mercuric acid fumes affected the brain," explains Colin McDowell. "The expression 'mad as a hatter' had a sound basis. Paralysis and loss of memory were followed by mental derangement and eventual death. Although the results were tragic, it was customary in the nineteenth century to make fun of those suffering from the disease."[240]

In spite of what seems to be an unfortunate affliction, the Mad Hatter was, and continues to be, a beloved *Alice* character, and one consistently referenced in fashion. Vivienne Westwood's Fall 2011 Red Label collection was inspired by the *Alice* stories, and included a number of oversize hats paired with colorful, artfully layered clothes. In her review of the show, the fashion writer Ella Alexander noted, "Westwood's models looked as if they would each sit happily at the Madhatter's tea party."[241] More recently, Westwood designed a cover for a 150th-anniversary edition of *Alice's Adventures in Wonderland*, and wrote an introduction.

For his Spring 2013 menswear collection, Walter Van Beirendonck collaborated with the Amsterdam-based artist Folker de Jong to create a series of painted foam top hats with a distinctly "Mad Hatter" appeal. One hat was styled with an un-

Undercover (Jun Takahashi)
Fall 2013, look 14
Courtesy Undercover

conventional take on the traditional suit, combining a colorful waistcoat and a striped bow tie with a loose over-jacket in lightweight white fabric. These pieces were paired with crisp black shorts that ended just above the knee, revealing black-and-white socks held up by garters. The ensemble was both quirky and classic in a way that seems suited to a contemporary "Mad Hatter" figure. Writing about the designer for a 2011 retrospective of his work, the fashion curator Kaat Debo wrote,

> Van Beirendonck is first and foremost a hopeless romantic. If we leave his interest in technology aside for the moment, we can say that he is a twentieth-century variation of the nineteenth-century romantic, with the same fascination for impossible loves and a predilection for the beauty of nature, fairy tales and their dark undertones, emotions, intuition, fantasy and the power of imagination.[242]

Also of sartorial note is the foul-tempered, but decidedly well-attired, Queen of Hearts. She is associated, unsurprisingly, with the color red, hence the playing-card-gardeners who scramble to paint the offending white roses crimson. Red was a color that Carroll seemed to be fond of, or at least one that he thought children would be attracted to (the first edition of *Alice's Adventures in Wonderland* was bound in bright red cloth at Carroll's request).[243] The Queen's ensemble as depicted by Tenniel consists of a headdress, a long dress with a layering of patterns, and a heart-shaped fan. Intriguingly, several *Alice* scholars have noted that the Queen of Hearts's dress is patterned like that worn traditionally by the Queen of Spades – a card that carries associations with death.[244] This is perhaps a reference to the Queen's predilection for ordering the beheading of so many Wonderland residents.

The Queen of Hearts is formidable and idiosyncratic, and her appearance must live up to her demeanor. *Heart*, an experimental work created by the Paris-based artist and designer Hideki Seo in

(facing) Louis Féraud
Evening dress in gold brocade with embellishment and appliqué, ca. 1989
The Museum at FIT, 2014.63.6

(below left) The Hatter by Sir John Tenniel, 1865

(below right) Walter Van Beirendonck
Spring 2013, look 15
Courtesy Walter Van Beirendonck

183 Alice's Adventures in Wonderland

2014, is made from fabric that is digitally printed in a colorful, intricate pattern reminiscent of that used on playing cards. The fabric is then sculpted and padded into fixed, three-dimensional shapes that take the form of a gown. This dress-as-sculpture – for which Seo also fashioned a custom mannequin – is topped with an immense, heart-shaped headdress. In a meeting with the designer, he described his career path as a personal "fairy tale," having decided to pursue what he feels is his calling – the crafting of pieces that combine art and fashion – during a coming-of-age trip to Tibet.[245]

(facing) Hideki Seo
Heart, 2014
Courtesy Hideki Seo

(left) The Queen of Hearts and Alice, by Sir John Tenniel, 1865

"You ought to be ashamed of yourself!"

The Wonderful Wizard of Oz
(Based on the story by L. Frank Baum)

Dorothy lives on the Kansas prairie with her Aunt Em and Uncle Henry, a farmer. When they see a tornado heading toward them, Uncle Henry sets off to tend to his livestock, while Dorothy and Aunt Em run for the cellar. Before she can close the cellar door, Dorothy's dog, Toto, leaps from her arms, and she must go and retrieve him. Dorothy feels her house being lifted into the cyclone by the winds, with her inside. The house continues gently to sway in the tornado for hours, and Dorothy eventually crawls over to her bed and falls asleep.

Dorothy awakens when the house lands. She steps outside and is greeted by a group of small, oddly dressed people who welcome her to Munchkinland. They show the girl that her house has landed on the Wicked Witch of the East, killing her, for which the Munchkins are grateful. All that is visible is a pair of feet in silver shoes with pointed toes. The feet quickly shrivel in the sun, but the shoes are left behind, and they are given to Dorothy by the Munchkins.

The Good Witch of the North also comes to greet Dorothy, and the girl asks her the way back to Kansas. She is told that she should head toward the City of Emeralds by following a yellow brick path. The city is ruled by the Great Wizard of Oz, who will be able to assist Dorothy.

Dorothy goes back into her house to prepare for her journey. She has a snack and a drink of water, and changes into a clean dress of blue-and-white gingham. Noticing how old and worn her shoes are, she changes into the silver shoes. She sets out on her way, and in time encounters a scarecrow. They strike up a friend-

Illustration for *The Wonderful Wizard of Oz* by W. W. Denslow, 1900
Everett Historical / Shutterstock.com

ship, and when the Scarecrow laments that he has no brain, Dorothy suggests he journey to Oz with her to ask the Wizard for help.

As they continue on the yellow brick road, Dorothy, Toto, and the Scarecrow hear a strange groaning noise. They discover that it is coming from the immobile figure of a man made from tin. He has rusted, and needs oil to function again, which Dorothy and the Scarecrow help him to apply. Once he can speak and move, the Tin Woodman explains his desire for a heart, and joins the others on the path to Oz. The travelers soon come across their final companion, a Cowardly Lion, who seeks courage.

After many setbacks and adventures, the group reaches the Emerald City, which glows green even from a distance. When they arrive at the city gates, they are given special glasses to protect their eyes from the city's brilliant green glare. Dorothy is taken to see the Wizard of Oz, who appears to her as a large, floating head above a throne. He asks her where she got her silver shoes, and upon learning that she has inadvertently killed the Wicked Witch of the East, he commands her to also kill the Wicked Witch of the West. If she does so, he will tell her how to get back to Kansas. Each of Dorothy's companions then makes his request. Oz changes form for each new visitor, but he makes the same demand of them all: they must kill the Wicked Witch before they can receive what they desire.

Dorothy, Toto, the Scarecrow, the Tin Woodman, and the Cowardly Lion head west, to the land ruled by the Wicked Witch. She sends wolves, crows, bees, and several Winkies (a group of Oz inhabitants enslaved by the Witch) after them, but Dorothy and her friends manage to defeat all of these opponents. The Witch must finally turn to another powerful object, a magic gold cap, to summon the winged monkeys. The monkeys disfigure the Scarecrow and the Tin Woodman, and tie up the Lion. They carry Dorothy back to the Witch's castle.

The Witch is terrified to see that Dorothy wears the silver slippers, but she realizes quickly that the girl has no notion of their power. She cannot harm the girl, as the good witch marked and protected Dorothy with a kiss before sending her off on her journey. Instead, she puts Dorothy to work sweeping, cleaning pots and kettles, and tending to the fire. The Witch later trips Dorothy, making one of the girl's shoes fall off. She quickly snatches it up, and Dorothy is so angry over the stolen shoe that she picks up a pail of water and throws it on the witch, which melts the villainess.

Dorothy rescues her friends, and they soon plan to head back to see the Wizard of Oz. Before they go, Dorothy grabs the witch's pretty gold cap and puts it in

her basket. When they realize it is a very long journey back to Oz, they ask some fieldmice for help, who tell the travelers of the golden cap's power. Dorothy calls for the monkeys using the hat, and the group is carried to the Emerald City in the monkeys' arms.

When the Wizard agrees to see the group, it is revealed that he is not a wizard at all, but a ventriloquist who worked for the circus in Omaha. He was carried away to the Emerald City in a hot air balloon, and has been pretending to be a wizard ever since. Explaining that, despite his deception, he is actually a good man, he gives the Scarecrow a brain made from bran, pins, and needles (offering proof that he is "sharp"), the Tin Woodman a heart made from silk stuffed with sawdust, and the lion a drink intended to give him courage.

The Wizard tells Dorothy that he can take her home to Kansas in a hot air balloon. As they prepare to leave, Toto chases after a kitten in the crowd. When Dorothy runs after him, the balloon floats away without her. A soldier of Oz suggests that Dorothy take a trip to see the Good Witch of the South, named Glinda, who may be able to help her get home. Dorothy's friends accompany her, and after several more adventures, they arrive at their destination with the help of the monkeys. In exchange for the golden cap, the Witch explains that Dorothy can use the silver shoes to carry her anywhere, if she knocks her heels together three times. Dorothy does so, and she flies back to Kansas. She loses her silver shoes on the way.

Fashioning *The Wonderful Wizard of Oz*

> Every healthy youngster has a wholesome and instinctive love for stories fantastic, marvelous and manifestly unreal [...] Yet the old-time fairy tale, having served for generations, may now be classed as "historical" in the children's library; for the time has come for a series of newer "wonder tales" in which the stereotyped genie, dwarf and fairy are eliminated.[246]

L. Frank Baum wrote these words in his introduction to *The Wonderful Wizard of Oz*, first published in 1900 – and a story that unquestionably breathed new life into the fairy tale genre. Like *Alice's Adventures in Wonderland*, it was written as a novelette, rather than a typical fairy tale, and its plot has been condensed greatly in the summary above.

In spite of the story's length and originality, however, Baum infused it with several hallmarks of classic fairy tales. There are magical shoes, of course, but

also consistent references to the number three. Dorothy encounters three companions in the woods, and she must click her heels three times to get back to Kansas. Also, the punishment that the girl must endure from the Wicked Witch is distinctly Cinderella-like: "Dorothy followed [the Wicked Witch] through many of the beautiful rooms in her castle until they came into the kitchen," Baum writes, "where the Witch bade her clean the pots and kettles and sweep the floor and keep the fire fed with wood."[247]

Although many of us read *The Wonderful Wizard of Oz* as children, we may have little recollection of the differences between the original text and the movie version, released in 1939 by Metro-Goldwyn-Mayer. In many ways, the movie has supplanted the novella, and its imagery is more ubiquitous than the book's original illustrations by William Wallace Denslow. We hardly ever picture Dorothy wearing sparkly silver shoes in favor of the now more familiar red ones, and the golden cap is completely eliminated from the on-screen version of the tale.

What might be surprising about rereading the original text of *The Wizard of Oz* is the underlying preoccupation with clothing and accessories throughout the story. This begins with the description of the Wicked Witch of the East's shoes, which are silver with pointed toes, and continues with Dorothy's selection of a dress to wear on her journey to Oz. Denslow's illustrations depict Dorothy first in a plain dress with a ruffled collar and yoke, knitted stockings, and flat-heeled, ankle-length boots. She is still wearing this outfit when she arrives in Munchkinland, but feels she must freshen up before embarking on the yellow brick road. Baum writes, "Dorothy had only one other dress, but that happened to be clean and was hanging on a peg beside her bed. It was gingham, and with checks of white and blue; and although the blue was somewhat faded with many washings, it was still a pretty frock. The girl washed herself carefully, dressed herself in the clean gingham, and tied her pink sunbonnet on her head."[248] After changing into her other dress, Dorothy looks down at her feet and notes with dissatisfaction that her shoes are old and worn. Spotting the silver shoes that had belonged to the Wicked Witch of the East, she decides to try them on, finding that they fit her perfectly. Denslow then shows Dorothy's dress to be made from gingham, and portrays her in her light-colored shoes with pointed, upturned toes and a bow at the ankle.

Dorothy's ruby slippers have become emblematic of the film version of the story, *The Wizard of Oz*, but her gingham dress is a close second. Gilbert Adrian, one of the most prolific Hollywood costume designers of his era, created

189 The Wonderful Wizard of Oz

most of the movie's costumes, including Dorothy's dress and shoes. Adrian was born in 1903, and *The Wizard of Oz* was purportedly one of his favorite books as a child.[249] When he learned that he was to design costumes for the film, he referred to a collection of drawings of the story's characters that he had made as a boy, and reacquainted himself with the text for further inspiration.[250] The blue-and-white gingham fabric was a small but important detail in the story that Adrian undoubtedly revived. A rich Munchkin named Boq tells Dorothy that blue and white are symbolic colors, with blue being the color of the Munchkins, and white being the color of good witches.[251]

The choice to dress Dorothy in blue-and-white gingham was obviously based on Baum's writing, but Adrian's decision to remain true to this detail – not always a given in Hollywood costume design – must surely relate to the fabric's connotations and its use in several other of his designs as well. According to Howard Gutner, the author of the book *Gowns by Adrian*, "The gingham was a touch of Americana that Adrian had found on a trip through Appalachia in 1938."[252] The designer used some of this fabric to dress Judy Garland as Dorothy, and also used it to make a gown for Katharine Hepburn's character, Tracy Lord, in the 1940 film *The Philadelphia Story*.

Early in the 1940s, Adrian shifted his focus away from Hollywood to design a line of high-end ready-to-wear and custom-made clothing. A dress from the collection of The Museum at FIT, dating to circa 1942, exemplifies that the designer continued to be interested in gingham, this time using it to make high fashion garments. As Patricia Mears observes, "The use of 'humble' materials like cotton gingham became very popular during World War II, as Gilbert Adrian made hostess gowns out of this crisp, simple plaid [... it was] especially emblematic of American nostalgia."[253] Mears also refers to an advertisement for Adrian's World War II-era gowns, in which models wearing red, white, and blue gingham dresses "are seated in and around rocking chairs made from what appear to be wagon wheels, the kind that carried settlers in the nineteenth century across the continent."[254] Gingham – often in shades of blue and white – continues to appeal to designers, evidenced by its use in numerous 2015 fashion collections. This fabric may still recall Dorothy's wardrobe, but it is used in a distinctly contemporary way. Altuzarra

Altuzarra
Spring 2015, look 7
Courtesy Altuzarra

reimagines the look of the classic shirtwaist dress, crafting his skirt with a deep split at the left front. On the runway, he presented it unbuttoned, revealing a spare black bodysuit underneath. This is no prairie dress.

Dorothy's silver shoes are quite the opposite of her dress – rather than humble, they are dazzling. When she receives them from the Munchkins and soon thereafter tries them on, she is attracted only to their beauty. The power of the shoes is completely unknown to her, and is in fact unknown to the Munchkins as well. "The Witch of the East was proud of those silver shoes," one Munchkin says to Dorothy, "and there is some charm connected with them; but what it is we never knew."[255] Although Dorothy does not discover the power of the shoes until the very end of the story, she is fiercely protective of them. The Wicked Witch thinks about stealing them while the girl is working as her servant in the castle, but Dorothy loves them too much to take them off. Later, when the Witch trips Dorothy and manages to steal one of the shoes, the girl is so enraged over the loss of her favorite accessory that she dumps water over her. (In this scene in the movie, there is no reference to the shoes. Instead, the Witch sets the scarecrow on fire, prompting Dorothy to throw a bucket of water to put out the flames.) After the Witch melts, Baum writes that Dorothy picks up the silver shoe, cleans it and dries it with a cloth, and puts it back on her foot.[256]

In spite of Adrian's desire to follow Baum's text when making costumes for MGM's film, it was decided that silver shoes would not be suitable for the movie. *The Wizard of Oz* was intended to push the limitations of Technicolor, the innovative production technique first developed in 1916. Even after twenty years, making films with Technicolor was costly and laborious, but it was ideal for this story. Baum's text is full of references to color, and Denslow's illustrations changed hue each time Dorothy traveled to a new place. The story begins with Dorothy in drab, grey Kansas, represented in black and white in the film, and bursts dramatically into the saturated tones of Technicolor when Dorothy arrives in Munchkinland.

Silver shoes against a yellow brick road simply did not provide enough contrast on screen to highlight the extraordinary vibrancy of Technicolor. "Louis B. Mayer spent more than three million Depression dollars to produce a movie using Kodak's expensive three-strip Technicolor film," remarks Rhys Thomas, who wrote an entire book about Dorothy's shoes. "He wasn't going to settle for black-and-white shoes."[257] Bright red shoes were determined to be optimal, and the famous ruby slippers came into being.

Adrian
Dress in red and blue gingham cotton, ca. 1942
The Museum at FIT, 71.248.1

Adrian's work on the red shoes began with what *Oz* enthusiasts refer to as the "Arabian test pair." These featured an elongated, upturned toe that were clearly informed by Denslow's original drawings of the silver shoes. The Arabian shoes were more elaborately ornamented than the final design for the ruby slippers, as they included large, faceted rhinestones in flower-shaped clusters, in addition to sequins. This exotic test pair was eventually rejected in favor of the round-toed, square-heeled shoes that have since become iconic. If we look past their vibrant sequins and rhinestone bows, the shoes are, quite simply, fashionable 1930s pumps. A Hollywood-based company called INNES made the basic shoes, which were then embellished by a man named Joe Napoli.[258] Each shoe was covered with approximately 2,300 sequins. Such elaborate craftsmanship was not unusual to Adrian's work for MGM. One year earlier, he had designed a costume for Joan Crawford to wear in the film *The Bride Wore Red* that used more than two million bright red bugle beads – even though the film was shot entirely in black and white.[259]

Dorothy's ruby slippers have become some of the most admired and valuable objects in film costume history. Currently, five pairs are known to have survived (including the test pair), though one pair was stolen in 2005 and has never been recovered. The Arabian test pair was sold at auction for more than $600,000 in 2011.[260] It is safe to say that most of us will never own a real pair of ruby slippers, but the appeal of these shoes has resulted in countless reproductions and interpretations. Even if designers are not directly channeling *The Wizard of Oz*, it is difficult to look at a pair of glittering, red shoes without making the association. Even Noritaka Tatehana's heel-less platforms – an unmistakably avant-garde design – acquire a Dorothy-like flair when covered in red crystals. Tatehana's gravity-defying shoes would be not be ideal for following the yellow brick road, but Dorothy might be convinced to trade in her classic pumps for something a little more provocative, such as Christian Louboutin's *Lady Lynch* stilettos covered in red *Fire Opal* strass. Of course, Louboutin's shoes are instantly recognizable by their signature red soles. The soles of Dorothy's ruby slippers were likewise painted red, to keep them from being too distracting on screen.

(faincg) Noritaka Tatehana
Crystal Rose heel-less platforms in red crystal, 2010
The Museum at FIT, 2014.52.1

(below) Christian Louboutin
Lady Lynch stilettos with *Fire Opal* strass, 2009–10
Courtesy Christian Louboutin

The anthropologist Margo DeMello writes that Dorothy's shoes underscore the ethos that one "should not wish for a different life than one has and should be thankful for what one already has."²⁶¹ After spending so much time trying to determine how to get home to Kansas, Dorothy learns that the very shoes on her feet hold the power she needs. However, any admirer of the original story will remember that the shoes are only one of two important accessories in the book. The gold cap has all but been forgotten, but it is of great importance to the original text. We first encounter the cap in the possession of the Wicked Witch of the West. Baum writes:

> There was, in her cupboard, a Golden Cap, with a circle of diamonds and rubies running round it. This Golden Cap had a charm. Whoever owned it could call three times upon the Winged Monkeys, who would obey any order they were given. But no person could command these strange creatures more than three times.²⁶²

He also informs readers that the Wicked Witch had already used the cap twice – once to enslave a group of Ozian residents called the Winkies, and another time to drive Oz himself out of the land of the West. Readers witness the summoning of the monkeys for the third time, when the Witch orders them to go after Dorothy and her friends.

The Wicked Witch wearing the Golden Cap, by William Wallace Denslow, 1900

Like the silver shoes, Dorothy's fascination with the cap is innocent. After the Witch's demise, the girl gathers her friends and prepares to head back to the Emerald City. She spots the Golden Cap and, thinking it pretty, decides to wear it, placing her sunbonnet in her basket. Dorothy ultimately uses the cap in a practical, straightforward way, summoning the monkeys to help carry her and her friends to various parts of Oz. During a journey, the king of the Winged Monkeys tells Dorothy about the history of the cap. It was made by a princess, Gayelette, as a wedding present for her husband, Quelala, and was said to have cost the princess half her kingdom. When Gayelette became angry at the monkeys for a prank played on her husband, she offered to spare their lives only if they became the slaves of the Golden Cap.

Before she leaves Oz, Dorothy gives the cap to the Good Witch of the South. The Witch immediately uses her three wishes, using monkeys to transport the Scarecrow back the to Emerald City, the Tin Woodman to the land of the Winkies, and the Lion back to his forest. Each is designated as the ruler of the land to which he is sent.

I have mostly avoided the political and psychological content of fairy tales in this essay, in large part because such complicated analyses would be better written by experts in those fields. Since *The Wonderful Wizard of Oz* is an original tale, however – that is, one that was not derived from an old oral tale or another literary tale – its political connotations are more straightforward and relevant to its use of fashion as a storytelling device. For example, both Baum's wife and his mother-in-law campaigned for women's suffrage, and Baum, too, was an advocate for women's rights. This is evident in his choice of a young, female protagonist – whose goal is something other than to marry a prince – and the inclusion of the Good Witches as positive and powerful leaders.[263]

Some historians have analyzed Baum's use of the silver shoes and a gold cap in light of the political and social atmosphere of late-nineteenth-century America. According to the political science historian Gretchen Ritter, "The use of financial metaphors begins as soon as Dorothy arrives in Oz. Oz is an abbreviation for ounces, one measure of the worth of gold and silver bullion. In the land of Oz, gold and silver are often the metaphors of power."[264] Dorothy's shoes are aligned with the silver standard, an aspect of Populism.[265] The People's (or Populist) Party was a left-wing political group that was formed in 1891, and although the myriad beliefs of this progressive party are too complex to be summarized here, its relation to silver can be explained. Currency was an enormous factor

in political debates late in the nineteenth century, due in large part to a divide between the northeast, where the economy was centered on industrialization, and the dependency on farming in the south and areas of the newly settled Midwest. Debates over the gold standard versus the silver standard worsened the economic divide.

"'Gold bugs' believed that a 'sound' national economy must be based on the gold standard to ensure the dollar's stability, guarantee unrestricted competition in the marketplace, and promote economic liberty," writes the historian Alan Gevinson. "'Silverites' believed that currency should be redeemable in silver as well as gold. They agitated for 'free silver,' or unlimited coinage of silver, a metal that could be mined in abundance in the West, to produce an increased and more flexible money supply that they hoped would lead to a more equitable economy and foster social reforms."[266]

While historians are reluctant to designate exactly what Baum's personal beliefs were, it seems clear that his references to silver shoes and a gold cap relate directly to the political climate during the time of his writing. Ritter believes it to be telling that Baum appears to treat the silver shoes in the story in a satirical manner, since the "common folks" (Dorothy and the Munchkins) do not understand their power.[267] The Golden Cap, meanwhile, is better understood, and its powers are put to use by all of its four owners over the course of the story.

The Witches

The Wicked Witch of the West is an intriguing character in both personality and appearance. Mark W. Scala, the curator of the 2012 exhibition *Fairy Tales, Monsters, and the Genetic Imagination* at the Frist Center for the Visual Arts, included the Wicked Witch in a group of villainesses he categorized as the "monstrous feminine," which also encompassed creatures such as Medusa and the Sirens.[268] Unlike Snow White's beautiful yet wicked stepmother (who is also a witch), *Oz*'s evil witch conforms to stereotypes of ugliness. Her appearance is given little description in the text. We learn that she has only one eye, but that it is especially strong and works "like a telescope." She also carries an umbrella, which she occasionally uses to hit Dorothy's little dog, Toto.

Today, the Wicked Witch is often envisioned as Margaret Hamilton portrayed her in the film, wearing a long black dress with puffed sleeves, a black pointed hat, and, most notably, bright green skin. Only one of these elements appears

197 The Wonderful Wizard of Oz

in Denslow's original illustrations: the pointed hat. In her book *Witches*, Erica Jong notes, "Pointed hats have long held associations with the devil; in the 1440s through the 1480s, a tall, pointed headdress known as the hennin was in vogue among aristocratic women in France, and many clergymen railed against it, saying that the point was connected to the devil's horns."[269] In her master's thesis on the history of witch's garb, Jessica Pushor writes that the black pointy hat, cape, and dress that we continue to associate with witches was fully developed during the eighteenth century, and that this costume was based on the clothing worn by elderly women, outcasts, and religious extremists.[270]

Beyond her hat, however, the appearance of Denslow's Wicked Witch is very specific. She sports an eye patch, and her thin hair is gathered into several wiry braids that protrude from her head and are adorned, quite unexpectedly, with ribbon bows. She wears a ruff at her neck, a boxy jacket, and high boots with spats. The most interesting element of her ensemble, however, is her skirt. Long and black, it features large appliqués of a toad, a snake, the sun, the moon, and clouds. A clear connection can be drawn between Denslow's drawings and a witch's costume as described in various editions of a costume-party book by Ardern Holt from late in the nineteenth century, entitled *Fancy Dresses Described, or What to Wear at Fancy Balls*. These editions offered suggestions for hundreds of costumes, including many fairy tale characters. For the witch's costume, it was recommended that women wear skirts adorned with "toads, cats, serpents, curlews, frogs, bats, and lizards in black velvet."[271]

Although the Good Witches play important but relatively minor roles in the story, their attire is worth a mention. Quite confusingly, Glinda is the *only* good witch we meet in MGM's film, though in the book Glinda is the Good Witch of the South (the Good Witch of the North is not named in Baum's book). In the film, Glinda wears a frothy, pale pink dress with large silver stars and enormously puffed, gauzy sleeves. Baum's original text describes the Good Witch of the North wearing something quite different: a "white gown that hung in plaits from her shoulder; over it were sprinkled little stars that glistened in the sun like diamonds."[272] The Good Witch of the South is also dressed in white, and she has ringlets of red hair. It is highly significant that Baum

Witch costume from the book *Fancy Dresses Described*, 1887
Image courtesy Fashion Institute of Technology/SUNY, FIT Library Special Collections and FIT Archives

chose to portray the Good Witches in white. This clearly characterizes them as "white witches," synonymous with good witches. Notably, a description and accompanying illustration for a white-witch costume appeared in the 1896 edition of *Fancy Dresses Described*. The overall silhouette and appearance of this costume resembled that of the bad witch, but it was made from all-white fabrics and had lacy cuffs. There was no embellishment on the skirt, although it was quilted. Fascinatingly, Kerry Taylor Auctions sold an extant "white witch" fancy-dress costume, dating to circa 1885, in 2014. This example is made from ivory satin and embellished with silver sequined motifs of an owl, a bat, lizards, snakes, and a lightning bolt. It appears to be a hybrid ensemble, incorporating elements of both bad-witch and good-witch costumes.

The guise of the contemporary witch, even if wicked, tends to be more vampish than hideous – in other words, more like Snow White's stepmother. Thierry Mugler's sexy yet sinister designs might be a more compelling choice for today's Wicked Witch. A black satin couture ensemble from Fall 1997 pairs a slinky, floor-length skirt with a corset top that extends into flame-like forms over the bust. The top is lined in vibrant red satin, subtly enhancing the flame-like effect. This seems especially appropriate for the Wicked Witch, since fire's opposite, water, is the element that leads to her demise. In the film of *The Wizard of Oz*, the Wicked Witch is portrayed more fully as a "fire witch," capable of forming fireballs with her hands, and smoke rises from her broomstick. Let us not forget that it is also in the film that the Witch sets the Scarecrow on fire, and it is this act, rather than the stolen shoe (as it is written in the book), that causes Dorothy to throw the fateful bucket of water.

(facing) Thierry Mugler
Evening set in black and red silk satin, Fall 1997
The Museum at FIT, 2004.49.1

(below) "White Witch" costume, ca. 1885
Courtesy Kerry Taylor Auctions

Conclusion
Fashion and Storytelling

The studies above, although by no means comprehensive, provide a solid foundation for exploring the fascinating connections between fashion and fairy tales. Of fashion's many functions within these stories, one of its most critical roles is as a marker of identity – a change of clothing can render a character utterly unrecognizable. In the eyes of other partygoers, Cinderella's opulent ball gown acts as a powerful disguise. Since it is believed that only nobility could wear such a dress, she is unrecognizable even to her own stepsisters – they cannot possibly equate her with the girl who sweeps their hearth. New clothing may also play a role in deception. Fanchon, the wicked sister in "The Fairies," is easily tricked by the fairy's fine clothing, since she expects to see an old peasant woman. And against all reason, Snow White is fooled not once, but *three times*, by her wicked stepmother, who is dressed as a peddler.

The link between dress and identity is equally significant – albeit considerably more complex – outside the pages of storybooks. Fashion is often viewed as a vehicle for self-expression, and can be understood as a physical manifestation of our inner selves. While many would agree that fashion is a nonverbal form of communication, an important question arises: can we "read" objects of clothing the way we read a story? This has been a subject of considerable debate among fashion theorists.

When we encounter strangers, we know nothing of their identities. As a result, assumptions are made based on physical characteristics – including, of

Comme des Garçons
Spring 2015, look 12.
Courtesy Comme des Garçons

course, the clothes they wear. It is true that many of us attempt to "read" someone's clothing to discern such factors as social position, economic standing, and personality traits. But these assessments are overly reductive and often incorrect. Joanne Entwistle is one of several theorists who warns against the notion of "reading" clothing, explaining,

> Fashion and dress have a complex relationship to identity: on the one hand the clothes we choose to wear can be expressive of identity, telling others something about our gender, class, status and so on; on the other, our clothes cannot always be "read," since they do not straightforwardly "speak" and can therefore be open to interpretation.[273]

The concept of a "language of fashion" is interesting to explore, but it is also one that should not be taken too far. Roland Barthes argues that text and clothing rely on similar structural principles: words can be "stitched together" as can pieces of fabric.[274] In his essay "The Storyteller," Walter Benjamin makes a similar connection between storytelling and crafting objects. He writes, "In fact, one can [...] ask oneself whether the relationship of the story-teller to his material, human life, is not in itself a craftsman's relationship, whether it is not his very task to fashion the raw material of experience, his own and that of others, in a solid, useful and unique way."[275]

Fashion designers, therefore, may be considered storytellers. The fashion writer Colin McDowell observes that "Designers love the make-believe element of clothing [...]. They no more want to be trapped in the everyday and humdrum than the rest of us, so they are happy to give us the clothes that help us escape." He notes further that designers "are also storytellers who use clothes to impart their vision of the world – a vision that is filtered through a prism of romance, beauty and escape."[276]

In the opinion of Debra Scherer, the definition of a fashion storyteller extends well beyond the role of designer. In a 2011 article for *The Business of Fashion*, Scherer wrote about her mentor, Franceline Pratt, a former editor at French *Vogue*. Pratt often emphasized the importance of translating personal experiences into one's work. For her, fashion was less about individual garments and more about how clothing could narrate a story. Scherer described this approach as being "like a beautiful dance between the couturiers, the models, the art directors, the editors and the photographers," and referred to this interrelationship as fashion's "ecosystem."[277] She believes that the contemporary fashion

industry suffers from a distinct lack of storytellers, a misfortune that she speculates is due, in part, to the recent emphasis on the "behind the scenes" look at the fashion world. This theory reminded me of another astute observation by Jack Zipes, who wrote that the literary fairy tale "wants to mark reality without leaving a trace of how it creates that wondrous effect."[278] Perhaps knowing too much about the workings of the fashion world has resulted in the dilution of its magic – or its ability to "tell stories" – but it is also clear from recent fashion collections that some designers are working to restore that magic.

Whether or not one is convinced that fashion can act as a form of narrative, it is clear that it can be a powerful agent for metamorphosis. We are frequently encouraged to believe that with the acquisition of the right wardrobe, we will lead better lives – a "fairy tale" existence. Virginia Postrel writes, "The glamour of fashion appeals to our desire for transformation, promising a makeover of our lives or our selves as well as our appearance."[279] Glamour is often linked casually to fashion, but a study of the history and meaning of the word "glamour" reveals that it has supernatural origins that also relate to the realm of fairy tales. It is an old Scots term, used to describe a type of magic spell that made people see things that were not there. "When devils, wizards, or jugglers deceive the sight, they are said to cast *glamour* o'er the eyes of the spectator," explained a 1721 glossary of poetry.[280] In dressing glamorously, we wish to cast our own kind of enchantment, one that eradicates flaws and projects an image of beauty and perfection. In real life, as in fairy tales, a change in the way we dress can act as a means to reinvent and reimagine the self. We truly can fashion our happily ever after.

Notes

1. Marina Warner, *Once Upon a Time: A Short History of Fairy Tale* (Oxford: Oxford University Press, 2014), xv.
2. Gerda Buxbaum, "Fairy-Tale Couture," in *Icons of Fashion: The 20th Century*, Gerda Buxbaum, ed. (New York and Munich: Prestel, 2005), 151.
3. Gareth Williams, *Telling Tales: Fantasy and Fear in Contemporary Design* (London: V&A Publishing, 2009), 29.
4. Paulina Szmydyke, "Rick Owens' Free Willy Moment," *M Collections* (Fall 2015): 28.
5. Jack Zipes, *When Dreams Came True: Classical Fairy Tales and Their Tradition* (New York: Routledge, 2007), 83.
6. Liana Satenstein, "The Perfect Party Attire." *Marie Claire* (February 11, 2014). Accessed July 27, 2015. http://www.marieclaire.com/fashion/a9071/alice-and-olivia-fall-2014/.
7. Ruth Eglash, "How a 14-year-old Israeli Became the New Face of Christian Dior." *Washington Post* (July 12, 2015). Accessed July 21, 2015. https://www.washingtonpost.com/blogs/worldviews/wp/2015/07/12/how-a-14-year-old-israeli-teen-became-the-new-face-of-christian-dior/.
8. "Elie Tahari Designer Profile." *The Cut* (n.d.). Accessed July 11, 2015. http://nymag.com/thecut/fashion/designers/elie-tahari/.
9. Tracy Smith, "Elie Tahari: Fashioning Success." CBSNews website. Accessed July 21, 2015. http://www.cbsnews.com/news/elie-tahari-fashioning-success/.
10. Luca Solca, "Cinderellas, Snow Whites or Sleeping Beauties?" *Business of Fashion* (May 12, 2015). Accessed May 13, 2015. http://www.businessoffashion.com/articles/opinion/are-fashions-smaller-brands-cinderellas-snow-whites-or-sleeping-beauties.
11. "Final Reflections on the Paris Openings," *Vogue* (October 1, 1933): 24e.
12. Warner, *Once Upon a Time*, xviii.
13. Charles Perrault, "The Sleeping Beauty in the Woods," in Jack Zipes, ed. and trans., *Beauties, Beasts and Enchantment: Classic French Fairy Tales* (Markham, Ontario: Nal Books New American Library, 1989), 48.
14. Bruno Bettelheim, *The Uses of Enchantment: The Meaning and Importance of Fairy Tales* (New York: Alfred A Knopf, 1976), 8.
15. Marie-Louise von Franz, *The Interpretation of Fairy Tales* (Boston and London: Shambhala, 1996), 1.
16. Marina Warner, *From the Beast to the Blonde: On Fairy Tales and Their Tellers* (London: Random House, 1994), XVII.
17. Roland Barthes, *The Fashion System* (New York: Hill and Wang, 1983), 16.
18. Yuniya Kawamura, *Fashion-ology: An Introduction to Fashion Studies* (Oxford and New York: Berg, 2005), 44.
19. Warner, *Once Upon a Time*, 178.
20. Bruno Bettelheim's career was marked by controversy, particularly when it was revealed that he was not actually educated in psychiatry. Although much of his work is now discredited, *The Uses of Enchantment* continues to be an influential text that is worthy of consideration – albeit sparingly.
21. Bettelheim, *The Uses of Enchantment*, 12.
22. Samantha Holland, *Alternative Femininities: Body, Age and Identity* (Oxford and New York: Berg, 2004), 53.
23. Jack Zipes, *The Irresistible Fairy Tale: The Cultural and Social History of a Genre* (Princeton: Princeton University Press, 2012), xi.
24. Zipes, *When Dreams Came True*, 3.
25. Zipes, *When Dreams Came True*, 12.
26. Catherine Orenstein, *Little Red Riding Hood Uncloaked: Sex, Morality, and the Evolution of a Fairy Tale* (New York: Basic Books, 2002), 28.
27. Dorothy R. Thelander, "Mother Goose and Her Goslings: The France of Louis XIV as Seen through the Fairy Tale," *The Journal of Modern History* 54, no. 3 (1982): 483.
28. Zipes, *Beauties, Beasts and Enchantment*, 2.
29. Zipes, *When Dreams Came True*, 42.
30. Zipes, *Beauties, Beasts and Enchantment*, 4.
31. Patricia Hannon, quoted in Zipes, ed. *The Irresistible Fairy Tale*, 24.
32. Lewis C. Seifert, *Fairy Tales, Sexuality, and Gender in France, 1690–1715* (Cambridge: Cambridge University Press, 1996), 5.
33. Mary Louise Ennis, "*Histoires ou contes du temps passé avec des moralités*," in Jack Zipes, ed. *The Oxford Companion to Fairy Tales* (Oxford, Oxford University Press, 2000), 237.
34. Jacob and Wilhelm Grimm, *The Complete First Edition of the Original Folk and Fairy Tales of the Brothers Grimm*, ed. and trans. Jack Zipes (Princeton and Oxford: Princeton University Press, 2014), xix–xx.
35. Maria Nikolajeva, "Hans Christian Andersen," in Zipes, ed., *The Oxford Companion to Fairy Tales*, 13.
36. Zipes, *When Dreams Came True*, 20.
37. Hilary Davidson, "Sex and Sin: The Magic of Red Shoes," in *Shoes: A History from Sandals to Sneakers*, ed. Giorgio Riello and Peter McNeil (London: Berg, 2006), 276.
38. Zipes, *When Dreams Came True*, 119.
39. Warner, *Once Upon a Time*, 78.
40. Andrew Lang, "Introduction," in Marian Roalfe Cox, *Cinderella: Three Hundred and Forty-five Variants* (London: Folklore Society by David Nutt, 1893), vi.
41. Jane Yolen, "America's Cinderella," in Dundes, *Cinderella*, 296.
42. Lang, "Introduction," in Cox, *Cinderella: Three Hundred and Forty-five Variants*, x.
43. Amanda Hess, "How Slut-Shaming has Evolved in the Age of Social Media and Celebrity Nude Hacks." *Marie Claire* (January 22, 2015). Accessed March 3, 2015. http://www.marieclaire.com/politics/news/a13080/slut-shaming-digital-age/.
44. Jo Eldridge Carney, *Fairy Tale Queens: Representations of Early Modern Queenship* (New York: Palgrave Macmillan, 2012), 119.
45. Victoria Ivleva, "Functions of Textile and Sartorial Artifacts in Russian Folktales," *Marvels & Tales* 23 no. 2 (2009): 272.
46. Charles Perrault, "Cinderella or The Glass Slipper," in Zipes, *Beauties, Beasts and Enchantment*, 25.
47. Jacob and Wilhelm Grimm, "Cinderella," in Maria Tatar, ed. and trans., *The Annotated Brothers Grimm* (New York and London: W. W. Norton, 2012), 122.

48 Perrault, "Cinderella," in Zipes, *Beauties, Beasts and Enchantment*, 25.
49 Charles Perrault, "Cinderella, or the Little Glass Slipper," in A. E. Johnson, trans., *Perrault's Fairy Tales* (New York: Dover, 1969), 69.
50 "The Summer of Sant'Angelo," *Women's Wear Daily* (February 11, 1971): 32.
51 David Colman, "New York Metro: Wild Child, Giorgio Sant'Angelo," (February 18, 2002). Accessed April 15, 2015. http://nymag.com/shopping/articles/02/springfashion/santangelo.htm.
52 Alison Gill, "Deconstruction Fashion: The Making of Unfinished, Decomposing and Re-assembled Clothes," *Fashion Theory* 2, no. 1 (February 1998): 28.
53 Caroline Evans, *Fashion at the Edge: Spectacle, Modernity, and Deathliness* (New Haven and London: Yale University Press, 2003), 263.
54 Rebecca Wong, "Yoshiki Hishinuma: A Lesson in Individuality, Dedication and UFOs." *Popspoken* (October 19, 2013). Accessed March 20, 2015. http://popspoken.com/style/2013/10/yoshiki-hishinuma-a-lesson-in-individuality-dedication-and-ufos.
55 Perrault, "Cinderella," in Zipes, *Beauties, Beasts and Enchantment*, 26.
56 Perrault, "Cinderella," in Zipes, *Beauties, Beasts and Enchantment*, 25.
57 C. S. Evans, *Cinderella* (New York: The Viking Press, 1972), 39.
58 Harold Bayley, *The Lost Language of Symbolism* (New York: Dover Publications, 2006), 181.
59 Bayley, *The Lost Language of Symbolism*, 212.
60 Perrault, "Cinderella," in Zipes, *Beauties, Beasts and Enchantment*, 27.
61 Grimm, "Cinderella," in Tatar, *The Annotated Brothers Grimm*, 128.
62 Grimm, "Cinderella," *The Original Folk and Fairy Tales of the Brothers Grimm*, 72.
63 Grimm, "Cinderella," 74.
64 Marie de Rabutin-Chantal Sévigné, *The Letters of Madame de Sévigné to her Daughters and Friends* (Boston: Little, Brown: 1900), 160.
65 Philip Mansel, *Dressed to Rule: Royal and Court Costume from Louis XIV to Elizabeth II* (New Haven and London: Yale University Press, 2005), 8.
66 Diana de Marly, *Louis XIV and Versailles* (New York: Holmes and Meier, 1987), 100.
67 Carney, *Fairy Tale Queens*, 118.
68 Carney, *Fairy Tale Queens*, 145.
69 Jo Ellison, *Vogue: The Gown* (Buffalo, NY: Firefly Books, 2014), 58.
70 Sarah Mower, "Young Guns," *Vogue* (October 1, 2014): 338.
71 Rob Haskell, "Joseph Altuzarra" (January 2011). Accessed August 01, 2015. http://www.wmagazine.com/fashion/2011/01/joseph_altuzarra_designer/.
72 Nicole Phelps, "Altuzarra Spring 2015 Ready-to-Wear Fashion Show: Runway Review – Style.com." Style.com (September 7, 2014). Accessed June 17, 2015. http://www.style.com/fashion-shows/spring-2015-ready-to-wear/altuzarra.
73 Jamie Samet, *Elie Saab* (New York: Assouline, 2012), 15.
74 Warner, *From the Beast to the Blonde*, 203.
75 Thelander, 488.
76 J. G., "Cinderella's 'Glass' Slipper," *New York Times* (October 17, 1926): SM13.
77 Paul Delarue, "From Perrault to Walt Disney: The Slipper of Cinderella," in Dundes, *Cinderella*, 113. Delarue cites several obscure tales that feature glass slippers, including a Scottish version of "Donkey Skin," an Irish variant of the Psyche tale, and an Irish story similar to "Beast with Seven Heads."
78 Delarue, 113.
79 Perrault, "Cinderella," in Zipes, *Beauties, Beasts and Enchantments*, 30.
80 Grimm, "Cinderella," in Zipes, *The Original Folk and Fairy Tales of the Brothers Grimm*, 76.
81 Bettelheim, *The Uses of Enchantment*, 252.
82 Yolen, "America's Cinderella," in Dundes, *Cinderella*, 301.
83 "Fashion: New Shoes for Cinderella," *Vogue* (March 1, 1919): 47.
84 Glenn O'Brien, "Cinderella," *Visionaire* 15 (1995), n.p.
85 "NORITAKA TATEHANA / Story." Noritaka Tatehana. Accessed July 31, 2015. http://noritakatatehana.com/story.html.
86 "Vogue's Eye View Paris: The Glass Slipper," *Vogue* (March 1, 1966): 105.
87 Jack Zipes, *The Enchanted Screen: The Unknown History of Fairy-Tale Films* (New York and London: Routledge, 2011), 11.
88 Tatar, *The Annotated Brothers Grimm*, 147.
89 Roald Dahl, "Little Red Riding Hood and the Wolf," reprinted in Orenstein, *Little Red Riding Hood Uncloaked*, 159.
90 Orenstein, 176.
91 Charles Perrault, "Little Red Riding Hood," in *Perrault's Fairy Tales*, 29.
92 Bettelheim, *The Uses of Enchantment*, 173.
93 Orenstein, 36–37.
94 Tatar, *The Annotated Brothers Grimm*, 146.
95 "Fashion for April, 1811," *La Belle Assemblée*, 1811: vol. 3: 156.
96 Walter de la Mare, *Told Again: Old Tales Told Again* (New York: A. A. Knopf, 1927), 80–81.
97 "Close-Up of the Paris Collections," *Vogue* (March 15, 1935): 53.
98 Max Factor advertisement, 1953.
99 "Into the Woods," *Vogue* (September 2009): 465.
100 "Into the Woods," 471.
101 Perrault, "The Fairies," in Zipes, *Beauties: Beasts, and Enchantment*, 61.
102 Perrault, "The Fairies," 62.
103 Thelander, 486.
104 Michael F. Page and Robert R. Ingpen, *Encyclopedia of Things That Never Were* (New York: Viking, 1987), 62.
105 Jorge Luis Borges, *The Book of Imaginary Beings* (New York: E. P. Dutton, 1969), 95.
106 Christopher Wood, *Fairies in Victorian Art* (Suffolk, UK: Antique Collectors Club, 2000), 12.
107 Wood, *Fairies in Victorian Art*, 11–12.
108 Quoted in Warner, *Once Upon a Time*, 16.
109 Quoted in Andrew Bolton and Harold Koda, *Schiaparelli and Prada: Impossible Conversations* (New York: Metropolitan Museum of Art; New Haven and London, Yale University Press, 2012), 101.
110 Susannah Frankel, "Collections Report," *AnOther* (Spring 2008): 221.
111 "How to Get the Elusive Prada Fairy Bag." *The Cut* (February 21, 2008).

Accessed April 5, 2015. http://nymag.com/thecut/2008/02/how_to_get_the_elusive_prada_f.html.

112 Perrault, "The Fairies," in Zipes, *Beauties, Beasts and Enchantment*, 62.

113 Kimberly Chrisman-Campbell, *Fashion Victims: Dress at the Court of Louis XVI And Marie-Antoinette* (New Haven and London: Yale University Press, 2015), 78.

114 George Frederick Kunz, *The Mystical Lore of Precious Stones* (North Hollywood, Cal.: Newcastle, 1986), 76.

115 Kunz, 80.

116 "Holly Fowler Illustrations." *Georgette*. Accessed July 31, 2015. http://georgettemagazine.com/holly-fowler/.

117 Jack Tresidder, ed. *The Complete Dictionary of Symbols* (San Francisco: Chronicle Books, 2004), 480.

118 Andrew Bolton, *Wild: Fashion Untamed* (New York: Metropolitan Museum of Art, 2004), 11.

119 Orenstein, 83.

120 Jack Zipes, "Spinning with Fate: Rumpelstiltskin and the Decline of Female Productivity," *Western Folklore* v. 52, no. 1 (January 1993): 52.

121 Perrault, "The Sleeping Beauty in the Woods," in Zipes, *Beauties, Beasts and Enchantment*, 48.

122 Susan J. Vincent, *The Anatomy of Fashion: Dressing the Body from the Renaissance to Today* (New York, Oxford: Berg, 2009), 27.

123 The rose-printed gown may be a reference to the Grimms' version of the tale, "Briar Rose."

124 "Hit Looks from Bill Gibb," *Vogue* UK (March 15, 1977): 94.

125 "Fashion Newsflash: Fantasy Highland," *Vogue* (October 1, 2008): 212.

126 Zipes, *When Dreams Came True*, 50.

127 Ruth B. Bottigheimer, "Beauty and the Beast," in Zipes, *The Oxford Companion to Fairy Tales*, 45.

128 Cristina Bacchilega, *Postmodern Fairy Tales* (Philadelphia: University of Pennsylvania Press, 1997), 72.

129 Bottigheimer, "Beauty and the Beast," 45.

130 Gabrielle-Suzanne Barbot de Villeneuve, *Madame de Villeneuve's The Story of Beauty and the Beast*, J. R. Planché, trans. (Somerset, UK: Blackdown Publications, 2014), 2.

131 De Villeneuve, *Madame de Villeneuve's The Story of Beauty and the Beast*, 3.

132 De Villeneuve, *Madame de Villeneuve's The Story of Beauty and the Beast*, 7.

133 Andrew Bolton, *Dangerous Liaisons: Fashion and Furniture in the Eighteenth Century* (New York: Metropolitan Museum of Art, and New Haven and London: Yale University Press, 2006), 16.

134 De Villeneuve, *Madame de Villeneuve's The Story of Beauty and the Beast*, 33.

135 De Villeneuve, *Madame de Villeneuve's The Story of Beauty and the Beast*, 39.

136 De Villeneuve, *Madame de Villeneuve's The Story of Beauty and the Beast*, 41.

137 Shannon Bell-Price and Elyssa Da Cruz, "Tigress," in Bolton, *Wild: Fashion Untamed*, 123.

138 Valerie Steele, ed., *Dance and Fashion* (New Haven: Yale University Press, 2014), 27.

139 Maya Singer, "Giles Spring 2015 Ready-to-Wear Fashion Show: Runway Review – Style.com." Style.com. Accessed March 5, 2015. http://www.style.com/fashion-shows/spring-2015-ready-to-wear/giles.

140 Bolton, *Wild: Fashion Untamed*, 11.

141 Grimm, "Snow White," in Tatar, *The Annotated Brothers Grimm*, 249.

142 In the original Grimm Brothers' "Snow White," the wicked queen is not Snow White's stepmother, but her birth mother. Later (and better known) versions of the story tell readers that Snow White's biological mother dies when the girl is an infant.

143 Bettelheim, *The Uses of Enchantment*, 195.

144 Joyce Thomas, *Inside the Wolf's Belly* (Sheffield: Sheffield Academic Press, 1989), 70.

145 Holland, *Alternative Femininities: Body, Age and Identity*, 58.

146 Alice Pfeiffer, "Rick Owens Spring 2011: The Prince of Darkness does Jedi-Chic," Fashionista.com (October 1, 2010). Accessed February 27, 2015. fashionista.com/2010/10/rick-owens-spring-2011-the-prince-of-darkness-does-jedi-chic#!

147 Bacchilega, *Postmodern Fairy Tales*, 33.

148 Grimm, "Snow White," in Tatar, 255.

149 Bettelheim, *The Uses of Enchantment*, 212.

150 Grimm, "Snow White," in Tatar, 257.

151 This group included Eddy Duchin, Hank Greenberg, Ray Bolger, Jack Kriendler, Frank Fay, John Kieran, and Alajálov.

152 "Fables Retold," *Vogue* (December 15, 1946): 59.

153 Carney, *Fairy Tale Queens*, 115.

154 Carney, *Fairy Tale Queens*, 1.

155 Warner, *Once Upon a Time*, 87.

156 Bettelheim, *The Uses of Enchantment*, 211.

157 Maria Tatar notes that the Grimms first called this character a fairy, and later an enchantress. In other versions of the story, she is often referred to as a witch.

158 Grimm, "Rapunzel," in Tatar, *The Annotated Brothers Grimm*, 58.

159 Joyce Thomas, cited in Tatar, *The Annotated Brothers Grimm*, 54.

160 The Grimms' initial publication of the story in 1812 included this plotline, but it was changed in later volumes to deemphasize Rapunzel's pregnancy outside of wedlock.

161 Thomas, *Inside the Wolf's Belly*, 180.

162 Roberta Milliken, *Ambiguous Locks: An Iconology of Hair in Medieval Art and Literature* (Jefferson, N.C.: McFarland and Company, 2012), 1–2.

163 Milliken, *Ambiguous Locks*, 46.

164 Warner, *From the Beast to the Blonde*, 372.

165 William Morris, "Rapunzel," SurLaLune Fairy Tales. Accessed May 25, 2015. www.surlalunefairytales.com/rapunzel/poetry/williammorris.html.

166 "More Dash Than Cash," *Vogue* (April 15, 1970): 102.

167 "Women's Autumn/Winter 2007 'In Memory of Elizabeth Howe, Salem, 1692,'" Alexander McQueen. Accessed June 18, 2015. http://www.alexandermcqueen.com/experience/en/alexandermcqueen/archive/womens-autumnwinter-2007-in-memory-of-elizabeth-howe-salem-1692/.

168 "Underneath All That Elegance." *(IN)DECOROUS TASTE* (October 30,

2011). Accessed May 05, 2015. http://www.indecoroustaste.com/2011/10/underneath-all-that-elegance.html.
169 Stephen Treffinger, "Rapunzel, Rapunzel, Let Down Your Window Panels," *New York Times* (November 24, 2005): F3.
170 Grimm, "Furrypelts," in Tatar, 300.
171 Grimm, "Furrypelts," in Tatar, 300.
172 Tatar, *The Annotated Brothers Grimm*, 63.
173 Carney, *Fairy Tale Queens*, 121–22.
174 Julia V. Emberley, *The Cultural Politics of Fur* (Ithaca, N.Y.: Cornell University Press, 1997), 12.
175 Caroline Weber, *Queen of Fashion: What Marie Antoinette Wore to the Revolution* (New York: Henry Holt and Company, 2006), 189.
176 This illustration is actually from a tale called "The True Sweetheart" that is very similar to "Furrypelts," and also includes the starry dress.
177 Jacob and Wilhelm Grimm, *Little Brother & Little Sister and Other Tales by the Brothers Grimm* (London: Constable & Company Ltd., 1917), n.p.
178 "Three," 2012. In *Brewer's Dictionary of Phrase and Fable*, ed. Susie Dent (London: Chambers Harrap). Online resource.
179 Thomas, *Inside the Wolf's Belly*, 212.
180 Zipes, *When Dreams Came True*, 123.
181 Horace Beck, *Folklore and the Sea* (Mystic, Connecticut: Mystic Seaport Museum, Incorporated, 1985), 227.
182 Dorothy Dinnerstein, *The Mermaid and the Minotaur* (New York: Harper and Row, 1976), 1.
183 Hans Christian Andersen, "The Mermaid," in *Andersen's Fairy Tales* (London: Wordsworth Classics, 1993), 9.
184 Beck, *Folklore and the Sea*, 230.
185 Andersen, "The Mermaid," 13.
186 Andersen, "The Mermaid," 18.
187 Andersen, "The Mermaid," 18.
188 Dilys Blum, *Shocking! The Art and Fashion of Elsa Schiaparelli* (Philadelphia: Philadelphia Museum of Art, 2003), 222.
189 Timothy Long, *Charles James: Designer in Detail* (London: V&A Publishing, 2015), 41.
190 Bernadine Morris, "Norell: The Clothes," in Sarah Tomerlin Lee, ed. *American Fashion* (New York: The Fashion Institute of Technology, 1975), 406.
191 Danièle Bott, *Thierry Mugler: Galaxy Glamour* (New York: Thames and Hudson, 2010), 121.
192 "Water World," *Vogue* India (May 2012): 58–59.
193 Mhairi Graham, "Mermaids," *Lula* (Spring/Summer 2015): 73.
194 Graham, "Mermaids," 73.
195 Hans Christian Andersen, "The Snow Queen: A Tale in Seven Stories," in *Andersen's Fairy Tales*, 188.
196 Erica Weitzman, "The World in Pieces: Concepts of Anxiety in H. C. Andersen's 'The Snow Queen'" *MLN* 122, no. 5 (2007): 1106.
197 Andersen, "The Snow Queen," 188.
198 William F. Fry, Jr. "A Gift of Mirrors: An Essay in Psychologic Evolution," *North American Review*, 265 no. 4 (December 1980): 53.
199 Fry, Jr. "A Gift of Mirrors," 53.
200 Fry, Jr. "A Gift of Mirrors," 53.
201 Andersen, "The Snow Queen," 194.
202 Andersen, "The Snow Queen," 194.
203 Davidson, 277.
204 Hans Christian Andersen, "The Red Shoes," 71.
205 Davidson, 272.
206 Charles T. Davis, *The Manufacture of Leather* (Philadelphia: H.C. Baird, 1885), 43.
207 Davis, *The Manufacture of Leather*, 57.
208 Andersen, "The Snow Queen," 190.
209 Weitzman, "The World in Pieces," 1107.
210 Weitzman, "The World in Pieces," 1108.
211 Judith Watt, *Alexander McQueen: The Life and Legacy* (New York: Harper Design, 2012), 249.
212 Watt, *Alexander McQueen*, 249.
213 Chioma Nnadi, "J. Mendel Fall 2012." Vogue.com (February 15, 2012). Accessed July 16, 2015. http://www.vogue.com/fashion-week/862762/j-mendel-fall-2012/.
214 Deborah Bee, *Couture in the 21st Century* (London: Harrods and A&C Black, 2010), 74.
215 Andersen, "The Snow Queen," 214.
216 Elizabeth Wayland Barber, *The Dancing Goddesses: Folklore, Archaeology, and the Origins of European Dance* (New York and London: W. W. Norton and Company, 2013), 204.
217 Joseph Jacobs, *European Folk and Fairy Tales* (New York: G. P. Putnam's Sons, 1916), 240.
218 Carole Scott, "Magical Dress: Clothing and Transformation in Folk Tales," *Children's Literature Association Quarterly* 21, no. 4 (Winter 1996): 153.
219 Scott, "Magical Dress," 152.
220 Andersen, "The Mermaid," 17.
221 Beck, *Folklore and the Sea*, 231.
222 Michael Ferber, "Swans," in *A Dictionary of Literary Symbols* (New York: Cambridge University Press, 2003). Electronic resource.
223 Tresidder, *The Complete Dictionary of Symbols*, 459.
224 Long, *Charles James: Designer in Detail*, 52.
225 Steele, *Dance and Fashion*, 52.
226 Meenal Mistry, "Giles Spring 2012 Ready-to-Wear Fashion Show: Runway Review – Style.com." Style.com (September 19, 2011). Accessed June 2, 2015. http://www.style.com/fashion-shows/spring-2012-ready-to-wear/giles.
227 Kadia Blagrove, "Giles: SS 2012 – London," Firstview.com (September 22, 2011). Accessed June 12, 2015. http://firstview.com/blog/tag/lfw/.
228 Brenda Cronin, "'Alice in Wonderland' Turns 150." *Wall Street Journal* (June 10, 2015). Accessed June 12, 2015. http://www.wsj.com/articles/alice-in-wonderland-turns-150-1433953629#livefyre-comment.
229 Kiera Vaclavik, "Alice in Wonderland: The Making of a Style Icon." *Inde-

229 *pendent* (March 23, 2015). Accessed July 7, 2015. http://www.independent.co.uk/arts-entertainment/books/features/alice-in-wonderland-the-making-of-a-style-icon-10128741.html.

230 Lewis Carroll, *Alice's Adventures in Wonderland* (New York: W. W. Norton and Company, 1992), 7.

231 Graham Ovenden, ed. *The Illustrators of Alice in Wonderland and Through the Looking Glass* (New York: St. Martin's Press, 1972), n.p.

232 Carolyn Vega, *Alice: 150 Years of Wonderland*. 2015. Exhibition, the Morgan Library & Museum, New York, N.Y.

233 Vega, *Alice: 150 Years of Wonderland*. 2015. Exhibition.

234 Vaclavik, "Alice in Wonderland: The Making of a Style Icon."

235 Vaclavik, "Alice in Wonderland: The Making of a Style Icon."

236 Kiera Vaclavik, "The Dress of the Book: Children's Literature, Fashion, and Fancy Dress," proceedings of *Beyond the Book: Transforming Children's Literature* (Cambridge: Cambridge Scholars Publishing, 2012): 68.

237 Hamish Bowles, "Alice in Wonderland," *Vogue* (December 1, 2003): 225.

238 Kiera Vaclavik, "Dressing down the Rabbit Hole – How to Become Alice in Wonderland." *Conversation* (April 29, 2015). Accessed May 22, 2015. http://theconversation.com/dressing-down-the-rabbit-hole-how-to-become-alice-in-wonderland-40398.

239 Carroll, *Alice's Adventures in Wonderland*, 7.

240 Colin McDowell, *Hats: Status, Style and Glamour* (New York: Rizzoli, 1992), 53.

241 Ella Alexander, "Vivienne Westwood Red Label." *Vogue UK* (February 20, 2011). Accessed July 26, 2015. http://www.vogue.co.uk/fashion/autumn-winter-2011/ready-to-wear/vivienne-westwood-red-label

242 Kaat Debo, "Walter's World of Wonder," in *Walter Van Beirendonck: Dream the World Awake* (Tielt, Belgium: Lannoo, 2011), 15.

243 Vega, *Alice: 150 Years of Wonderland*.

244 Martin Gardner, *The Annotated Alice: The Definitive Edition* (London: Penguin, 2001), 81.

245 Author's interview with Hideki Seo, April 13, 2015.

246 L. Frank Baum, *The Wonderful Wizard of Oz* (Chicago: Rand McNally, 1956), 3.

247 Baum, *The Wonderful Wizard of Oz*, 146.

248 Baum, *The Wonderful Wizard of Oz*, 30.

249 Howard Gutner, *Gowns by Adrian* (New York: Harry N. Abrams, 2001), 63.

250 Gutner, *Gowns by Adrian*, 63.

251 Baum, *The Wonderful Wizard of Oz*, 33.

252 Gutner, *Gowns by Adrian*, 63.

253 Patricia Mears, *American Beauty: Aesthetics and Innovation in Fashion* (New Haven and London: Yale University Press, 2009), 7.

254 Mears, *American Beauty*, 7.

255 Baum, *The Wonderful Wizard of Oz*, 24.

256 Baum, *The Wonderful Wizard of Oz*, 151.

257 Thomas, *Inside the Wolf's Belly*, 15.

258 Thomas, *Inside the Wolf's Belly*, 60.

259 Mears, *American Beauty*, 171.

260 "Judy Garland's Wizard of Oz Dress & Ruby Slippers Sell for Over 1.5 Million Dollars." Judy Garland News Events website (June 18, 2011). Accessed June 20, 2015. http://judygarlandnews.com/2011/06/18/judy-garlands-wizard-of-oz-test-dress-ruby-slippers-sell-for-over-1-5-million-dollars/.

261 Margo DeMello, "Fairy Tales," in *Feet and Footwear: A Cultural Encyclopedia* (Santa Barbara, Cal.: Greenwood), 2009. http://ebooks.abc-clio.com/reader.aspx?isbn=9780313357152&id=GR5714-1, 232.

262 Baum, *The Wonderful Wizard of Oz*, 140.

263 Gretchen Ritter, "Silver Slippers and a Golden Cap: L. Frank Baum's 'The Wonderful Wizard of Oz' and Historical Memory in American Politics," *Journal of American Studies* 31, no. 2 (August 1997): 178.

264 Ritter, "Silver Slippers and a Golden Cap," 192.

265 Terry Staples, "The Wizard of Oz," in Zipes, *The Oxford Companion to Fairy Tales*, 553.

266 Alan Gevinson, "Silverites, Populists, and the Movement for Free Silver," Teaching History.org. Accessed June 13, 2015. http://teachinghistory.org/history-content/ask-a-historian/25222.

267 Ritter, "Silver Slippers and a Golden Cap," 193.

268 Mark W. Scala, ed. *Fairy Tales, Monsters, and the Genetic Imagination* (Nashville, TN: Vanderbilt University Press, 2012), 6.

269 Erica Jong, *Witches* (New York: Harry N. Abrams, 1981), 93.

270 Jessica Ann Pushor, *From Folk to Fashionable: The Witch in Fashion from 1880 to 1930*. Master's thesis, Fashion Institute of Technology, 2013, 11.

271 Ardern Holt, *Fancy Dresses Described, or What to Wear at Fancy Balls* (London: Debenham and Freebody, 1882), 70.

272 Baum, *The Wonderful Wizard of Oz*, 20.

273 Joanne Entwistle, *The Fashioned Body* (Cambridge: Polity Press, 2000), 112.

274 Ivleva, "Functions of Textile and Sartorial Artifacts in Russian Folktales," 268.

275 Walter Benjamin, "The Storyteller: Reflections on the Work of Nikolai Leskov," in Dorothy J. Hale (ed.), The Novel: An Anthology of Criticism and Theory 1900–2000 (Malden, Mass.: Blackwell Publishing, 2006), 377.

276 Colin McDowell, *The Anatomy of Fashion: Why We Dress the Way We Do* (London: Phaidon, 2013), 222.

277 Debra Scherer, "Why Do We Take Pictures of Clothes?" *Business of Fashion* (September 7, 2011). Accessed April 22, 2015. http://www.businessoffashion.com/articles/opinion/op-ed-why-do-we-take-pictures-of-clothes.

278 Zipes, *When Dreams Came True*, 31.

279 Virginia Postrel, *The Power of Glamour: Longing and the Art of Visual Persuasion* (New York: Simon and Schuster, 2013), 38.

280 Postrel, *The Power of Glamour*," 10.

(facing) Illustration for "Cinderella" by Edmund Dulac, 1910.

(following) Alice revised, with hairband, by Sir John Tenniel (1865), in *Through the Looking-Glass*.

3

Sleeping Beauty:
A Fairy Tale's Dance with Fashion

By Patricia Mears

The most enthroned of the classics, *The Sleeping Beauty* [. . .] is set to what most people believe is Tchaikovsky's greatest score. It has a king and a queen, a castle and a dark woods, and an evil fairy, grinning nastily, and a good fairy [. . .] As for historical importance of *The Sleeping Beauty*, it is doubtful that any other art work, ever, has influenced its own field so heavily. *Beauty*, in its original, 1890 production [. . .] was what converted the young Serge Diaghilev to classical dance. It was therefore the seed of the Ballets Russes, the company that revived the dying art of ballet in Europe in the early twentieth century. In 1921, Diaghilev put on his own production of *Beauty*, in London, and that, in turn, was the foundation of British ballet culture, which for many people in the West [. . .] was ballet culture itself.[1]

Classical ballet did not assume its position as an influential and esteemed art form in the west until well into the twentieth century. While ballet's ascent can be attributed to a number of factors, one the most important occurred on the evening of November 2, 1921, on the stage of the Alhambra Theatre in London. It was the debut performance of *The Sleeping Princess*. This revival of the ultimate classical, full-length, Imperial-style ballet (originally called *The*

Ballet Russes de Monte Carlo ballerinas Irina Baronova (left) and Nini Theilade wearing dresses by B. Altman, New York. Photograph by George Hoynengen Huene, *Harper's Bazaar*, May 1940. Coutesy of Hearst Publications.

Sleeping Beauty), was the brainchild of the daring Russian impresario, Serge Diaghilev. Not only was it the biggest gamble of his career, it was the grandest and by far the most significant ballet production of its kind ever seen outside of his home country.

Sadly, Diaghilev did not live to see the sweeping impact of *The Sleeping Princess*. The classical ballet he brought from his homeland would not only survive, it would go on to become the most popular performing art in the United Kingdom during the 1930s and 1940s, and later in cities such as New York. While classical ballet took its place in the pantheon of modern high culture in the west, it also asserted a profound influence on other fields of creativity, one of the most important being fashion. At the same time, the ballerina blossomed into a revered and aspirational figure of beauty and glamor, and her signature costume – the corseted tutu – would inspire many of fashion's leading designers. At its peak, from the interwar years through the mid-century, haute couture looked for the first time to classical ballets such as *Giselle*, *Swan Lake*, and *Sleeping Beauty* as sources of stylistic and aesthetic inspiration.

From around 1932, articles on dance began to appear regularly in leading fashion magazines such as *Vogue* and *Harper's Bazaar*. By the end of the 1930s and throughout World War II, ballerinas were regularly featured as models in fashion editorials while, in the same issues, dance coverage abounded. Goods from stockings to nightgowns were advertised using ballerinas or packaged with balletic elements, drawing a clear connection between these products and the elegant qualities of classical dance. Meanwhile, designers freely adapted elements of the ballet costume into their work, with some even designing dance costumes, and both were covered widely in fashion publications. Fashion mirrored the establishment of classical ballet in the west, and their intertwined ascent echoed the fairy tale narrative in full-length, classical ballets.

The original production of *The Sleeping Beauty*, which debuted on the stage of the Mariinsky Theater in St. Petersburg in 1890, was considered at the time to be revolutionary. Contemporary critics deemed it the first *ballet féerie*, or fairy tale ballet, and one that was strongly inspired by France's *ancien regime*. *Beauty*, as it has become affectionately known, was a collaboration of three Francophiles who were leading artistic powers during Russia's Silver Age: the Mariinsky Ballet director, Ivan Vsevoloshsky (who wrote the libretto based on Charles Perrault's seventeenth-century version of the fairy tale, entitled *La Belle au bois dormant*); the company's ballet master and chief choreographer, Marius Petipa

(who was French); and the composer, Pyotr Ilyich Tchaikovsky. *Beauty* not only references the era of Louis XIV, the Sun King, it also evokes his classical mentor, Apollo, the Sun God. The connection to the Romanov Tsar, Alexander III, was unmistakable.

Numerous ballets at the time were akin to fairy tales but few were actually populated with fairies, let alone dominated by them. *Beauty* was an exception. It is true that the central characters are members of a royal family and that the plot revolves around one of them, Princess Aurora, but the ballet's narrative and rich content could not exist if it were not for fairies, especially the Lilac Fairy, the symbol of goodness, and her evil counterpart, Carabosse. They, in turn, head a cast of five fairies in the prologue (Aurora's christening) and another four in the final act (her wedding.) The latter is enriched further with other fairy tale characters, from Red Riding Hood to Puss in Boots. What made *Beauty* so compelling was, as the critic Laura Jacobs noted, a "supreme integration of aesthetic affinities – musical, theatrical, and epochal – with seventeenth- and eighteenth-century ideals recapitulated in nineteenth-century forms."[2]

The fact that Diaghilev restaged *Beauty* was remarkable and unexpected. From the 1909 Parisian debut of his Ballets Russes, the company garnered success and reinvigorated interest in ballet in France and England, largely because of the exotic allure of its most popular works. The entire field of design, from

Prologue of the 1921 Ballets Russes production of *The Sleeping Princess*, Alhambra Theatre, London. Sets and costumes by Léon Bakst.

the decorative arts to fashion, was influenced by the choreographer Mikhail Fokine's newly commissioned one-act works, sometimes set to music by avant-garde composers such as Igor Stravinsky, and with sets and costumes by contemporary artists, including Léon Bakst. By the end of World War I, the Ballets Russes was the acknowledged leader in modern ballet. *Beauty*, however, was a potent and pivotal force in Diaghilev's life. He noted that it "would hardly be an exaggeration to say that, had it not been for my enthusiasm for *Sleeping Beauty* [. . .] and had I not infected my friends with it, there would have been no Ballet Russes and none of the Balletomania which their success evoked."[3]

The Ballets Russes was in a weak financial position after World War I, and Diaghilev surmised that a full-scale, Imperial Russian ballet might secure a long-running season in the conservative and lucrative London theater world. Described as a "gorgeous calamity" by critics, *The Sleeping Princess* ran for 115 performances but in fact nearly bankrupted both Diaghilev and the Ballets Russes. He fled to escape his creditors, legal actions ensued, and the Ballets Russes was barred from performing in England until late in 1924. It would be years before this full-length ballet was seen again in the west, but *Aurora's Wedding*, a twenty-minute, one-act version of the court scenes from the ill-fated production became a Ballets Russes staple and was performed over 200 times around the world until 1929, the year Diaghilev died.

Diaghilev boasted of his own prescience. He noted, "I was always ahead of my time [. . .] but this time too many years."[4] *Beauty*'s success and long-term influence were slow to gain traction, yet the impresario knew he was setting the groundwork for a great shift in ballet's future. Radical modernism was giving way to the rise of historicism. Thanks in large part to the fortuitous fervor of British talents who were profoundly influenced by the 1921 production of *Beauty* – mainly Ninette de Valois, Marie Rambert, and Frederick Ashton, all former Ballets Russes dancers – classical ballet would awaken and thrive on the stages of London.

It is an irony that "toe dancing," once viewed as a tawdry form of entertainment in England, would become that nation's most beloved and popular performing art from around 1930. Against all odds, the Royal Ballet (originally called the Vic-Wells Ballet and later the Sadler's Wells Ballet) was born and thrived during one of the most difficult periods in modern history – the worldwide economic Depression of the 1930s, World War II, and the rebuilding of Europe during the Cold War of the 1950s. The director, Ninette de

Valois, canonized a small number of full-length Russian works dating to late in the nineteenth century; they would form the modern incarnation of "classical" ballet. She did so with input and support from "balletomanes," as they called themselves: Philip Richardson, Cyril Beaumont, Arnold Haskell, and especially the renowned economist John Maynard Keynes. (Keynes was so impassioned a fan that, although homosexual, he married the ballerina Lydia Lopokova in 1925.) During and shortly after World War II, Keynes was a member of CEMA (Council for the Encouragement of Music and the Arts) and was instrumental in securing government funds for the Sadler's Wells Ballet and Covent Garden Opera House. Although the Sadler's Wells Ballet regularly commissioned and performed one-act ballets like its precursor, the Ballets Russes, it was the revival of full-length classics – *Swan Lake*, *The Nutcracker*, and especially *Sleeping Beauty* – that became the company's hallmarks.

Classical ballet's influence on fashion, like the impact of *Beauty* on the creation of a classical canon in the west, was gradual. Aside from the mania for exoticism propelled by the Ballets Russes before World War I, few of their historicized ballets made a mark on couture. One exception was Mikhail Fokine's 1910 one-act ballet *Carnaval* set to music by Robert Schumann. It featured long, full,

Tamara Karsavina as Columbine in *Carnaval* by Bassano Ltd., June 27, 1919, © National Potrait Gallery, London

ruffled skirts, similar to those that would come to dominate fashion during the mid-1910s, and later, after the war, the "robe de style de dix-huitième siècle" that was popularized by the leading couturier, Jeanne Lanvin. By 1921, the *robe de style* became a Lanvin staple and was a viable option for women who could not easily wear the narrow cylindrical "flapper" sheaths. This dress, with its dropped waist and billowing, flared skirt, was also called the "Camargo frock," after the French-Belgian ballet dancer Marie de Cupis de Camargo (1710–1770), who was famous for shortening her panniered gowns to reveal her virtuoso footwork. Lanvin's creations, however, were more often evocative of Léon Bakst's *Carnaval* costumes, especially the tiered and flounced dress worn by the character Columbine, as well as the *Beauty* costume worn by the Lilac Fairy in 1921. For her Winter 1924–25 collection, Lanvin designed an ivory silk taffeta *robe de style*, with black velvet circles appliquéd on the skirt and a red silk velvet bow around the waist, and named it "Colombine."

Offshoots of the original Ballets Russes continued to produce one-act works after Diaghilev's death. By the early years of the 1930s, however, romantic-style

"Colombine" *Robe de Style* by Jeanne Lanvin, Winter 1924–25. Ivory silk taffeta, black silk velvet appliqués, trimmed with pearls and gold thread embroidery, red silk velvet bow around the waist. The dress is modeled by actress Carlotta Monterey, photograph by Edward Steichen for *Vogue*, December 1, 1924. Courtesy of Condé Nast.

works were the most influential and their impact on couture was evident. Fashion designers consistently embraced elements of the neo-romantic ballet costume: yards of tulle for long, full skirts and fitted bodices were paired with billowy sleeves, or were swathed in shawls made from transparent fabrics. Avowed modernists, including the couturieres Madeleine Vionnet and Gabrielle "Coco" Chanel, were producing gowns with skirts that wafted like the sylph-style tutus of old yet were more varied in color.

In an earlier essay on ballet and fashion, I noted that the connections between these two creative entities – ballet and fashion – seemed evident especially in George Balanchine's *Cotillon*. First performed by the Ballets Russes de Monte Carlo on April 12, 1932, the sets and costumes were designed by the French artist Christian Bérard. His V-necked velvet bodices and long, multi-colored tulle skirts embroidered with sequin-edged stars, worn with opera-length gloves, had a strong impact on fashionable eveningwear. The look was so popular that it was featured in a two-page article about the Ballet Russes de Monte Carlo in the September 1, 1932 issue of *Vogue*. The following year, Lincoln Kirsten, co-founder of the New York City Ballet, highlighted the same ballet in an article for the November 1, 1933 issue of *Vogue*.

Initially, research indicated that Bérard may have been a direct source of inspiration for Chanel's later romantic-style evening clothes. While her day clothes retained her signature simplicity and modernity throughout the 1930s, her evening dresses became increasingly ornate and extravagant. Chanel chose fine muslins and tulle to craft small-waisted, full-skirted gowns. In 1937, her "robe à danser" (photographed by Cecil Beaton for *Vogue*), with its fitted top and voluminous bottom, made of pale silk net and tinsel embroidery, exemplified the ballet style that was sweeping fashion. That same year, both *Vogue* and *Harper's Bazaar* featured a dark blue gown and matching head-covering by Chanel. Fashioned from tulle and embroidered with metallic sequins in the shape of stars, the gown is reminiscent of the tutus sprinkled with celestial imagery that Bérard designed for *Cotillon*. The notion that Chanel used *Cotillon* as a primary source of inspiration for this gown makes sense. She was close to both Bérard and Diaghilev and even designed the costumes for the Ballets Russes' work *Le Train Bleu* in 1924.

Chanel's ballet costumes made an impression on the burgeoning British choreographer Frederick Ashton. In 1926, for his first work, entitled *A Tragedy of Fashion, or the Scarlet Scissors*, he hoped to hire Chanel as the costumier. Ashton

SEPTEMBER 15, 1932

CHRISTIAN BÉRARD'S GREY MARBLE BALLROOM SET FOR "COTILLON"

The NEW RUSSIAN BALLET

THE Russian Ballet has come to life again—and all Europe is talking about it! No longer need this greatest of all dance classics be just a memory—for, in Monte Carlo, under the guiding hands of Messieurs René Blum and W. de Basil, the work of the former master Diaghilev has been taken up again. With supreme taste and intelligence, they have revived the early ballets and originated new ones —presenting them both in Monte Carlo and Paris to storms of approval. Here are scenes from "Cotillon," the ballet by Boris Kochno, with music by Emmanuel Chabrier, décor and costumes by Christian Bérard. It is a lovely thing, half classic, half modern, set in a marble ballroom, danced with understanding, and starring the fourteen-year-old Tamara Toumanova, who promises to be a second Pavlova.

TAMARA TOUMANOVA

HOYNINGEN-HUENÉ LUBOV ROSTOVA

221 Sleeping Beauty

felt it was an inspired choice because, as the name suggests, his ballet was about a couturier, Monsieur du Chic, who, despondent when his work is not liked, commits suicide. Marie Rambert, the production's director, however, quashed the choice. As a couturier, Chanel was both too expensive and, like most couturiers (as Rambert believed), not effective as a costumier. Instead, Ashton hired a Polish-born artist, Sophie Fedorovitch. Fedorovitch would become one of the main costumiers for the Sadler's Wells Ballet as well as Ashton's closest collaborator. For his 1936 ballet *Nocturne*, Fedorovitch created what have been described as her most gorgeous costumes.[5] Photographed by Cecil Beaton, the dancer June Brae, in the role of The Rich Girl, wears a ravishing, dark tulle gown sprinkled with sequined stars. Its silhouette, fabrication, ornamentation, and even its tulle head-covering appear to be identical to the Chanel gown produced later. In the biography of Frederick Ashton by Julie Kavanagh, the caption lists no date for the image, but one could infer that it was a period image dating to 1936. Had this been true, then the impact of British ballet on couture would indeed have been far-reaching and literal.[6] However, the photograph appeared in the April 1937 issue of British *Vogue*. Brae and Ashton were featured in an editorial along with fellow Sadler's Wells dancer Margot Fonteyn, and both women wear couture gowns, not costumes. The caption notes that Brae wears a dress credited to Rose Taylor and a "diamond bandeau" by the noted jewelry firm William Ogden. One can assume that Rose Taylor, a name regularly featured in English fashion magazines, legally licensed the Chanel original design for the British market. This single, romantic-style gown illustrates the amazing connection between the French artist Bérard, the choreographers Balanchine and Ashton, the Parisian couturier Chanel, the London fashion house of Rose Taylor, American, French, and British fashion magazines and photographers, and the Sadler's Wells Ballet. It also demonstrates the far-reaching reverberations of classical ballet on the worlds of art and design.

While the silhouette of romantic-style ballet costumes clearly influenced high fashion before World War II, *Aurora's Wedding* may have been the catalyst for the popularization of two trendy colors on the eve of global conflict: a vibrant shade of blue and pale purple (or lilac). From the 1890 debut of the original *Beauty*,

(facing) "The New Russian Ballet," September 15, 1932, *Vogue*. This is one of the first articles in a major fashion magazine presenting the popular trend of romantic-style ballet costumes.

(below) Silk tulle evening dress embroidered with sequined stars by Chanel. Photograph by Man Ray for *Harper's Bazaar*, May 1937. © Man Ray Trust/Artists Rights Society (ARS), NY/ADAGP. Paris 2015.

critics consistently lauded the production's gorgeous sets and costumes. With its bright and sometimes clashing pigments, *Beauty* recalibrated ballet's palette and made an indelible impression on Serge Diaghilev and his coterie of costume and set designers.

One of the signature variations in *Beauty* is the Bluebird *pas de deux*. Based on a fairy tale, Petipa choreographed it especially for Enrico Cecchetti, the Italian virtuoso who was instrumental in transforming the traditionally conservative roles of the male dancer. His performance as the Bluebird caused a sensation. Done properly, the dancer appeared to hover airborne throughout the demanding *brisés volés*, a scissoring series of beats and small jumps that shifted continuously from front to back. Enhancing the Bluebird was his costume in a rich, vibrant shade of blue.

This shade is remarkably similar to Elsa Schiaparelli's second signature color, "Sleeping blue" (after her "Shocking pink"). The presentation of her Summer 1940 collection on January 26 featured a "linen jacket trimmed with Sleeping blue velvet"[7] and a fitted black evening dress topped with a jet-trimmed bolero in the same color of blue. The latter ensemble was a hit. A full-page, color image of the dress and bolero illustrated by the Surrealist artist Lenore Fini appeared in the March 15, 1940 issue of *Harper's Bazaar*.[8] (On the opposite page was another rich blue Schiaparelli gown topped with a "bright pinkish red" bodice, also illustrated by Fini.[9]) The same jacket was photographed by Leslie Gill for the April 1940 issue of *Harper's Bazaar*.[10] The color celebrated Schiaparelli's latest perfume, aptly named "Sleeping." Described as a heavy, sugary scent with a touch of vanilla, "Sleeping" was bottled in a Baccarat-crystal candlestick with a lighted taper and a cone-shaped extinguisher. The bottle and taper were depicted in numerous advertisements illustrated by the artist Marcel Vertès between 1940 and 1948. Furthermore, the perfume was sold in a box depicting either a miniature eighteenth-century drawing room or a royal canopied bed.[11] The similarity between *Beauty*'s sets and Schiaparelli's packaging is unmistakable.

Sadler's Wells dancer June Brae in the role of the "The Rich Girl" with Frederick Ashton in his 1936 ballet, *Nocturne*. British *Vogue*, April 1937. Cecil Beaton/*Vogue* © Condé Nast Publications Ltd.

The curator Dilys Blum cites 1940 as the year of the perfume launch, while Schiaparelli's biographer, Palmer White, claims it was 1938. White's assertion may explain why Schiaparelli was already incorporating vibrant blue into her Winter 1938–39 collection: the January 1939 issue of *Harper's Bazaar* features her "turquoise velvet dress [. . .] embellished with sapphires and silver-thread embroidery." Vertès also illustrated two advertisements for *Shocking* perfume. In one, a dancer-like figure in a blue jacket draws back a stage curtain;[12] in the other, a young woman wears a cloak covered in candles.[13] The candle is symbolic in that other popular Russian ballet, *The Nutcracker*. (Indeed, elements of *The Nutcracker* were incorporated into the western productions of *The Sleeping Beauty*.)

Was Schiaparelli inspired by the fairy tale ballet? *Aurora's Wedding* was performed hundreds of time by the Ballets Russes throughout the 1920s and 1930s, so there would have had been ample opportunity for Schiaparelli to see it. And the designer was certainly aware of ballet. During a trip to Cuba in 1917, she was often mistaken for the ballerina Anna Pavlova, whom she resembled, and who was performing in Havana at that time.[14] After opening her couture house, Schiaparelli designed a striking white, coq-feathered cape for herself in 1931. This dramatic garment may have been a tribute to the great ballerina who died that year and whose signature work was "The Dying Swan."[15]

The color blue was also worn at various times by Princess Aurora. For her first Ballets Russes performance in London during the Fall 1911 season, Mathilda Kschessinska danced a *pas de deux* from *Beauty* with Vaslav Nijinsky. She wrote in her autobiography that Serge Diaghilev chose for her a "very beautiful blue costume, and together we discussed the question of the jewels I was to wear."[16] Diaghilev's costumes for the famous production in London in 1921 were confiscated to pay off debts, so for his abbreviated production of *Aurora's Wedding* in 1922, he commissioned Alexandre Benois to design new ones. Aurora's tutu was white with undulating bright blue branches appliquéd on top. It was worn, in various altered forms, for at least the next two decades.

Léon Bakst, designer
Costume for the Bluebird, ca. 1921
from the Ballets Russes' production of *The Sleeping Princess* [*La Belle au Bois Dormant*]
National Gallery of Australia, Canberra
Purchased 1980

Another color closely associated with *The Sleeping Beauty* is lilac, the signature hue of the story's heroine. By choosing this color, *Beauty*'s librettist, choreographer, composer, and designer evoked the flower's ancient and modern symbolism. Since antiquity, lilacs have been harbingers of spring, or rebirth. For the Victorians, in their "language of flowers" (sometimes called floriography), purple lilacs symbolize the first emotions of love, while white lilacs represent youthful innocence. This is most fitting as the Lilac Fairy mitigates the deadly spell of her antagonist, the evil fairy Carabosse. Angry that she was not invited to Princess Aurora's christening, Carabosse's spell originally called for Aurora to prick her finger on a spindle and die. However, the Lilac Fairy instead calls for Aurora to fall into a deep sleep for a century, only to be awakened by the kiss of a prince, her true love.

In the original 1890 production, lilac's symbolism is expanded further thanks to the costume design. While most of the non-dancing female characters wear eighteenth-century-style panniers, the Lilac Fairy wears a "corseted, bustled, *tapissier* [upholsterer] style of the contemporary couturier Charles Worth"[17] in Act II, as does Princess Aurora for her wedding. These modish costumes were more than fashion statements; they are linked "in divine right."[18] This would have been understood by contemporary audiences, as purple was long associated with royalty. It was a rare and precious commodity as the extraction of purple dye from the glands of mollusks was a highly labor intensive and expensive process. The Lilac Fairy's costume was also evocative of Minerva, the ancient Roman goddess of wisdom. As Tim Scholl has stated, "Many writers have noted the symbolism of the small effulgences of flowers that partially conceal the Lilac Fairy's martial guise: the lilacs that bloom from her helmet and mask [and] the long spear she carries symbolize wisdom in Russian folklore."[19]

Purple's denotation of royal power waned during the Victorian era, thanks to the discovery in 1856 of a lilac-colored synthetic dye called "mauveine" that could be produced easily. In 1862, the year after Prince Albert died, Queen Victoria was seen wearing this pale purple color to the Royal Exhibition and thus it soon became the color of half-mourning. Black clothing and veils associated with

(facing) Illustration for Elsa Schiaparelli's "Sleeping Blue" evening jacket by Lenore Fini, for *Harper's Bazaar*, March 15, 1940. Courtesy of Hearst Publications.

(below) Illustration for Elsa Schiaparelli's *Sleeping de Schiaparelli* perfume by Marcel Vertes, ca. 1940.

the first stage of mourning were replaced gradually by garments in shades of purple, as well as shades of gray.

As strict mourning rituals fell out of favor by the end of nineteenth century, fashion embraced the new-found, youthful spirit of lilac and similar pastel hues. By the 1930s, gone were lilac's connections to Victorian mourning ritual; in its place were warm-weather gowns embroidered with lilacs or ornamented with large lilac corsages. New York fashion retailers placed advertisements of their exclusive designs in the Spring 1940 issues of *Harper's Bazaar*. Bergdorf Goodman celebrated its "Full Moon Skirt of silk leaves and lilacs on stiff coarse net," while Stein & Blaine lauded a gown with the caption: "It's Lilac Time – fragrant exquisiteness." Editorial features in *Harper's Bazaar* that Summer also featured gowns by Alix and Chanel accessorized with lilac bouquets and corsages. Fashion's infatuation with lilacs coincided with the 1939 Sadler's Wells debut production of *The Sleeping Beauty* in London and numerous versions of *Aurora's Wedding*, which were presented by the Ballets Russes and the New York-based Ballet Theater throughout the 1930s and early in the 1940s.

While influences from the full-length 1921 production of *The Sleeping Beauty* upon ballet and fashion during the 1930s are still being discovered, its effect after World War II is undisputed. Of utmost importance was the 1946 revival staged by the Sadler's Wells Ballet. It is not too much to say that this production, which debuted at the restored Covent Garden Opera House in London with glorious sets and costumes by Oliver Messel, did for classical ballet what Christian Dior's 1947 New Look collection would do for fashion one year later in Paris. After the devastation of World War II and the deprivation that continued after the war's end, the Sadler's Wells production of *The Sleeping Beauty* was a revelation.

Perhaps it is appropriate that as one of the last viable monarchies in modern Europe, Britain restored classical ballet to its full glory and disseminated it throughout the western world. The dissident artists of the fallen Imperial Russian Empire "saw themselves," according to one critic,

Marie Petipa as the Lilac Fairy in the 1890 Mariinsky production of *The Sleeping Beauty*, St. Petersburg. Costume by Ivan Vsevolozhsky, photographer unknown.

"as ballet's rescuers, bestowing the kiss of life on an art that lay moribund in Paris."[20] That kiss, like the one Prince Désiré bestows upon the sleeping Princess Aurora, waking her and her court from a one hundred-year-long slumber, was again imparted on the British. And the post-war staging of *Beauty* became the hallmark of the British ballet.

The first Sadler's Wells production of *The Sleeping Beauty* in 1939 was indeed modest. The critic Arnold Haskell noted that Aurora's wedding was "rather sparsely attended"[21] and Margot Fonteyn, its star, was relegated to wearing a satin-covered cardboard crown (which she noted despairingly in her autobiography[22]). Although Britain was still recovering from World War II, its "make do and mend" philosophy of wartime fashion on a ration was not readily evident in the 1946 production. Audiences were unaware that the opulent looking costumes were made with whatever materials could be procured, such as cuffs made from paper doilies instead of real lace and curtains made from old parachutes. Compared with the Sadler's Wells pre-war effort, however, the 1946 version was resplendent.

In *Beauty*'s post-war revival, British ballerinas became the embodiment of classical beauty and chic. No dancer personified the correlation between classical ballet and fashion better than Margot Fonteyn (born Margaret Hookman; 1919–1991). A talented technician and a great actress, her body and carriage exemplified the look of the modern ballerina: sleek and elegant, with dark hair and features, and perfect proportions. She also danced in what was described as the "British style": one of restrained line, a ramrod straight back, and near flawless technical control that hid her great inner strength. Already a rising star in Britain during the 1930s and a national idol during the war, she became an international phenomenon after her 1949 debut in New York dancing Aurora in *The Sleeping Beauty*. Featured on the cover of *Time* magazine, Fonteyn's celebrity was enhanced by her affinity for fashion as she carried forth the Russian tradition set by the previous generation. This included the Imperial darling Mathilda Kschessinska

Evening dress by Bergdorf Goodman, New York. Its caption reads: "Full Moon Skirt of silk leaves and lilacs on stiff coarse net." *Harper's Bazaar*, May, 1940.

228 Fairy Tale Fashion

and world-famous Anna Pavlova. Both were regularly depicted not only in their dance costumes, but also wearing a range of high-fashion garments, from fur coats to tea gowns.

Like them, Fonteyn and her female colleagues were ideal models of contemporary fashion. Post-war styles evocative of the nineteenth century were perfect on the slender dancers who, in turn, modernized these historically inspired ensembles. When the Sadler's Wells Ballet embarked on its 1949 tour of the United States and Canada, the company highlighted not only British dance but also high fashion, and the Incorporated Society of London Fashion Designers used the tour as a selling tool. Designer members of the ISLFD, such as Norman Hartnell, Digby Morton, and Bianca Mosca, produced clothes and accessories for female members of the company, with special garments made for Fonteyn

The Sadler's Wells Ballet 1946 production of *The Sleeping Beauty*, Royal Opera House, London. Sets and costumes designed by Oliver Messel. Photograph of the Prologue by Frank Sharman/ Royal Opera House/ ArenaPAL.

and other ballerinas, including Pamela May, Beryl Grey, and Moira Shearer. On top of their grueling, sell-out tour, top dancers were photographed for American magazines and newspapers. Fonteyn, for example, modeled a Bianca Mosca black evening gown – the same gown she wore in America – and was photographed by Cecil Beaton for British *Vogue*. The dancer William Chappell wrote:

> I should have greatly enjoyed seeing Fonteyn's entrance into the reception given for the Sadler's Wells Ballet, after their premiere in New York in the autumn of 1949. I have been told that when she arrived the guests rose to their feet and broke into spontaneous applause. This could have been no less a tribute to the brilliance of her performance than to her actual looks, for I have little doubt that she appeared exactly as everyone hoped she would, the ideal of a ballerina.[23]

The collaboration between British designers and dancers was not sustained, at least not by Fonteyn. Soon after the war, she opted to buy her clothes at the house of Dior in Paris. Introduced to the couturier by the French dancer and choreographer Roland Petit, shortly after Dior's debut collection in 1947, Fonteyn recalled that the "Maison Dior decided to take me under its wing, and I bought one of the first seasons outfits [. . .] I bought some ravishing dresses from Dior and of course, ordered my wedding dress there."[24] The wedding ensemble, and approximately sixty other fashion objects from her wardrobe that exist in public collections, including the Fashion Museum in Bath, England, were designed by Christian Dior, and then, after Dior's death in 1957, Yves Saint Laurent. Some items, such as a beautifully simple Dior gown that Fonteyn wore on her tour to Australia in 1957, echo the bodices of her post-war costumes. Fonteyn, in turn, may have been the inspiration for Dior's "Cygne Noir" (or "Black Swan") evening gown, designed for his Autumn/Winter collection of 1949–50. William Chappell noted that Fonteyn loved Paris and, "she fits now, most neatly, into the background of that ravishing city. She has chic that is not so much French as international, although she is usually dressed by Dior. [Anna] Pavlova

Margot Fonteyn as Princess Aurora in *The Sleeping Beauty*, ca. 1950. ©Maurice Seymour, courtesy of Ronald Seymour, the Royal Academy of Dance. This photograph may have been taken while the Sadler's Wells Ballet was on tour in the United States and Canada in 1949.

showed the same kind of elegance, a timeless style, that to-day [sic] Fonteyn in Paris seems to move in a setting built especially for her."[25]

By the late years of the 1940s, French couturiers often created dresses that echoed the look of post-war classical ballet costumes. Christian Dior, along with Pierre Balmain and Jacques Fath, designed a continuous stream of evening gowns with strapless bodices constructed like corseted ballet costumes that sat atop full skirts made from layers of tulle and other filmy fabrics. Even the fashion show presentations at Dior were balletic. Reportedly, house models were taught how to stand and how to walk, specifically through classical ballet training. As the models brushed by the seated attendees, they twirled. Dior would even try his hand at designing ballet costumes. For Roland Petit's *Trieze Danses* in 1947, and against a plain stage set, Dior's costumes were "fantastic, ingenious, and beautiful in themselves, but too exquisitely conceived to be effective in a theatre."[26]

Fonteyn was not the only British ballerina to promote Parisian couture. Early in the 1950s, Moira Shearer, a fellow principal at the Sadler's Wells Ballet, would become the most famous ballet dancer in the world because of her starring role in the British film *The Red Shoes*. While she also was the first Cinderella in Ashton's full-length ballet set to the music of Sergei Prokofiev, as well as a model for British companies such as Church shoes, it was the film that made her a star. Although the storyline differs significantly from Hans Christian Andersen's famous 1845 version, the film of *The Red Shoes* is nonetheless a riveting modern-day fairy tale containing outstanding dance sequences. It is considered to be one of the best films of its time and the best ballet movie ever made.

A key element of *The Red Shoes* is its gorgeous costumes. The film credits "Miss Shearer's Dresses" to "Jacques Fath of Paris" and "Mattli of London," and "Mlle. Tcherina's [her fellow dancer] Dresses" to "Carven of Paris." The wardrobe credit goes to Dorothy Edwards who, one assumes, designed and oversaw the dance costumes and rehearsal clothes. Everything in *The Red Shoes* is a hymn to excess, understandable in the post-war era. Its ultimate symbol is one particular Fath gown, whose iridescent blue-green color and silky sheen enhances Shearer's rich, bright auburn hair and pale complexion. Topped with a matching cape, the silhouette of the layered and tiered tulle gown is evocative of those designed by Norman Hartnell for the Queen Mother before the war. Shearer's crowning touch is just that – a small, jeweled crown akin to that worn by Prin-

Margot Fonteyn married Roberto "Tito" Arias in Paris, on February 6, 1955. She wore a gray silk faille dress and an elaborate blue and brown feather headdress, both by Christian Dior. © Bettmann/Corbis.

cess Aurora. The gown, the crown, and the ballerina were constant elements within the post-war, historicized couture lexicon.

In the minds of most critics, ballet's great mid-century revival waned before Frederick Ashton's death in 1988, and the even earlier passing of his transatlantic competitor, George Balanchine in 1983. Like haute couture, ballet's glamor and creativity, so vital during the hardships of the Depression, World War II, and the Cold War, had already begun to dim during the 1960s. Jennifer Homans, in her tome on ballet, *Apollo's Angels*, wrote:

> If we are lucky, I am wrong and classical ballet is not dying but falling instead into a deep sleep, to be reawakened – like *The Sleeping Beauty* – by a new generation [. . .] If artists do find a way to reawaken this sleeping art, history suggests that the kiss may not come from one of ballet's own princes but from an unexpected guest from outside – from popular culture or from theater,

(left) Moira Shearer as Cinderella in Frederick Ashton's 1948 full-length ballet, *Cinderella*.

(right) Moira Shearer wearing a gown by Jacques Fath in the film, *The Red Shoes*, 1948. ©Moviestore/REX Shutterstock.

music, or art; from artists or places foreign to the tradition who find new reasons to believe in ballet.[27]

The 2010 publication of *Apollo's Angels* was sandwiched between two important contemporary revisions of the original 1890 *The Sleeping Beauty*. In 1999, the Mariinsky mounted a lavish and faithful version, replete with accurately rendered costumes. Despite its length, "four hours long, this *Beauty* flies by," noted Laura Jacobs.[28] In 2015, American Ballet Theater staged its version of *Beauty* with 1890s-era choreography and costumes from *The Sleeping Princess* of 1921. Both adaptations received a great deal of attention in the press. Even more noteworthy was the ballet film, *Black Swan*. The 2010 movie was a hit despite grumblings about its clichéd portrayal of ballerinas and weak dance sequences. Such attention reflects, at least in part, the burgeoning of interest in ballet by an uninitiated generation of fashion professionals.

Since the beginning of the twenty-first century, the world of fashion has taken an increasingly strong interest in classical ballet. Ballet productions as well as ballet dancers are regular features in magazine editorials and on fashion blogs. A number of top fashion figures, including Carine Roitfeld, have begun to take ballet classes. Major dance companies, such as the New York City Ballet, regularly hire leading fashion designers to create costumes for newly commissioned works each year. Superstar couturiers from Karl Lagerfeld to Laura and Kate Mulleavy of Rodarte have tried their hands at designing classical tutus. Could fashion be that "unexpected guest," one whose love of ballet will be a key element in its resurgence? If so, perhaps the fairy tale narrative will also be the tie that binds together these beautiful and enchanted entities, and leads them both into new realms of creativity.

Notes

1. Joan Acocella, "Fifty Shades: Alexi Ratmansky stages the 'Sleeping Beauty.'" *New Yorker* (June 1, 2015) (accessed May 30, 2015, www.newyorker.com).
2. Laura Jacobs, "Tchaikovsky at the Millennium," *New Criterion*, vol. 18 (September 1999): 24.
3. Alexander Benois, *Memoirs*, 2 vols. Trans. Moura Budberg (London: Chatto and Windus, 1964); and *Reminscences of the Russian Ballet*. Trans. Mary Britgiegva (London: Putnam, 1941). As quoted by Beth Genné, "Creating a Canon, Creating the 'Classics' in Twentieth-century British Ballet," in *Dance Research: The Journal of the Society for Dance Research*, vol. 18, no. 2 (Winter 2000): 156, n. 16.
4. Arnold Haskell, *The Sleeping Princess* preliminary notice and order for the Sadler's Wells premiere performance on Thursday, February 2, 1939, Enthoven Collection, Theatre Museum, London. As quoted by Genné, "Creating a Canon," 160, n. 63.
5. Mary Clark, "June Brae" (obituary), *Guardian* (January 12, 2000) (accessed July 4, 2015, www.theguardian.com).
6. According to several British critics, Fedorovitch was a highly talented artist who was both compared with and eclipsed by Christian Bérard. Elizabeth McLean, "Influences and Inspiration: The Ballet Designs of Sophie Fedorovitch," *Research in Dance Education*, vol. 13, no. 2 (July 2012): 197.

 It should also be noted that the Sadler's Wells ballet participated in the in the 1937 Exposition Internationale des Arts et Techniques dans la Vie Moderne, held in Paris. The company performed several one-act ballets by Ashton at the Théâtre des Champs-Élysées in June to little fanfare. It is not clear whether or not *Nocturne* it was performed but William Chappell mentions this ballet in his discussions of the Paris trip. William Chappell, *Fonteyn: Impressions of a Ballerina*, London: Spring Books, 1951, 25–29.
7. Dilys Blum, *Shocking! The Art and Fashion of Elsa Schiaparelli* (Philadelphia: Philadelphia Museum of Art, 2003), 239.
8. *Harper's Bazaar* (March 15, 1940): 42.
9. *Harper's Bazaar* (March 15, 1940): 43.
10. *Harper's Bazaar* (April 15, 1940): 68.
11. Palmer White, *Elsa Schiaparelli: Empress of Fashion* (New York: Rizzoli, 1986), 156.
12. *Vogue* (December 1, 1939): 92.
13. *Vogue* (December 15, 1939): 2.
14. Blum, *Shocking!*, 45.
15. Blum, *Shocking!*, 45.
16. Mathilda Kschessinska, *Dancing in Petersburg: The Memoirs of Kschessinska* (London: Gollancz, 1960), 133.
17. Jacobs, "Tchaikovsky at the Millennium," 26.
18. Jacobs, "Tchaikovsky at the Millennium," 26.
19. Tim Scholl, *Sleeping Beauty: A Legend in Progress* (New Haven and London: Yale University Press, 2004), 36. Scholl cites the work of the Russian scholar, Marina Konstantinova and her 1990 publication on *The Sleeping Beauty*.
20. Arlene Croce, *Writing in the Dark, Dancing in the New Yorker* (New York: Farrar, Strauss, and Giroux, 2000), 741.
21. Arnold Haskell, Mark Bonham Carter, and Michael Wood (eds.), *Gala Performance* (London: Collins, 1955), 54.
22. Fonteyn described her three tutus as "bare" and "'little cotton house frocks' instead of the rich costumes suitable for a ballerina." Margot Fonteyn, *Margot Fonteyn: Autobiography* (New York: Alfred A. Knopf, 1976), 70–71.
23. Chappell, *Fonteyn: Impressions of a Ballerina*, 84.
24. Fonteyn, *Margot Fonteyn*, 101.
25. Chappell, *Fonteyn: Impressions of a Ballerina*, 29.
26. Richard Buckle, *Modern Ballet Design* (London: Adam and Charles Black, 1955), 78.
27. Jennifer Homans, *Apollo's Angels: A History of Ballet* (New York: Random House, 2010), 550.
28. Jacobs, "Tchaikovsky at the Millennium," 26.

Dancing, Desire, and Death:
The Role of Footwear in Fairy Tales

By Ellen Sampson

> Then she seated herself on a stool, drew her foot out of the heavy wooden shoe, and put it into the slipper, which fitted like a glove. And when she rose up and the king's son looked at her face he recognized the beautiful maiden who had danced with him and cried, that is the true bride.[1]
>
> ("Cinderella" by the Brothers Grimm)

The most famous of all fairy tale transformations may be the moment when Cinderella, found by the prince who has been searching for her, changes from a lowly servant girl into a royal bride. The symbol of Cinderella's transformation is a shoe, a single golden slipper. She achieves her alteration when she is shod by the prince: he places the slipper upon her foot and finds that it is a perfect fit.

In the pantheon of fashion, the shoe holds a particular place as an object that is both everyday and symbolically loaded. Shoes are often interpreted as representative of their wearers; people talk of "reading" people by their shoes.[2] Shoes are regularly task-specific (designed for a particular activity or occasion), and through this specificity, they may come to represent a wearer's gender, age, social status, employment, or behavior. Shoes are, to borrow Freud's term, "over determined"[3] objects, ambiguous and multivalent.

Shoes are potent symbols in folklore, recurring across multiple stories and cultures.[4] In fairy tales, shoes are magical objects, artifacts that may pique one's

Illustration for "The Twelve Dancing Princesses" by Arthur Rackham, 1909

desire, incite one to dance, or lure one toward danger and death. Red shoes, glass slippers, iron pattens, and giant boots litter fairy tales; they are metaphor and materiality entwined. Fairy tale shoes are at once analogous to real-world shoes and something different altogether.

Although shoe tales exist across many cultures and locations, this essay focuses upon four that were written or recorded by the Brothers Grimm and Hans Christian Andersen early in the nineteenth century: "Cinderella,"[5] "The Red Shoes,"[6] "Snow White,"[7] and "The Twelve Dancing Princesses."[8] Through collection and publication, and their subsequent reiteration and reinterpretation in film and animation, these stories have been transformed from their origins in the spoken word. It is these transformed tales, edited heavily and bowdlerized, that have come to typify fairy tales today. When we speak of fairy tale weddings, fairy tale dresses, or fairy tale castles, it tends to be the filmic Cinderellas,[9] Sleeping Beauties,[10] or Snow Whites[11] that we refer to, not their darker and more ambiguous literary ancestors explored in this chapter.

Although footwear has been described as the "Cinderella of fashion theory,"[12] ignored by academia in favor of other garments, it functions as a powerful and complex symbol within folklore. Fairy tales, like all forms of mythology, use metaphor to unravel and contextualize the problems of day-to-day life. They are, to paraphrase Levi-Strauss, "good to think with." Fairy tales are systems of signs, or sets of metaphors, for teaching and learning about the world. The psychoanalytic folklorist Marie-Louise Von Franz suggests that "fantasy [within fairy tales] is not just whimsical ego-nonsense but comes really from the depths; it constellates symbolic situations which give life deeper meaning and a deeper realisation."[13] These tales emphasize the desirable traits and temperaments to which their readers should aspire. Bruno Bettelheim points to the task of sorting lentils from ashes set by Cinderella's stepmother as representative of the obedient behaviors that fairy tales teach: "[T]o develop one's personality to the fullest, one must be able to do hard work and be able to separate good from evil, as in the sorting of the lentils."[14] The situations played out in fairy tales are lessons with relevance beyond the story.

In fairy tales, as in the real world, clothing is often viewed as an agent of change; alter egos and true selves are mediated and produced through clothes. Shoes, with their ability to help or hinder movement and to elevate their wearers, are literal and metaphorical causes of transformation. In fairy tales, the acquisition of shoes is often linked to a shift in a wearer's status or morality; new

shoes enable the production of a new self. In many cases, fairy tale shoes are not representative merely of a change or shift in their wearers' status or experience, but are the catalysts and facilitators of the change itself. From Cinderella's glass slippers to Dorothy Gale's ruby ones,[15] magical shoes have the capacity to alter far more than their wearers' outfits. Hilary Davidson[16] writes of the frequent occurrence of magical-shoe tales across cultures and the ways in which they behave: "In tales from Ireland to Canada, Iceland to India, wondrous shoes render their owners invisible, carry them on the sea, let them climb a stone pillar, sing their way through the snow, produce love, point out the right road, and even approve judicial decision."[17]

Although magical shoes in fairy tales may perform many functions, they all at some point permit a crossing of boundaries, a shift from one state, form, or space to another. In being shod, the characters in these tales are altered. They are made beautiful, manic, or liberated, and sometimes they are killed. For Cinderella, the shift is in social and marital status, from pauper to princess. For Karen in "The Red Shoes," the change is of movement and gesture, as her shoes begin to take control of her body. In "The Twelve Dancing Princesses," change is both geographical, from high tower to subterranean cavern, and emancipatory, as the princesses are freed from their father's control. Finally, for the wicked stepmother in "Snow White," the change is – through the application of red-hot, iron shoes – pain and death.

Fairy tale shoes may be read as metaphors for their wearer's bodily self, either the body as a whole or a particular aspect of it. Freudian interpretations of footwear, particularly in fairy tales, have read the shoe as both a phallic and a vaginal symbol.[18] Bettelheim[19] interpreted being shod in fairy tales as both productive of bodily pleasure and as symbolic of the onset of sexual maturity. In "The Twelve Dancing Princesses," a king wakes each morning to find his daughters' shoes "danced to pieces;" that is, worn out through the pleasure of dance. Unable to understand how the princesses escaped from their locked room, he employs a soldier to follow them. Bettelheim interprets the sisters' nightly sojourns, during which they descend into caverns of subterranean pleasure, as a metaphor for sexual awakening. Similarly, Freudian interpretations of Cinderella have focussed on the shoe as a bodily metaphor: in the act of being shod, Cinderella is deflowered. Eroticising fairy tale footwear gives it potency, and in turn makes the shoe an additional bodily boundary that must be policed. Shoes are read as sexual metaphors both within and outside fairy tales; Havelock Ellis even sug-

gested that "of all the forms of erotic symbolism, the most frequent is that of the foot and shoe."[20] The feet, as analogs to the self, are particularly vulnerable to pollutants. As Mary Douglas states, "Bodily margins are thought to be specifically invested with power and danger."[21] Thus feet and shoes, the extremities of the body, are especially vulnerable peripheries.

Much like real shoes, fairy tale shoes act as signifiers of adherence to a social contract. To shoe oneself is to prepare to become social, and in so doing to forgo certain freedoms; putting on shoes is an act of consent. If the acquisition of footwear within fairy tales represents a shift or juncture in the characters' experiences, it also signals a change in their relationship to society. Fairy tales often describe young women on the cusp of adulthood and fecundity, and the sense is that their bodily experience or freedoms must be policed carefully. Shoe tales and superstitions relate frequently to rites of passage. They may highlight the shift from childhood to adulthood or from unwed to wed. In wedding and marriage customs, shoe symbolism abounds – from the tying of shoes to the back of wedding cars,[22] to Swedish brides placing coins in their shoes,[23] to Indian bridesmaids stealing the groom's footwear. Just as Cinderella's transformation from maiden to bride is mediated through shoes, in Finnish "shoeing laments," the ritual act of the bride being shod by a male relative marks her final departure from the family home:

> Why are you shoeing me my little brother-maple tree,
> Why are you putting stockings on me at night?
> Even God's little birds have gone to sleep,
> And they are all in their nests.
> Why are you hurrying my most unhappy self
> On this greenish last evening?
> I should feel better at this hour
> If you would shoe me with shoes of death.[24]

Objects Of Desire

"In 'Cinderella,' the pretty, tiny foot exercises an unconscious sexual appeal, but only in conjunction with a beautiful, precious slipper into which the foot fits snugly."[25] The shoe in "Cinderella" is an object of desire, a found talisman that the prince believes will lead him to his true love. To catch a wife, he must first possess her shoe. Often in fairy tales, as in contemporary western culture, shoes

239 Dancing, Desire, and Death

are presented as a locus of uncontrollable longing. Examples of women lusting over shoes are familiar, such as Carrie in *Sex and the City* spending $40,000[26] on shoes and Imelda Marcos's 3,000-pair collection.[27]

Within a culture of commodity fetishism, shoes have come to represent far more than a means of protecting the foot. Footwear has long been an object of conspicuous consumption, from red-heeled seventeenth-century court shoes to red-soled twenty-first-century Christian Louboutins. Footwear acts in a dual manner, both as a status symbol and an artifact that can literally raise you above the street and the heads of others. Perhaps more than any other garment, shoes may demarcate where one stands within the social system: whether one should be looked up to or down upon. In fairy tales, shoes frequently represent a shift in status, from Cinderella's upward trajectory, to Puss in Boots's anthropomorphic shift. The acquisition of finer and more delicate shoes indicates the ability to eschew sensible shoes designed for manual labor or traversing long distances – activities undertaken by the lowly. In this context, "impossible shoes" such as Cinderella's glass slippers – shoes that one could never walk in – are particularly telling. Her shift from sabots to slippers, even without the attendant transformation of rags to magnificent clothing, pumpkin into carriage, and mice into footmen, would be enough to indicate her upward social shift. This transformative potential makes the shoe an object of desire that is coveted, stolen, or otherwise procured at any cost.

Although fairy tale shoes exist only as a fantasy, their material forms and qualities are amply described: golden slippers, glass shoes, and boots of bright red kid leather are conjured up for the reader. The shimmering materiality of these artifacts is no accident. They are written to trigger our desires, to tempt readers much as they would tempt the characters within the tales. In contemporary versions of the Cinderella story (and in particular the animated Disney version of 1950), her slippers are usually glass. However, they may be made of other equally alluring materials, as long

Cinderella shoe by Christian Louboutin, 2012
Courtesy Christian Louboutin

as their spectacular materiality sets them apart from everyday shoes and demarcates their magical or transformative potential. As Davidson states, "Cinderella's slippers are always splendid. Some are red: Madame d'Aulnoy adorned her Finette Cendron's feet with 'red velvet embroidered with pearls.' Others are of silk, satin, spangled with jewels, matchless, or like the sun. Overall, though, the cinder-girl's shoes are golden."[28] Fairy tale shoes are extraordinary artifacts, spectacular in their beauty, size, and/or form. Even plain shoes, such as Cinderella's clogs, are exceptional in their abjection and resulting capacity to signify her poverty and subjugation.

In "The Twelve Dancing Princesses," the materiality of the shoes is a pervasive theme. Toes are continuously scuffed and soles worn through: "When [the king] awoke the next morning, the twelve had been dancing, for their shoes all had holes in their soles."[29] The king is disturbed by the failure of his daughters' shoes to retain their pristine state. Their shoes, acting as metaphors for their physical selves, are sullied by their night-time activities.

The color of fairy tale footwear is also symbolic – redness, in particular, alludes to blood, vitality, and sin. Fairy tale shoes are often made in regal colors, which afford status and distinguish them from everyday black or brown. These include red ("The Red Shoes," "The Juniper Tree," "The Snow Queen," and "The Elves and the Shoemaker"), gold ("Cinderella"), and silver ("Cinderella," *The Wonderful Wizard of Oz*). Fairy tale shoes are meta-symbols, objects abundant with signification, spilling over with meaning and metaphor.

Longing, yearning, and craving – the desire for what one does not and may not have – is one of the predominant themes in fairy tales. The longing that shoes trigger in fairy tales is not simply a desire to possess them, but a yearning for their power to transform. Fairy tale shoes possess qualities beyond those of the normal material world, allowing their wearers to travel further,[30] dance faster, battle supernatural forces,[31] or change their bodily forms. From Prince Charming's tireless search for the woman who will fit the glass slipper to Karen's yearning for inappropriate and impractical red shoes, footwear triggers a relinquishing of

Illustration for "Puss in Boots" by Walter Crane, 1874

the self to desire. Heroes are sent on seemingly impossible errands, pregnant women trade children for delicious things to eat, brides yearn for babies, and wives are sought continually. The satiation of longing can be both the fairy tale "happy ending" and a trigger for catastrophic events. Even in darker tales, such as "The Juniper Tree," the satisfaction of acquiring new shoes is evident. "Oh," the tale's protagonist, Marlinchen, says, "I was so sad when I went out and now I am so contented. That is a splendid bird, he has given me a pair of red shoes."[32] Susan Stewart[33] writes of how longing for an artifact makes it animate; through desire, objects become vital and life-like. Within fairy tales, the simple act of wanting may awaken static objects and render them capable of movement and mischief.

Yielding to desire is quite at odds with the Calvinist Protestantism prevalent at the time when many of these stories were recorded. In a culture of self-denial, giving in to desires was a transgressive act. Just as shoes may trigger uncontrollable longing, they may also trigger another sin: envy. In the Grimm Brothers' version of "Cinderella," the shoes cause her stepsisters to butcher their own feet in a desperate quest for what the shoes represent: the chance of marriage to the prince. Judith Long Laws writes about "the familiar image of Cinderella's stepsisters industriously lopping off their toes and heels so as to fit into the glass slipper (key to the somewhat enigmatic heart of the prince) – when of course it was never intended for them anyway."[34] In "The Red Shoes," the beauty of the shoes emphasizes the difference between Karen's life and that of a count's daughter: "Amongst the shoes stood a pair of red ones, like those, which the princess had worn. How beautiful they were! And the shoemaker said that they had been made for a count's daughter, but that they had not fitted her."[35] In the acquisition of these shoes, Karen indicates that she considers herself equivalent to aristocracy; she literally puts herself in their shoes. The redness of Karen's shoes tempts her as an apple would tempt Eve. Their red coloring acts as a warning, and is indicative of the destruction that they will cause. These shoes seem to compel our heroine to step out of line – to aspire to the lives of others. Compulsivity and ambition, particularly among young women, are perceived as dangerous.

In contrast to Karen, Gerda in "The Snow Queen"[36] gives up her red shoes willingly, though she adores them. This demonstrates her moral fortitude and self-sacrificing nature, and she reveals her capacity to shun the material for the spiritual in the form of friendship. Through this abstemious behavior, Gerda shows that she possesses desirable feminine traits. She is humble, while Karen

is proud; Snow White is modest, while the stepmother is vain; Cinderella is selfless, while the stepsisters are greedy. These tales are warnings against the vices of self interest, vanity, and desire. Giving into desire is to refuse or reject the normative feminine traits of eighteenth-century Europe: modesty, humility, and subservience. It is an engagement with bodily self that is active rather than passive. Desire and the longing for shoes enlivens the static, female, fairy tale body.

Dancing

> Once upon a time there was a king who had twelve daughters and each of them was more beautiful than the next. They slept together in a big room in a row and every night, when they had gone to bed, the king locked them in and bolted the door. But when he opened the door the next morning, he always saw that their shoes had been danced to pieces, and no one could ever make out how this had happened. So this king proclaimed that whoever could find where his daughters had spent the night dancing, could marry which of them he chose.[37]
>
> ("The Twelve Dancing Princesses" by the Brothers Grimm)

The opening lines of "The Twelve Dancing Princesses" presage the intense and secretive night-time dances of the sisters. Desire animates the shoe and makes it powerful; in turn, shoes may compel our heroines to dance. Whether the performance they inspire is a formal courtly dance or a maniacal *danse macabre* depends upon the moral constitution of the wearer. The good and humble dance meekly and demurely, while those unable to control their bodily desires are contorted and compelled by their shoes. Dance – and in particular dancing as a forbidden transgressive act – is a recurrent theme within fairy tales. Cinderella goes to the ball, Karen dances until she is near death, and the twelve princesses retreat to a subterranean cavern to dance the night away. In each case, the shoes facilitate the dance.

Th dance historian Sally Barnes states that "dancing is often a metaphor for libidinous sexuality."[38] Dancing as a form of sexual display is acceptable only when performed in a controlled manner. Within the correct context, dancing serves to highlight the desirability of the performers, without bringing their

Illustration for "The Twelve Dancing Princesses" by Elenore Abbott, 1920

244 Fairy Tale Fashion

morality into question. It is the formalized setting of the arena (the ballroom, stage, or party) and the expectations of those watching that make dancing acceptable, but dancers within fairy tales frequently fail to adhere to the rules. Outside its designated performance spaces, dance becomes threatening or dangerous. For fairy tale heroines, the consequences of dancing too hard and too fast, or dancing in the wrong places or in the wrong ways, are terrible.

In fairy tales, women's bodies are strictly regimented and disciplined. They are controlled physically (putting Sleeping Beauty or Snow White to sleep), spatially (locking Rapunzel in a tower), maritally (gifted to Rumpelstiltskin as a

Illustration for "The Twelve Dancing Princesses" by Kay Nielsen, 1912. Picture Collection, New York Public Library, Astor, Lenox and Tilden Foundations

reward), or sexually. Their bodies may be transformed (into geese or trees), altered (made handless or footless, smaller or larger) or even consumed, but they are rarely inhabited or possessed by their owners for long.

Unusually, in "The Twelve Dancing Princesses," through dancing, our heroines inhabit their own bodies – they take ownership of them. Dancing in this particular fairy tale is an act not only of performance and pleasure, it is one of defiance. Expanding upon Bettelheim's psychoanalytic reading of "The Worn out Dancing Shoes" (an alternate title for "The Twelve Dancing Princesses"), Hayley Thomas[39] interprets the tale as being about mobile women capable of rebellion and subterfuge, and contrasts that with the paralysis and silence normally experienced by fairy tale heroines. Ruth Bottigheimer suggests that silence reflects the social context in which the tales were written, stating, "Silence as a positive feminine attribute gained wide acceptance in the free cities that made up the Germanys."[40] Hence the role of the fairy tale is to teach the values of silence and passivity. Jenny Waelti-Walters[41] suggests that central to that passivity is the process of loss of the self, that the malleability of the Grimms' heroines expresses their submission to wills of their fathers and lovers. Similarly, Madonna Kolbenschlag explores the ambivalence of these stories, and the ideas of passive endurance and submission that underpin them.

Traditional connotation would, of course, associate it with the paternal mandate of obedience, and a threat: if the heroine does not return to domesticity and docility at regular intervals she may lose her "virtue" and no longer merit her expected one. Like the old conduct manuals for ladies, the moral of the tale warns against feminine excursions as well as ambition.[42]

In the context of this passivity and bodily stillness, it is worth noting that a shoe's primary function is to facilitate movement. Shoes are, after all, made for walking. In putting on these shoes, fairy tale heroines are made able – or are forced – to dance. They cross spaces and boundaries, moving from garret to palace, from street to church to graveyard, and from castle to cave.

In interpreting the "The Twelve Dancing Princesses," Thomas suggests that "the holes in the soles of his daughters' shoes attest to the intensity and duration of their dancing."[43] For Thomas, the intensity of the princesses' rebellious movements is where the symbolism of the story lies. Shoes represent a shift in that their wearer gives in to their allure – there is a loss of self-control. These shoes, with their magical or malevolent qualities, compel the characters to act. There is an obvious ambiguity about who is in control: do the wearers or the

shoes perform the dance? For Karen, leaping in agony, the shoes are steadfastly in control. She is overtaken by them. As Erin Mackie states, "Karen is driven by the shoes that are at once inseparable from her body and severed from her will in ways that violate both her autonomy and body."[44]

Death

> And when she went in she recognized Snow-White, and she stood still with rage and fear, and could not stir. But iron slippers had already been put upon the fire, and they were brought in with tongs, and set before her. Then she was forced to put on the red-hot shoes, and dance until she dropped down dead.
>
> ("Snow White" by the Brothers Grimm)

In the denouement of the Grimms' "Snow White," the stepmother is punished for her jealousy of Snow White's burgeoning beauty by being forced to perform an unbearable dance in heated metal shoes. This wicked queen's literal dance of death is indicative of the punishments that animate bodies endure in fairy tales. Women who stray from the desirable traits of self-abnegation and give into their longings are punished – in "The Red Shoes," Karen's feet are amputated, in "Snow White," the stepmother is executed, and in "Cinderella," the stepsisters are maimed. In filmic fairy tales such as *The Wizard of Oz*[45] and *The Red Shoes*, the Wicked Witch of the East and Vicky Page are crushed by a house and a train, respectively. The animation of the body that shoes induce is punished in the most violent and spectacular manner. Fairy tales are spectacles, fables in which horrors are acted out. The spectacle was one of many methods used to discipline and control the social body. Michel Foucault writes of public executions and torture, and in many ways the mechanics and function of spectacles in fairy tales are similar. For example, the reader's body is made docile through learning about the punishment of another equivalent body in the tale: "In the ceremonies of the public execution, the main character was the people, whose real and immediate presence was required for the performance. An execution that was known to be taking place, but which did so in secret, would scarcely have had any meaning."[46]

Bodies in fairy tales are often punished repeatedly and violently. The production of stillness and silence is the aim of fairy tale violence – it renders the (female) body docile. Foucault writes, "A body is docile that can be subjected,

used, transferred and improved."⁴⁷ Within these tales, desire animates the shoes and they, in turn, animate the body, inducing movement and disruption. The body that wears magical shoes is not docile and disciplined, but subversive and hard to control.

The putting on of shoes and the ensuing animation compels or encourages transgressive acts. The wearers cross boundaries or enter spaces not normally accessible to them. The type of transgression is particular to each fairy tale and relates to the type of behaviors the tale is attempting to teach. Cinderella, from her position of humility, attempts and finally succeeds at crossing class boundaries. Isabel Cardigos suggests that shoes "amplify the meaning of disjunction, which is now the enchanted freedom of moving between two realms: the arms of the prince (when in riches) and away from them (when in rags)."⁴⁸ Conversely, Cinderella's stepsisters, who have "hearts that were foul and black,"⁴⁹ are punished violently for pretending to be what they are not. In the Brothers Grimm version of the tale, they attempt to pull the wool over the eyes of the prince, and their punishment is to be blinded: "When the wedding came to an end, and Aschenputtel [Cinderella] and her prince marched out of the church, the doves flew again, striking the remaining eyes of the two evil sisters blind, a punishment they had to endure for the rest of their lives."⁵⁰

For Karen in "The Red Shoes," her final pair of shoes⁵¹ – costly, red leather boots – induce geographic and moral transgression. She thinks of "nothing but the shoes" while receiving communion, and later dances on graves:

> She was frightened, and wanted to throw the red shoes away; but they stuck fast. She tore off her stockings, but the shoes had grown fast to her feet. She danced and was obliged to go on dancing over field and meadow, in rain and sunshine, by night and by day – but by night it was most horrible.⁵²

Her punishment for these mortal sins is simple: the objects of her desire possess her, so that she is taken over by them and the dance. The curse from the sorcerer is to "dance in your red shoes till you are pale

Illustration for "Cinderella"
by Harry Clarke, 1922
Image courtesy Fashion Institute of Technology/SUNY, FIT Library Special Collections and FIT Archives

and cold, till your skin shrivels up and you are a skeleton."[53] The shoes, which made her forget her piety and humility, consume her so totally that eventually her feet must be cut off to remove them.

In "Snow White," the queen's transgressions are many, but it often seems to be her pride and envy that are punished, rather than her murderous rage. She is unwilling to be cast aside for a younger version of herself. The Brothers Grimm write, "She was a beautiful woman, but she was proud and arrogant, and she could not stand it if anyone might surpass her in beauty."[54] Her punishment, like that of Cinderella's stepsisters, occurs after Snow White's wedding, where happy ending and horror story are intertwined. Although the queen is the only character who kills in the tales I have examined here, all of the women who step out of line are punished, through amputation, blinding, or death.

Although at times these tales may seem defined by their violence, as morality tales they must also offer moments of reform and the possibility of redemption. It is important that some, if not all, unruly and wayward bodies are again made docile and obedient. The characters that are not punished for their transgressions are those whose restless movements may be stilled. Through marriage, patriarchal rule is re-established and the dancing is stopped. Both the twelve princesses and Cinderella are reformed through their incorporation into this social contract. The princesses' nightly jaunts are resolved by the halting of their dances, and for Cinderella by the stealing of one of her shoes. The image of the prince covering the palace steps with pitch in order to trap Cinderella's beautiful, delicate shoe is potent:

> On the third evening, she appeared dressed in spun gold with slippers of gold. Now the prince was determined to keep her, and had the entire stairway smeared with pitch. Aschenputtel [Cinderella] lost track of time, and when she ran away one of her golden slippers got stuck on that pitch.[55]

Enchanted by her beauty and frustrated by her nightly vanishing act, the prince attempts to trap Cinderella by fixing her feet to the ground.[56] Quite literally, he is going to stop her dancing away from him. In "The Twelve Dancing Princesses," the young women's night-time trips to dance with the enchanted princes allow them to explore caves, wander forests, and cross lakes, their bodies in almost perpetual motion. They are stilled through the marriage of their eldest sister to the soldier who has uncovered their secret.

In "The Red Shoes," Karen also finds reformation, though it is partial and achieved through a violent act. Her capacity to move freely is taken from her.

Illustration for "Cinderella" by Gustave Doré, 1867

Her salvation is the amputation of her feet and her shoes, and she learns to repeat the repentant psalms of prisoners and to kiss the hand that crippled her:

> And then she confessed her entire sin, and the executioner struck off her feet with the red shoes, but the shoes danced away with the little feet across the field into the deep wood. And he carved out little wooden feet for her, and crutches, taught her the psalm criminals always sing; and she kissed the hand which had wielded the axe, and went over the heath.

Notes

1. Jacob and Wilhelm Grimm, "Aschenputtel," in *Children's and Household Tales* (publisher unknown, 1812), 231.
2. In 2011, the UK's Educational and Social Research Council funded a project titled, "If the Shoe Fits: Footwear, Identification and Transition," (Jenny Hockey, *et al*) at Sheffield University. It looked at the symbolic meanings afforded to shoe shopping. In particular they examined how buying and retaining footwear post-use can be linked to the maintenance of past or fantasy identities. A summary of the research can be read at http://www.socresonline.org.uk/18/1/20.html.
3. Sigmund Freud, *The Interpretation of Dreams* (London: Vintage, 1900), 137.
4. Famously Marian Roalfe Cox wrote in 1893 of there being 345 variants of "Cinderella" alone (London: Folklore Society, 1893). Although the links between these tales are at times tenuous, shoe-based tales do appear across many cultures. From Japan to Nigeria, the shoe is represented in folklore as a magical and transformative object.
5. Grimm, "Aschenputtel," 231.
6. Hans Christian Andersen, "The Red Shoes," in *The Complete Fairy Tales of Hans Christian Andersen* (New York: Anchor, 2011), 289–95.
7. Jacob and Wilhelm Grimm, "Snow White," in *Children's and Household Tales* (unknown binding, 1812), 53.
8. Jacob and Wilhelm Grimm, "The Twelve Dancing Princesses," in *Children's and Household Tales* (unknown binding, 1812), 133.
9. *Cinderella* (Film). Walt Disney Animation Studios (1950).
10. *Sleeping Beauty* (Film). Walt Disney Animation Studios (1959).
11. *Snow White and the Seven Dwarfs* (Film). Walt Disney Animation Studios (1937).
12. Alexandra Sherlock, "Footwear: Transcending the Mind-Body Dualism in Fashion Theory," in Barbara Brownie, Laura Petican, and Johannes Reponen (eds.), *Fashion: Exploring Critical Issues* [e-book] (Oxford: Interdisciplinary Press, 2011), 1.
13. Marie-Louise Von Franz, *The Interpretation of Fairy Tales* (London: Shambhala, 1970), 103.

14 Bruno Bettelheim, *The Uses of Enchantment* (London: Penguin Books, 1976), 237–40. In "Cinderella," the impossible task she is given by her stepmother is to sort lentils from the dirt.
15 *The Wizard of Oz* (Film). Metro-Goldwyn-Meyer Studios (1939). Though the ruby slippers are one of the star turns in the film, in the L. Frank Baum novella (1900), Dorothy's shoes are silver. However, MGM chose to make the slippers red in order to capitalize on the power of Technicolor.
16 Hilary Davidson, "Shoes as Magical Objects," in Helen Persson (ed.), *Shoes: Pleasure and Pain* (London: V&A Publishing, 2015), 26.
17 Davidson, "Shoes as Magical Objects," 26.
18 For Freud, the shoe is a symbol of the vagina: "The shoe or slipper is a corresponding symbol of the female genitals." (*Fetishism*, 1905, 353) and similarly for psychoanalyst Karl Abraham, the shoe is a site of great conflict and desire. In his 1910 paper on shoe and corset fetishism ("Remarks on the Psycho-Analysis on a Case of Foot and Corset Fetishism"), Abraham describes how, through the process of binding the shoe to the foot, its slimness, delicacy, and restraint become qualities of desire for the patient.
19 Bettelheim, *The Uses of Enchantment*, 237–40.
20 Havelock Ellis, quoted in Colin McDowell, *Shoes: Fashion and Fantasy* (London: Thames & Hudson, 1989), 64.
21 Mary Douglas, "Purity and Danger," in Judith Butler, *Bodies that Matter* (London: Routledge, 1993), 168.
22 Rebecca Shawcross, *Shoes: An Illustrated History* (London: Bloomsbury, 2014), 80.
23 Shawcross, *Shoes: An Illustrated History*, 80.
24 Aili Nenola-Kallio, "Lucky Shoes or Weeping Shoes: Structural Analysis of Ingrain Shoeing Laments," in *Finnish Folkloristics*, vol. 1 (Helsinki, 1974), 62–91.
25 Bettelheim, *The Uses of Enchantment*, 26.
26 *Sex and the City*, Episode 64, Home Box Office (2003). TV Series.
27 Amy Olivier (September 23, 2012). "Imelda Marcos' famous collection of 3,000 shoes partly destroyed by termites and floods after lying in storage in the Philippines for 26 years since she was exiled." *Daily Mail* website. Accessed August 30, 2013, http://www.dailymail.co.uk/news/article-2207353/Imelda-Marcos-legendary-3-000-plus-shoe-collection-destroyed-termites-floods-neglect.html.
28 Davidson, "Shoes as Magical Objects," 26.
29 Grimm, "The Twelve Dancing Princesses," 13.
30 The "Seven League Boots" appear in several folk tales including "Tom Thumb" and "Jack and the Beanstalk." The magical boots allow their wearer to travel seven leagues with each step.
31 In the nineteenth-century Finnish folk saga, "Kalevala," the hero, Väinämöinen, asks the blacksmith, Ilmarinen, to make him copper soles for his shoes that will allow him to walk over needles, swords, and hatchets.
32 Jacob and Wilhelm Grimm, "The Juniper Tree," in *Children's and Household Tales* (unknown binding, 1812), 225–35.
33 Susan Stewart, *On Longing* (Durham: Duke University Press, 1993), 61–69.
34 Judith Long Laws, quoted in Madonna Kolbenschlag, *Kiss Sleeping Beauty Good-bye: Breaking the Spell of Feminine Myths and Models* (London: Harpers Collins, 1979), 1.
35 Andersen, "The Red Shoes," 290.
36 Hans Christian Andersen, "The Snow Queen," in *New Fairy Tales*, vol. 1 (unknown binding, 1845), 234–63.
37 Grimm, "The Twelve Dancing Princesses," 187.
38 Sally Barnes, *Dancing Women: Female Bodies On Stage* (London: Routledge, 1998), 33.
39 Hayley Thomas, "Undermining a Grimm Tale: A Feminist Reading of 'The Worn Out Dancing Shoes,'" in *Marvels and Tales Journal of Fairytale Studies*, vol. 13, no. 2 (1999), 170–83.
40 Ruth Bottigheimer (ed.), *Grimm's Bad Girls and Bold Boys* (London and New Haven: Yale University Press, 1987), 116.
41 Jenny Waelti-Walters, "On Princesses: Fairy Tales, Sex Roles and Loss of Self," in *International Journal of Women's Studies*, vol. 2 (1981), 180–88.
42 Kolbenschlag, *Kiss Sleeping Beauty Good-bye*, 4.
43 Thomas, "Undermining a Grimm Tale," 170–83.
44 Erin Mackie, "Red Shoes and Bloody Stumps," in Shari Benstock and Suzanne Ferriss (eds), *Footnotes: On Shoes* (New Brunswick: Rutgers University Press, 2001), 233–47.
45 *The Wizard of Oz* (1939).
46 Michel Foucault, *Discipline and Punish: The Birth of the Prison* (New York: Vintage, 1977), 58.
47 Foucault, *Discipline and Punish*, 136.
48 Isabel Cardigos, "The Wearing and Shedding of Enchanted Shoes," in *Estudos de Literatura Oral*, no. 5 (1999), 219–26.
49 Grimm, "Aschenputtel," 231.
50 Grimm, "Aschenputtel," 231.
51 Karen has three or four pairs of shoes in the story: her red patchwork rag shoes, clogs stained red with her blood, the malevolent magical red shoes and finally the feet/shoes carved for her by the executioner.
52 Andersen, "The Red Shoes," 292.
53 Andersen, "The Red Shoes," 292.
54 Grimm, "Snow White," 53.
55 Grimm, "Aschenputtel," 231.
56 This scene features in the Brothers Grimm version of 1812 but not in the version by Charles Perrault.

Of Bands, Bows, and Brows:

Hair, the *Alice* Books, and the Emergence of a Style Icon

By Kiera Vaclavik

It is perhaps quite curious, but nonetheless incontestable, that a century and a half after her first appearance in print, Lewis Carroll's Alice has become a firm fashion favorite. She graces the windows of high-end fashion stores, serves as an organizing principle in clothing roundups and fashion shoots, adorns anything from sweatshirts to stilettos, and inspires entire collections by leading companies such as Liberty, Furla, and Marc Jacobs. But it was not always thus. Alice did not spring into the world as a fully formed "trend doyenne," as she was recently referred to in a London Fashion Week publication.[1] As opposed to other literary characters, such as Goethe's Werther, who have triggered fashion crazes at the point of publication, Alice was a much slower burner. Her gradual evolution in this context has received barely any serious critical attention to date. Now, though, as biases about both children's literature and fashion studies are beginning to fall away, combined with the insights of fashion/fiction scholarship that has underlined how much "attention to literary fashioning can contribute to a significantly deeper understanding of texts, their contexts, and their innovations," the two-way traffic between Alice and fashion has become ripe for exploration.[2] It can be most effectively traced by focussing on a single key feature: hair, the symbolic role of which, in both fairy tales and Victorian culture, has already been explored extensively.[3] Hair may not seem an obvious way into *Alice's Adventures in Wonderland* (first published in 1865) and *Through the Looking-Glass, and What Alice Found There* (first published in 1871), but it was something to which Carroll was

The first illustration of Alice by Sir John Tenniel (1865), with hair swept back in *Alice's Adventures in Wonderland*

highly attentive and which recurs as a constant refrain within the *Alice* books. It was, moreover, this particular feature of his heroine's appearance that gave rise to the first major Alice-based fashion trend, the impact of which was both international and long-term. Let's begin, however, at the beginning . . .

Carroll and Hair

Much of what we think we know about Carroll is, as revisionist scholars have shown, in fact unfounded.[4] One extremely influential strand of the myth concerns the eccentricity of Carroll's physical appearance. Most commonly cited in this context is an obsession with gloves and a rejection of overcoats in Winter, but hair also feeds into the construction of Carrollian eccentricity. In a memoir published in 1899, just after Carroll's death, his actress friend Isa Bowman described his silver-gray hair as "rather longer than it was the fashion to wear."[5] Certainly, early images of Carroll, which are also some of the best known, show quite long hair smoothed down against the head, with what Karoline Leach refers to as "just-so curls" to the jawline.[6] Smooth, and shiny, with a razor-edge side parting, Carroll clearly lavished attention on his hair and would have known just what it meant to manage and maintain natural curls. In later photographs, however, taken in the "silver-gray" years when Bowman knew him, Carroll's hair is considerably shorter, cropped close to the head and worn in a

(far left) A youthful Lewis Carroll with "just-so" curls. Self-portrait, ca. 1857
© National Portrait Gallery, London

(left) Carroll in later years with more closely cropped hair. Print Collection, Miriam and Ira D. Wallach Division of Art, Prints and Photographs. The New York Public Library, Astor, Lenox and Tilden Foundations

slightly unkempt fashion. There is a clear mismatch between Bowman's account on the one hand and the visual evidence on the other, which shows no sign of anything particularly eccentric or unconventional in Carroll's appearance generally or his hair specifically.

The nature of his own hair, as well as his general interest in all things aesthetic, meant that Carroll was attentive to the ways in which other people's hair was dressed. He condemns the French hairstyles of the small daughters of one family as having "an absurd effect," although he also praises the beauty of another child achieved through her hair being dressed "*a l'imperatrice*."[7] The apparent inconsistency is less important than the manifest attendance to such details and – what's more – familiarity with their associated terminology. As far as his photographic practice was concerned, one of his sitters recalled his distinct preference for a "'natural-child' with ruffled untidy hair" – an observation borne out by the surviving images, in the vast majority of which the child-sitter's hair hangs loose and unadorned.[8] Perhaps as a result of personal experience, he was certainly well aware of the demands that hairdressing placed upon children, and this awareness allowed him to form a bond with new acquaintances. George MacDonald's son, Greville, who was an early reader of the initial manuscript and pushed for publication, was, for example, extremely enthusiastic about Carroll's teasing recommendation to exchange his head for a marble one that "would not have to be brushed and combed."[9] The same slightly off-kilter, absurdist approach was also marshalled to help another child friend overcome the torments of hairdressing. Carroll deploys his comic arsenal in a vaguely Hitchcockian illustrated "story-letter," about a child with hair so untidy that birds nest in it. But however carnivalesque, the point of the story is not to fan the flames of rebellion but to encourage acceptance and docility (and it worked).[10] Carroll's own hair may not have been eccentric, nor did he advocate such eccentricity for children, but his general outlook on hair-related matters was certainly highly mirth-filled and whimsical, and this is also apparent in the *Alice* books.

Hair in the *Alice* Books

Unsurprisingly, Carroll's awareness of, and preoccupation with, hair extended beyond private correspondence into his published writing. He is closely concerned with the ways in which his characters will appear in the accompanying illustrations, including how their hair will be styled.[11] It is, moreover, a recur-

rent trope in the *Alice* books, with the vast majority of situations involving, or referring to, hair and headgear being in the absurdist, comic vein discussed above. Wigs are prevalent, especially when the excised chapter from *Through the Looking-Glass* featuring a bewigged wasp is taken into account. The King of Hearts adopts the uncomfortable and "not at all becoming" option of wearing his crown over his judge's wig while the entanglement of the fish and frog-footmen's "powdered hair that curled all over their heads" is funny enough to provoke laughter even from the habitually glum Alice.[12] In *Through the Looking-Glass*, the White Knight (who is often associated with Carroll himself) is particularly preoccupied by hair. He asks Alice whether hers is "well fastened on,"[13] an enquiry that seems rather less far-fetched in the light of a *Punch* sketch from January 1864. In this sketch, a maid informs her mistress in total deadpan that she has already dressed the hair of the young ladies of the house and that "it's on the dressing table ready to be pinned on!"[14] Hair was clearly not always naturally attached to the head, then, and the White Knight's own plan to prevent it from falling off is to train it up a stick "like a fruit-tree."[15] For her part, the White Queen's hair is in such "a state" that her hairbrush is "entangled in it."[16]

Alice's own hair adds to the topsy-turvy absurdist carnival, being held onto by the White Knight to prevent his falling off his horse,[17] seized in both hands by the White Queen,[18] and blown about by the leaf fanning of the two queens.[19] None of which is particularly pleasant for Alice herself, of course. Similarly, she finds herself on the receiving end of a series of disobliging remarks about her personal appearance generally and her hair specifically. The very first thing that the Hatter says to her is that her "hair wants cutting."[20] In the second book, there are clear indications of the slightly unkempt state of Alice's hair, with the flowers commenting upon her petals being "tumbled about" and "a little untidy,"[21] and the narrator later mentioning "the ends of her tangled hair dipping into the water" as she gathers bulrushes.[22] The "wandering hair that *would* always get into her eyes," generating "that queer little toss of her head,"[23] is one of the few characteristics mentioned in the visualization of Alice by her sister at the very end of the first book. Similarly, Alice herself immediately goes to the subject of hair when exploring the vexed issue of her own identity soon after arriving in Wonderland: she is certain that she hasn't become Ada (a girl she knows in the real world), "for her hair goes in such long ringlets, and mine doesn't go in ringlets at all."[24]

Overall, the text tells us relatively little about what Alice's hair actually looks like, or indeed about her appearance more generally.[25] What it does say, directly

or indirectly – that it is long, untidy, and non-compliant with respect to ringlets – carries a good deal of significance both because of the rarity of such markers, and because of their alignment with Carroll's photographic ideal. The relative lack of information regarding Alice's appearance can be explained by the fact that Carroll always knew that the story would be illustrated, thus freeing the text from descriptive detail. The earliest visualization of Alice – the handwritten and illustrated "Alice's Adventures Under Ground," offered to Carroll's now-famous young friend Alice Liddell in November 1864 – sees a good deal of variation in Alice's dress. Against this, it is notable how consistent the style of her hair remains throughout: long dark waves falling below the shoulder, with a very definite center parting from which the hair frames the face on both sides.

In John Tenniel's illustrations to the first published version of the story, the heroine's hair retains the length and wave of the manuscript drawings, but key changes are also made. Although her ears remain hidden, Alice's hair is now swept straight back from her face, rather than parted in the center. This style was extremely common in depictions of little girls of the period (but it does render the characteristic toss of the head to free the eyes of wandering hair somewhat redundant). The other major shift – confirmed fully only in the colored *Nursery Alice* of 1890 – is that, in line with the vast majority of fairy tale heroines, Alice is transformed from a brunette to a blonde. In making this shift in hair color, another crucial step is taken away from the original recipient of the manuscript gift, Alice Liddell. For reasons yet to be explored fully, in the years when Carroll regularly met and photographed Alice Liddell, her dark hair was, unlike that of her sisters, cut into a – not terribly neat – bob and fringe.[26] It is an image of Alice from this period that Carroll draws and then sticks into the final page of the manuscript, making a striking contrast with his own images accompanying the story.[27] Hair is, then, an important means of distinguishing Alice the character from Alice Liddell the child, but it also serves in all four Alice books (*Wonderland*, *Looking-Glass*, the original manuscript and the *Nursery Alice*) as an age marker. Critics today regularly refer to Alice as

Carroll's own vision of Alice with center parting. Lewis Carroll, *Alice's Adventures Under Ground* manuscript, 1864 © British Library.

an *enfant femme* decidedly older than the 7–7½ explicitly stated in the text.[28] But at a time when the putting up of one's hair was a significant rite of passage, usually occurring at age 15 or 16, Alice's loose hair (as well as various aspects of her clothing) meant that the Victorians would have been in absolutely no doubt that they were reading the adventures of a child rather than a woman or anything in between.

Key aspects of Alice's iconic image – namely, the long blonde hair – were, then, clearly in place by the end of the nineteenth century. But what of that further defining feature still so commonly associated with her today? It was not until the second book, in which Alice's overall appearance is fussier, in line with children's fashion of the day, that a dark hairband decorated with a small bow, was actually introduced (even though the swept-back style of her hair in *Wonderland* suggests that it was always already there!). The integration of this accessory into the Alice look was assisted by its inclusion in the *Nursery Alice*. An adaptation of the text and illustrations of *Wonderland*, this later work inserts the *Through the Looking-Glass* headwear with varying degrees of success into each of the images of Alice. However haphazard the execution (which often leaves a bow without a band), some form of hair decoration was now firmly part of the official, authorized identity of Carroll's heroine.[29]

(far left) Alice revised, with hairband, by Sir John Tenniel (1865), in *Through the Looking-Glass*

(left) A blonde Alice with variable hair decoration, by Sir John Tenniel (1890), in the first authorized colored Alice book, the *Nursery Alice*

Other Early Print and Performance Alices

If, by dint of being in constant circulation, Tenniel's illustrations formed a visual bedrock, they were by no means the only nineteenth-century Alices. Even in this early stage of her "career," there emerged a dizzying array of alternative versions across a whole range of formats, which offered considerable variety in the way that her appearance in general and hair specifically were portrayed.[30] While some stayed close to Tenniel's depiction, many others made substantial modifications to Alice's overall look and to any or all aspects of her hair. If early music sheets issued long before the *Nursery Alice* show a blonde Alice, Dutch editions of the text dating from 1875 and 1890 offer a redhead and a brunette respectively.[31] Several American editions, as well as early Alice-based marketing, showed a dark rather than fair heroine, and the majority of the actresses who played the role in the period also seem to have been brunettes.[32] Other, more dramatic departures in this period include an Alice with blue hair (!), an Alice with short ringlets, another with hair tied back (this was an illustration to an adaptation for dometic theatricals), or tied up in two American editions.[33] Fringes, or at least a closer framing of the face by the hair, are also common modifications. American editions published by Donohue and Belford-Clark, as well as Isa Bowman's on-stage Alice, adopt a style that would become closely associated with Alice-related hair in subsequent years: a combination of curls at the front and from the nape of the neck, with the remaining hair smoothed down close over the skull.

As in these examples, accessories of any kind are frequently dispensed with, although some hairbands, and particularly bows at the top part of the hair, do feature at times. Overall, it is difficult to discern clear trends or patterns within this visual potpourri. Alice seems to have been modified repeatedly to conform to shifting ideals of beauty and changing trends, with even Carroll himself – considerably more anti- than pro-fashion – not immune to their influence. In a rough sketch of Alice produced just a few months before his death, and in line with the contemporary fashion for the close framing of the features by the hair, this final vision of his heroine comes complete with fringe.

In the first thirty years of the twentieth century, the proliferation of Alice's image accelerated further with the oft-cited copy-

Curls with hair smoothed over the head on the cover of an American edition published by M. A. Donohue. (Unknown artist and date)

right lapse of 1907. This heralded a new wave of editions with entirely new sets of illustrations, as well as the advent of the new motion-picture media, which rapidly and repeatedly took up Carroll's work. As in nineteenth-century stage productions, the earliest Alices on the silent screen all had dark hair that usually fell below the shoulder. The quality of the films and scarcity of close-ups makes it hard to discern details, but it seems that only Viola Savoy in 1915 wore a hairband, while Gladys Hulette (1910) had a side parting and no accessories, and the very earliest screen Alice, May Clark (1903), had her hair held off her face and fastened behind by some form of comb. The first walking and talking Alice, Ruth Gilbert (1931), was also the first blonde on-screen Alice whose long hair had a side parting with a bow perched on top (although, in one of the publicity posters for the film, her blonde hair falls down in two long sausage-shaped ringlets!). In illustrated editions from the 1920s and 1930s, distinctly un-Tenniel-esque partings and fringes were common. Alice's hair is plaited rather than loose in illustrations by A. E. Jackson and Anthony Rado, but, following general trends in hairdressing for women and girls, several artists (such as Hume Henderson [1928], Willy Pogány [1929], and D. R. Sexton [1933]) portray her with shorter, bobbed hair in a sort of return to Alice Liddell. Whatever the length or style, various accessories are incorporated: hairbands are perhaps the most common (Gwynedd Hudson, Harry Rountree, and Peter Newell all feature them and there is an interesting variant version by Milo Winter), but bows and clips are also featured. In short, in the early decades of the twentieth century, it seems to have been permissible to restyle Alice and her hair in any way that felt becoming. If the benchmark of Tenniel remains (clearly evident in Le Galienne's stage production or Jessie Wilcox Smith's 1923 illustrations), it was by no means adhered to slavishly in any media. Alice was free to follow the fashions of the day.

Beyond the Books: Alice Bands and Open Brows

Alice-the-follower-of-fashion was eventually joined and indeed overshadowed by Alice-the-trendsetter. It was in the rather unlikely setting of a Kansas newspaper as early as 1882 that the first clear link is made between Alice and hair beyond the book, heralding a small but important step in Alice's ascension to global style icon. The "Women Folks" column of the *Wichita City Eagle* of November 30, 1882 informed readers that Queen Olga of Greece wears her "fair curling hair drawn back from the forehead with a comb such as one sees in the

pictures of Alice in Wonderland."³⁴ Already, there is both the panache of celebrity and, in the reference to a "comb," a certain haziness in terminology, both of which would become standard features of later reporting.³⁵

Half a century passed before the link between Alice and a named individual's hairstyle was made again, this time tucked away at the very end of a *Vogue* report of August 15, 1932 on Parisian headwear and hairstyles:

> If your hair isn't moulded into ringlets over the top in the evening, then you wear a bandeau across the top, or a wreath. Lady Abdy, her curls shorn in the nape of the neck and her hair brushed straight back, wears a diamond comb in the evening, Alice-in-Wonderland fashion.³⁶

It is unclear whether the association was made by the Russian-born socialite herself or was instead forged by the reporter in a year of celebrations marking the centenary of Carroll's birth. This was a time when Alice was certainly very much in the air and when even Alice Hargreaves (née Liddell) herself – pre-empting the mode – wore a ribbon around her head during a widely reported visit to New York in May.³⁷ But it may also have come from Lady Abdy directly, since she was certainly moving in the society of avant-garde people fascinated by Carroll's works.³⁸ Such a person may well have adopted the look as a deliberate gesture to a heroine much appreciated in the Surrealist circles she frequented.³⁹

Whatever the precise origin, *Vogue* kept referring back to this brief mention the following year, with each new reference becoming more prominent and substantial. In the February 1933 issue, the same style is recommended (being "extremely young, very pretty, and desperately Alice in Wonderland") and again, Lady Abdy is cited for celebrity endorsement.⁴⁰ In the editorial, a small line sketch of the profile of a head and shoulders illustrates the look described, which, we might note in passing, is not hugely dissimilar from the earlier styles gracing nineteenth-century American editions, or even Carroll's own early hairstyle! The following month, a feature with photographs stretching over four pages gives even more prominence to the style. Although there is also a nod to another nineteenth-century literary classic, *Little Women* ("a sort of Louisa M. Alcott idea gone smart"), the connection with Alice is much more insistent, being referenced not only in the title ("March Hairs for Mad Hats"), but also in image captions and within the text.⁴¹ The Paris-based pioneer of the look is marshalled yet again, this time in a full-page photograph captioned, "Lady Abdy in Wonderland."⁴² Lee Miller also models the look, with a Depression-

friendly "tortoise-shell-like hoop," which can be purchased "for not too high a price." Indeed, five months later, *Vogue* recommends the "Alice-in-Wonderland bandeaux" (now available in colors) as a fuss-free option for college students.[43]

Originally worn by a Russian émigrée in Paris, as reported by an American publication, the eminently cosmopolitan Alice-inspired hairstyle also had international reach, as Australian newspaper reports of 1933 make clear. In August, a Melbourne newspaper chronicling Parisian styles mentions women wearing "bands of ribbon in Alice-in-Wonderland style."[44] Although no mention is made here of Lady Abdy, the requisite glamor would soon be provided by the Hollywood actress Shirley Grey in a short piece, including a head-shot, that was picked up by newspapers across Australia that September and October. The new style, "which has been given the charming name of 'The Alice in Wonderland' hairdress," as worn by Grey with an open brow without parting, hair kept in place by a band and curled at the nape, was identical to that presented by *Vogue*.[45] Both the style and the name seem to have caught on quickly: by mid-October the report of a Melbourne ball refers to "quaint Alice-in-Wonderland hairbands" forming part of the alluring scene.[46]

The first reference to the Alice hairstyle in the British regional press came relatively late, in December 1933, in connection to the Paramount film adaptation starring Charlotte Henry, released the previous week. The *Yorkshire Post and Leeds Intelligencer* journalist condemns the film's lack of fidelity to the Tenniel illustrations specifically and uniquely with reference to the heroine's hair (which is too long and insufficiently wavy). In passing, he also refers to the "snood" worn over her head, "of the kind that has sprung into fashion these last two months as an 'Alice band.'"[47] The article ends with a further whimsical connection being made between the Alice books and contemporary hairstyling: "It had not struck me before I saw the film how the White Knight anticipated the process of the permanent wave. He told Alice to take a stick and make her hair creep up it."[48]

Early in 1934, the *Nottingham Evening Post* was already sounding the death knell of the "Alice band," which "seems to have had its day, having become too popular, and thereby losing its piquancy."[49] Certainly journalists in Australia reported the "extraordinary rapidity" with which the "'Alice-in-Wonderland' hairband has swept [London's] West End."[50] Yet in February it was still being referred to as "a very fashionable mode" in the *Lancashire Evening Post*. The *Nottingham Evening Post* itself had a change of heart, reporting in March that "quite 80 per cent of the women who dine and dance at London clubs wear the halo head-

dress in some form."⁵¹ Indeed, it seems that 1934 was the year of the mainstream adoption of the "Alice" band. Regional newspapers show clearly that it was all the rage at weddings and balls across Britain. A February 1934 *Photoplay* feature, "Our 'Alice in Wonderland' has Inspired these Diadems," apparently linking the Paramount film to hairbands variously worn by a range of stars (including Judith Allen, Carole Lombard, and Lona Andre), suggests that the style was also still going strong on the other side of the Atlantic.⁵²

Across these examples, the sheer versatility and adaptability of the style is striking. Made from a wide variety of materials, from the most basic to the most luxurious, it was worn by both adults and children alike in a whole range of contexts from weddings, balls, and the races, to college lecture theaters, tennis courts, and the beach. Even a male Italian street-sweeper was described as wearing one in an Australian travelog!⁵³ Within what was an international trend, there was local variation in both the exact styling and the terminology. The 1933 "March Hairs" *Vogue* feature explicitly drew a contrast between the adoption of the style by the Paris-based Lady Abdy and the New Yorker Lee Miller, with the former wearing the band further forward and with larger curls than the latter. It is also clear why the term "Alice band" for hairband "took" in Britain but nowhere else in the English-speaking world. In both America and Australia, there was considerable variation in terminology (bandeau, hoop, wreath, comb, circlet, and so on) whereas in Britain almost no other term was used. What's more, in Australia and America, the full "Alice in Wonderland" qualifier was always used and must have been rather a mouthful. But in Britain "Alice" alone sufficed, presumably because Carroll's works had become so integrated into the culture that the longer form was redundant. Birth registers show that "Alice" had been a popular name for families whose surname was Band, but after 1933 it rapidly

Lady Abdy modeling an "Alice in Wonderland" hairband. *Vogue*, March 1, 1933. Photograph by George Hoyningen-Huene © Condé Nast Publications Ltd

264 Fashion and Fairy Tales

fell into obsolescence, becoming as absurd a choice to be coupled with the surname "Band" as "Rubber" or "Brass"!

Another reason the term did not catch on in the United States was that, by the 1940s, the connection between Alice and hair had largely shifted away from referring to both a style and a particular accessory to instead designating the clear-browed, non-parted, swept-back style alone (which could be combined with different types of accessory, including but not limited to hairbands). In a striking "*Vogue*'s Junior Fashions" feature from 1944, two of the three styles associated with Alice do not involve bands. One image, captioned "The combed-back, non-parted coiffure: Alice-in-Wonderland," involves only a small comb to the side of the head.[54]

In Britain, the Alice band (by now increasingly referred to without quotation marks) enjoyed continued popularity in the 1940s – when it was worn by racegoers or actresses like Sally Ann Howes – and indeed well beyond. Reports of marriages in *The Times* show that it continued to be a firm favorite for brides

Lee Miller modeling an "Alice in Wonderland" hairband, 1933
© Lee Miller Archives, England 2015. All rights reserved.
www.leemiller.co.uk

as well as bridesmaids, and it was also recommended for sailing holidays, tennis matches, and cocktail parties. In addition to the floral or ribbon versions of wedding processions, it could also be made from fur, sequins, or brilliants (with these more opulent versions being recommended regularly as Christmas gifts). In fact, the Alice band became a wardrobe staple to such an extent that the British taxman took the effort to amend the taxes to which it was subject (aligning it with hats rather than jewelry, with the exception of the aforementioned luxury versions).[55]

It was not just in fashion writing that the association between Alice and hair was registered. A cluster of hair-related Alice allusions can be found in women's writing of the 1940s on both sides of the Atlantic. Rather than its glamorous origins and associations, it is the untidiness (and absence of attention) referred to in *Through the Looking-Glass* that both Elizabeth Bowen and Emily Hahn pick up on in their war-time narratives. Bowen remarks sardonically that "[w]eeks of exile from any hairdresser had driven Miss Bates to the Alice-in-Wonderland style."[56] Similarly, Hahn's first description of the 32-year-old former *Vogue* editor Corin Bernfelt mentions the style of an Alice band holding back her long straight hair, due to the absence of a stylist's attentions in Chungking during the early months of the war.[57] For her part, Dorothy Whipple in 1943 uses hair within a much more standard evocation of prettiness: a child character's very fair, "shoulder-long hair turning under at the ends" is a (not very Tenniel-esque) component of her appealing "Alice-in-Wonderland air."[58] By this point, hair had clearly become an integral part of Alice's visual identity. Maxim de Winter instructs his young bride to "Put a ribbon round your hair and be Alice-in-Wonderland," for the doomed fancy-dress ball she is planning in Daphne Du Maurier's 1938 novel *Rebecca*.[59] The narrator rejects the suggestion (foolishly, as events will prove), asserting, "I know my hair is straight, but it isn't as straight as that."[60] In Noel Streatfeild's *Ballet Shoes* of 1936, one child knows she is auditioning for the role of Alice simply on the strength of having been asked to bring hair ribbons. At the theater, the heroines see eight other girls with hair swept back off their faces and secured by a ribbon band, "so it was obvious they wanted to be Alice too."[61] Hot-housed on the stage, the visual codification of Alice was completed on the silver screen. With Disney's *Alice in Wonderland* of 1951, there was a return to Carroll with a prominent (indeed rather voluminous) centre parting, but there were also three already-longstanding elements – long hair, blondeness, and an accompanying hairband. These were now fixed firmly in the popular imagination.

Conclusion

Given his general outlook on all things hirsute, Lewis Carroll would have found much to relish and delight in all this: that his heroine would give her name to a hairstyle, not hugely dissimilar from that of his own in youth; that the associated accessory would (in Britain) take her name and further bolster Carroll's extensive legacy to the English language; that the style, in all its intricacies of correct positioning on the head, would be reported upon seriously in newspapers across the world, with Americans reporting on exiled Russians in Paris or Australians writing about American movie stars – not to mention Italian street-sweepers. A determined lion-hunter, as well as someone always on the lookout for the picturesque, he would have been gratified to know that Alice was keeping company with the world's most beautiful and famous women, including queens and actresses.

While the espousal of a style explicitly associated with Alice by children is fairly understandable, its wholesale adoption by grown women is much less so. Perhaps for the originator of the trend, it was part of a deliberate homage to a character exerting considerable intellectual and artistic fascination in the avant-garde circles of Europe in the 1920s and 1930s. As the style took off, it offered women less conscious of Alice's high cultural credentials the opportunity to tap into the numerous qualities of a very bright young thing, not least her youth. In those early years of the style, the reference to Alice in fashion magazines and newspapers was still new enough to be noticed. Today, however, a woman who buys and wears an Alice band, is probably not even conscious of such a link, given that the term has either become so much part of the language or dropped out of it altogether. Alice might well have fallen into a fashion abyss after her hair-related moment in the 1930s and 1940s. Instead, though, this was just the first movement of a snowball, involving many other accessories and garments, which continues to roll and accumulate to this day.

Notes

1. "Quirky Girly," in *A to Z of Fashion Week*, London Fashion Week website. Accessed June 30, 2015, www.lfwdaily.com/2015/02/21/a-z-of-fashion-week/.
2. Cynthia Kuhn and Cindy Carlson, "Introduction," in *Styling Texts: Dress and Fashion in Literature*, ed. Cynthia Kuhn and Cindy Carlson (Youngstown, N.Y.: Cambria, 2007), 3.
3. See Marina Warner, *From the Beast to the Blonde: On Fairy Tales and their Tellers* (London: Chatto & Windus, 1994), and Galia Ofek, *Representations of Hair in Victorian Literature and Culture* (Farnham, Surrey, UK, and Burlington, V.T.: Ashgate, 2009).
4. See particularly Karoline Leach, *In the Shadow of the Dreamchild: A New Understanding of Lewis Carroll* (London: Peter Owen, 1999), and Jenny Woolf, *The Mystery of Lewis Carroll: Understanding the Author of "Alice's Adventures in Wonderland"* (London: Haus, 2010).
5. Isa Bowman, *The Story of Lewis Carroll* (London: Dent, 1899), 9.
6. Leach, *In the Shadow of the Dreamchild*, 182.
7. September 29, 1856, *Lewis Carroll's Diaries*, ed. Edward Wakeling, vol. 2 (Luton Lewis Carroll Society, 1993–2007), 102; May 20, 1857, *Diaries*, vol. 3, 61.
8. Ella C. F. Bickersteth [née Monier-Williams], "He gave one the sense of […] *perfect understanding*," ed. Morton N. Cohen, *Lewis Carroll: Interviews and Recollections* (Basingstoke: Macmillan, 1989), [189–91] 190.
9. S. D. Collingwood, *The Life and Letters of Lewis Carroll* (London: T. Fisher Unwin, 1898), 83.
10. Edith Alice Maitland, "He […] gave me the name of 'Ducky'," ed. Cohen, *Lewis Carroll: Interviews and Recollections* [174–82] 177–8.
11. On Lady Muriel's hair in *Sylvie and Bruno*, for example, see Carroll's September 9, 1887 letter to Harry Furniss, in *Lewis Carroll and his Illustrators: Collaborations and Correspondence 1865–1898*, ed. Morton N. Cohen and Edward Wakeling (London: Macmillan, 2003), 149.
12. Lewis Carroll, *The Annotated Alice: The Definitive Edition*, ed. Martin Gardner (London: Penguin, 2001), 114; 59. All references to the *Alice* books are to this edition.
13. Carroll, *The Annotated Alice*, 249.
14. "Hair-Dressing in 1863," *Punch*, January 2, 1864, 4.
15. Carroll, *The Annotated Alice*, 249.
16. Carroll, *The Annotated Alice*, 205.
17. Carroll, *The Annotated Alice*, 251.
18. Carroll, *The Annotated Alice*, 278.
19. Carroll, *The Annotated Alice*, 268.
20. Carroll, *The Annotated Alice*, 72.
21. Carroll, *The Annotated Alice*, 169.
22. Carroll, *The Annotated Alice*, 214.
23. Carroll, *The Annotated Alice*, 131.
24. Carroll, *The Annotated Alice*, 23.
25. See Richard Kelly, "'If you don't know what a Gryphon is': Text and Illustration in *Alice's Adventures in Wonderland*," in *Lewis Carroll: A Celebration*, ed. Edward Guiliano (New York: Clarkson N. Potter, 1982), 62–74.
26. Anne Clark argues that "Mrs Liddell understood the structure of her daughters' faces well, and had chosen for each a distinctive and seemingly timeless style which enhanced her own particular beauty," but this is mere conjecture. Anne Clark, *The Real Alice: Lewis Carroll's Dream Child* (London: Joseph, 1981), 54.
27. On the basis of a painting of the Liddell sisters by Sir William Blake Richmond produced in 1864, it seems likely that Alice's hair had grown out a good deal by the time Carroll handed over the manuscript gift.
28. See, for example, Rodney Engen, *Sir John Tenniel: Alice's White Knight* (Aldershot: Scolar Press, 1991), 76.
29. The Wonderland Postage Stamp Case issued in the same year also included a bow, at least on the cover (when the case is opened, not only has the baby turned into a pig, but her hair decoration has also evaporated).
30. The term "career" for this eminently vibrant character is borrowed from S. S. Prawer, in preference to the more standard "afterlife"; S. S. Prawer, *Comparative Literary Studies: An Introduction* (London: Duckworth, 1973), 90.
31. Lewis Carroll, *Lize's Avonturen in 't Wonderland* (Nijmegen: Blomhert and Timmerman, 1875); Lewis Carroll, *Alice in het Land der Droomen*, Eleonora Mann, trans. (Amsterdam: Jan Leendertz, 1890).
32. A Worcester College Gardens performance in 1895 with a very fair Rachel Daniel being the exception to this rule.
33. Lewis Carroll, *Through the Looking-Glass, and What Alice Found There* (Chicago: W. B. Conkey, 1900); Lewis Carroll, *Alice's Adventures in Wonderland & Through the Looking-Glass*, illus. Blanche McManus (New York: Wessels, 1899); Kate Freiligrath-Kroeker, *Alice thro' the Looking-Glass and other Fairy Plays for Children* (London: Swan Sonneschein, 1882); Lewis Carroll, *Through the Looking-Glass, and What Alice Found There* (Boston: DeWolfe, Fiske & Co., 1898); Lewis Carroll, *Through the Looking-Glass, and What Alice Found There* (Chicago: Donohue, Henneberry & Co., 1899).
34. "The Women Folks: Items of Interest for and Concerning Them," *Wichita City Eagle* (November 30, 1882): 1.
35. Variously designated as bandeaux, fillets or snoods, the style had existed for centuries at this point. See Alex Newman and Zakee Shariff, *Fashion A–Z: An Illustrated Dictionary* (London: Laurence King, 2009).
36. "The Heads have it in the New Mode," *Vogue* (August 15, 1932): 71. In the intervening fifty years, a single other anonymous reference was made in a 1910 report of a horse show to an elaborate bandeau-based, "Alice-in-Wonderland conception of a hat" ('What they Wore at the Horse Show,' *Vogue*, December 15, 1910): 24.
37. Robert Douglas Fairhurst draws attention to the elderly Alice's wearing a hairband during this trip, but is wrong to call it "newly fashionable"

268 Fairy Tale Fashion

(Robert Douglas Fairhurst, *The Story of Alice: Lewis Carroll and the Secret History of Wonderland*. London: Harvill Secker, 2015), 5.

38 Lady Abdy (née Iya de Gaye) was a *Vogue* regular (referred to as exercising "great influence on fashion in Paris" [*Vogue*, June 15, 1932: 26]), who had already had a hat named after her in 1929. Daughter and mother of actors, she herself was a "gifted painter" who had studied at the Slade School of Art, according to one undated clipping that again connects Lady Abdy to the hairband ("Wearing an 'Alice'") from the Sewell Collection in the Harry Ransom Center.

39 See Jeffrey Stern, "Lewis Carroll the Surrealist," in *Lewis Carroll: A Celebration*, ed. Edward Guiliano (New York: Clarkson N. Potter, 1982), 132–53.

40 "Vogue Points Seen Here and There," *Vogue* (February 1, 1933): 27.

41 "March Hairs for Mad Hats," *Vogue* (March 1, 1933).

42 The main text of the article reiterates the fact that with her golden bandeau, "she looks like a 1933 Alice-in-Wonderland." There would be yet another reference in the September 1 issue where Lady Abdy displays "demureness" in a Peter Pan collar and "the famous gold Alice-in-Wonderland band" ("Lady Abdy in Velvet," *Vogue* [September 1, 1933]: 55).

43 "Majoring in Beauty," *Vogue* (August 15, 1933): 68.

44 "Round the Shops," *Table Talk* (August 31, 1933): 24.

45 The piece was run, for example, by the *Muswellbrook Chronicle* in New South Wales (September 8, 1933), *Sunday Times* of Perth (September 24, 1933), and *Riverine Herald* in Victoria (October 14, 1933), among several others.

46 "Four Debutantes at Coming-out Ball," *Argus* (October 14, 1933): 20.

47 *Yorkshire Post and Leeds Intelligencer* (December 29, 1933): 6.

48 *Yorkshire Post and Leeds Intelligencer* (December 29, 1933): 6.

49 "Echoes From Town," *Nottingham Evening Post* (January 25, 1934), 6.

50 "'Halo' Hats Change Hairdressing Styles," *Table Talk* (January 18, 1934): 12.

51 "Good Looks Make Us Glad," *Lancashire Evening Post* (February 6, 1934), 8; "Echoes from Town," *Nottingham Evening Post* (March 1, 1934): 6.

52 "Our 'Alice in Wonderland' has Inspired these Diadems," *Photoplay* (February, 1934). Andre was also shown sporting the same style (which "retains its vogue in Hollywood – and elsewhere") in an Australian report the previous year ("Gossip Jottings," *World's News*, November 15, 1933: 15.)

53 Nina Murdoch's *Vagrant in Summer*, reviewed in the *Sydney Mail* (September 8, 1937): 14.

54 "Vogue's Junior Fashions," *Vogue* (October 1, 1944): 162–63.

55 "Purchase Tax Cut on Alice Bands," *The Times* (November 27, 1958): 15.

56 Elizabeth Bowen, "Green Holly," in *Collected Stories* (London: Vintage, 1999), 819 [first published in *Listener*, November 1941]. Bowen also titled her unfinished memoirs "Pictures & Conversations."

57 Emily Hahn, *China to Me* (London: Virago, 1987) [1944], 116.

58 Dorothy Whipple, *They Were Sisters* (London: Persephone, 2007) [1943], 43.

59 Daphne Du Maurier, *Rebecca* (London: Penguin, 1962) [1938], 193. In Hitchcock's adaptation of the novel released two years later, the heroine has already adopted a hairband in an effort to smarten herself up, and it is this which prompts her husband's costume suggestion: "Will you be Alice in Wonderland, with that ribbon in your hair?"

60 Du Maurier, 194.

61 Noel Streatfeild, *Ballet Shoes* (London: Puffin 2011) [1936], 119. The teacher in *Ballet Shoes* tells her students that it "helped if they looked like Alice" (p. 118) and the same seems to have been true in the 1950s. Jane Asher remembered auditioning for a sound recording: "I think I got the part because I looked like Alice – that influenced them, even for a record. I always wore an Alice band; I didn't put it on specially. Perhaps it was a bit unfair." (Wendy Monk, "What does Alice think of Alice?" *The Times* [December 29, 1966], 11.)

Selected Bibliography

Fairy Tales

Andersen, Hans Christian. *Andersen's Fairy Tales*. London: Wordsworth Classics, 1993.

Andersen, H. C. and Charles Perrault. *The Fairy Tales of Hans Christian Andersen and Charles Perrault*. New York: Illustrated Editions Company, n.d.

Baum, L. Frank. *The Wonderful Wizard of Oz*. Chicago: Rand McNally, 1956.

Carroll, Lewis. *Alice's Adventures in Wonderland*. New York: W. W. Norton and Company, 1992.

Carroll, Lewis. *The Annotated Alice: The Definitive Edition*, Martin Gardner (ed.). London: Penguin, 2001.

Couch, Sir Arthur Quiller. *In Powder and Crinoline*. London: Hodder and Stoughton, n.d. [1913].

—. *The Sleeping Beauty and Other Tales from the Old French*. New York: George H. Doran Company, 1910.

De la Mare, Walter. *Told Again: Old Tales Told Again*. New York: A. A. Knopf, 1927.

Evans, C. S. *Cinderella*. New York: The Viking Press, 1972.

Grimm, Jacob and Wilhelm. *Hansel and Gretel and Other Stories*. New York: Crown Publishers, 1925.

—. *Little Brother & Little Sister and Other Tales by the Brothers Grimm*. London: Constable & Company Ltd., 1917.

—. *Children's and Household Tales*. Publisher unknown, 1812.

Halifax, John. *The Fairy Book*. London: Macmillan, 1979.

Jacobs, Joseph. *European Folk and Fairy Tales*. New York: G. P. Putnam's Sons, 1916.

Johnson, A. E. (trans.), *Perrault's Fairy Tales*. New York: Dover, 1969.

Lang, Andrew (ed.). *The Blue Fairy Book*. New York: Dover, 1965.

—. *The Grey Fairy Book*. New York: Dover, 1967.

Paulsen, Valdemar (trans.). *Hans Andersen's Fairy Tales*. New York: Rand McNally, 1916.

Planché, J. R. (trans.). *Madame de Villeneuve's The Story of Beauty and the Beast*. Somerset, UK: Blackdown Publications, 2014.

Tatar, Maria (ed. and trans.). *The Annotated Brothers Grimm*. New York and London: W. W. Norton, 2012.

Zipes, Jack (ed. and trans.). *Beauties, Beasts, and Enchantment: Classic French Fairy Tales*. Markham, Ontario: Nal Books New American Library, 1989.

— (ed. and trans.). *The Complete First Edition of the Original Folk and Fairy Tales of the Brothers Grimm*. Princeton and Oxford: Princeton University Press, 2014.

Books and articles

A to Z of Fashion Week, London Fashion Week website (February 21, 2015). Accessed June 30, 2015, www.lfwdaily.com/2015/02/21/a-z-of-fashion-week/.

Acocella, Joan. "Fifty Shades: Alexei Ratmansky stages 'The Sleeping Beauty,'" in *New Yorker* (June 1, 2015): online edition.

Bacchilega, Cristina. *Postmodern Fairy Tales*. Philadelphia: University of Pennsylvania Press, 1997.

Barber, Elizabeth Wayland. *The Dancing Goddesses: Folklore, Archaeology, and the Origins of European Dance*. New York and London: W.W. Norton and Company, 2013.

Barnard, Malcolm. *Fashion as Communication*. London and New York: Routledge, 1996.

Barnes, Sally. *Dancing Women: Female Bodies On Stage*. London: Routledge, 1998.

Barthes, Roland. *The Fashion System*. New York: Hill and Wang, 1983.

Bayley, Harold. *The Lost Language of Symbolism*. New York: Dover Publications, Inc., 2006.

Beaton, Cecil. *Ballet*. Garden City, New York: Doubleday & Company, 1951.

Beck, Horace. *Folklore and the Sea*. Mystic, Connecticut: Mystic Seaport Museum, Incorporated, 1985.

Bee, Deborah. *Couture in the 21st Century*. London: Harrods and A&C Black, 2010.

Bell, Quentin. *On Human Finery*. London: The Hogarth Press, 1948.

Bell, Robert (ed.). *Ballet Russes: The Art of Costume*. Canberra, Australia: National Gallery of Australia, 2010.

Benstock, Shari, and Suzanne Ferriss (eds). *Footnotes: On Shoes*. New Brunswick, N.J.: Rutgers University Press, 2001.

Bettelheim, Bruno. *The Uses of Enchantment: The Meaning and Importance of Fairy Tales*. New York: Alfred A. Knopf, 1976.

Blum, Dilys. *Shocking! The Art and Fashion of Elsa Schiaparelli*. Philadelphia: Philadelphia Museum of Art, 2003.

Bolton, Andrew. *Dangerous Liaisons: Fashion and Furniture in the Eighteenth Century*. New York: The Metropolitan Museum of Art, and New Haven and London: Yale University Press, 2006.

—. *Superheroes: Fashion and Fantasy*. New York: Metropolitan Museum of Art, 2008.

—. *Wild: Fashion Untamed*. New York: Metropolitan Museum of Art, 2004.

Borges, Jorge Luis. *The Book of Imaginary Beings*. New York: E. P. Dutton, 1969.

Bott, Danièle. *Thierry Mugler: Galaxy Glamour*. New York: Thames and Hudson, 2010.

Bottigheimer, Ruth (ed.). *Grimms' Bad Girls and Bold Boys*. London and New Haven: Yale University Press, 1987.

Bowman, Isa. *The Story of Lewis Carroll*. London: Dent, 1899.

Brodovitch, Alexey. *Ballet*. New York: J. J. Augustin, 1945.

Buckle, Richard. *Diaghilev*. New York: Atheneum, 1979.

—. *Modern Ballet Design: A Picture Book with Notes*. London: Adam and Charles Black, 1955.

Butler, Judith. *Bodies That Matter*. London: Routledge, 1993.

Buxbaum, Gerda (ed.). *Fashion in Context*. New York and Vienna: Springer, 2009.

—. (ed.). *Icons of Fashion: The 20th Century*. New York and Munich: Prestel, 2005.

Campbell, Joseph. *The Power of Myth*. Anchor Books, 1988.

Cardigos, Isabel. "The Wearing and Shedding of Enchanted Shoes," in *Estudos de Literatura Oral*, no. 5 (1999): 210–28.

Carney, Jo Eldridge. *Fairy Tale Queens: Representations of Early Modern Queenship*. New York: Palgrave Macmillan, 2012.

Chappell, William. *Fonteyn: Impressions of a Ballerina*. London: Spring Books, 1951.

Chrisman-Campbell, Kimberly. *Fashion Victims: Dress at the Court of Louis XVI and Marie-Antoinette*. New Haven and London: Yale University Press, 2015.

Clark, Anne. *The Real Alice: Lewis Carroll's Dream Child*. London: Joseph, 1981.

Cohen, Morton N. (ed.). *Lewis Carroll: Interviews and Recollections*. Basingstoke: Macmillan, 1989.

Cohen Morton N. and Edward Wakeling (eds). *Lewis Carroll and His Illustrators: Collaborations and Correspondence, 1865–1898*. London: Macmillan, 2003.

Collingwood, S. D. *The Life and Letters of Lewis Carroll*. London: T. Fisher Unwin, 1898.

Cox, Marian Roalfe. *Cinderella: Three-hundred and Forty-five Variants*. London: Folklore Society by David Nutt, 1893.

Croce, Arlene. *Writing in the Dark, Dancing in the "New Yorker."* New York: Farrar, Straus and Giroux, 2000.

Davidson, Hilary. "Sex and Sin: The Magic of Red Shoes," in *Shoes: A History from Sandals to Sneakers*. Giorgio Riello and Peter McNeil (eds). London: Berg, 2006.

—. "Shoes as Magical Objects," in Helen Persson (ed.). *Shoes: Pleasure and Pain*. London: V&A Publishing, 2015.

De Marly, Diana. *Louis XIV and Versailles*. New York: Holmes and Meier, 1987.

Denby, Edwin. *Looking at the Dance*. New York: Pellegrini & Cudahy, 1949.

Dinnerstein, Dorothy. *The Mermaid and the Minotaur*. New York: Harper and Row, 1976.

Du Maurier, Daphne. *Rebecca*. London: Penguin, 1962.

Dundes, Alan. *Cinderella: A Folklore Casebook*. New York and London: Garland Publishing, Inc., 1982.

Eco, Umberto. *On Ugliness*. New York: Rizzoli, 2007.

Ellison, Jo. *Vogue: The Gown*. London: Firefly Books, 2014.

Engen, Rodney. *Sir John Tenniel: Alice's White Knight*. Aldershot: Scolar Press, 1991.

Entwistle, Joanne. *The Fashioned Body*. Cambridge: Polity Press, 2000.

Estés, Clarissa Pinkola. *Women Who Run With the Wolves: Myths and Stories of the Wild Woman Archetype*. New York: Ballantine Books, 1992.

Evans, Caroline. *Fashion at the Edge: Spectacle, Modernity, and Deathliness*. New Haven and London: Yale University Press, 2003.

Fairhurst, Robert Douglas. *The Story of Alice: Lewis Carroll and the Secret History of Wonderland*. London: Harvill Secker, 2015.

Finkelstein, Joanne. *The Fashioned Self*. Philadelphia: Temple University Press, 1991.

Fonteyn, Margot. *Margot Fonteyn: Autobiography*. New York: Alfred A. Knopf, 1976

Foucault, Michel. *Discipline and Punish: The Birth of the Prison*. New York: Vintage, 1977.

Freud, Sigmund. *The Interpretation of Dreams*. London: Vintage, 1900.

Fry, William F. Jr. "A Gift of Mirrors: An Essay in Psychologic Evolution," in *The North American Review*, 265 no. 4 (December 1980): 52–58.

Genné, Beth. "Creating a Canon, Creating the 'Classics' in Twentieth-Century British Ballet," *Dance Research: The Journal of the Society for Dance Research*, vol. 18, no. 2 (Winter, 2000): 132–62.

Gill, Alison. "Deconstruction Fashion: The Making of Unfinished, Decomposing and Re-assembled Clothes," in *Fashion Theory*, vol. 2, no. 1 (February 1998): 25–49.

Greenblatt, Stephen. *Renaissance Self-Fashioning: From More to Shakespeare*. Chicago: The University of Chicago Press, 1980.

Gutner, Howard. *Gowns by Adrian*. New York: Harry N. Abrams, 2001.

Hahn, Emily. *China to Me*. London: Virago, 1987.

Harden, Rosemary. "Margot Fonteyn and Fashion Designers of the 1940s," in *Costume*, vol. 44 (May 2010): 96–105.

Haskell, Arnold L. *Ballet: A Complete Guide to Appreciation, History, Aesthetics, Ballets, Dancers*. Harmondsworth, Middlesex, England, 1938.

—. *Balletomania: The Story of an Obsession*. New York: Simon and Schuster, 1934.

Hockey, Jenny, *et al*. *If the Shoe Fits: Footwear, Identification and Transition*. Research paper. Sheffield: Sheffield University, 2012.

Holland, Samantha. *Alternative Femininities: Body, Age and Identity*. Oxford and New York: Berg, 2004.

Holt, Ardern. *Fancy Dresses Described, or What to Wear at Fancy Balls*. London: Debenham and Freebody, 1882.

Homans, Jennifer. *Apollo's Angels: A History of Ballet*. New York: Random House, 2010.

Ilyin, Natalia. *Blonde Like Me*. New York: Simon and Schuster, 2000.

Ivleva, Victoria. "Functions of Textile and Sartorial Artifacts in Russian Folktales," in *Marvels & Tales*, vol. 23, no. 2 (2009): 268–99.

Jacobs, Laura. "Tchaikovsky at the Millennium," in *New Criterion*, vol. 18 (September 1999): 21–28.

Jennings, Michael W. (ed.). *Walter Benjamin: Selected Writings*. Cambridge and London: The Belknap Press of Harvard University, 2002.

Jong, Erica. *Witches*. New York: Harry N. Abrams, 1981.

Jung, Carl. *Man and His Symbols*. Garden City, NY: Doubleday, 1964.

Kavanagh, Julie. *Secret Muses: The Life of Frederick Ashton*. New York: Faber & Faber, 1998.

Kawamura, Yuniya. *Fashion-ology: An Introduction to Fashion Studies*. Oxford and New York: Berg, 2005.

Kelly, Richard. "'If you don't know what a Gryphon is': Text and Illustration in *Alice's Adventures in Wonderland*," in *Lewis Carroll: A Celebration*, Edward Guiliano (ed.). New York: Clarkson N. Potter, 1982.

Kirsten, Lincoln. "Ballet," *Vogue* (November 1, 1933): 28–31, 103.

Koda, Harold. *Extreme Beauty: The Body Transformed*. New York: The Metropolitan Museum of Art, and New Haven and London: Yale University Press, 2001.

Kolbenschlag, Madonna. *Kiss Sleeping Beauty Good-bye: Breaking the Spell of Feminine Myths and Models*. London: Harper Collins, 1979.

Kschessinska, Mathilda. *Dancing in Petersburg: The Memoirs of Kschessinska*. London: Gollancz, 1960.

Kuhn, Cynthia, and Cindy Carlson. *Styling Texts: Dress and Fashion in Literature*. Youngstown, N.Y.: Cambria Press, 2007.

Kunz, George Frederick. *The Mystical Lore of Precious Stones*. North Hollywood, Cal.: Newcastle, 1986.

Leach, Karoline. *In the Shadow of the Dreamchild: A New Understanding of Lewis Carroll*. London: Peter Owen, 1999.

Long, Timothy. *Charles James: Designer in Detail*. London: V&A Publishing, 2015.

Long Laws, Judith. *The Second X: Sex Role and Social Role*. Amsterdam: Elsevier Publishing Co., 1979.

Mackie, Erin. "Red Shoes and Bloody Stumps," in Shari Benstock and Suzanne Ferriss (eds.), *Footnotes: On Shoes*. New Brunswick: Rutgers University Press, 2001.

Mansel, Philip. *Dressed to Rule: Royal and Court Costume from Louis XIV to Elizabeth II*. New Haven and London: Yale University Press, 2005.

McDowell, Colin. *The Anatomy of Fashion: Why We Dress the Way We Do*. London: Phaidon, 2013.

—. *Hats: Status, Style and Glamour*. New York: Rizzoli, 1992.

—. *Shoes: Fashion and Fantasy*. London: Thames & Hudson, 1989.

McLean, Elizabeth. "Influences and Inspiration: The Ballet Designs of Sophie Fedorovitch," in *Research in Dance Education*, vol. 13, no. 2 (July 2012): 197–213.

Mears, Patricia. *American Beauty: Aesthetics and Innovation in Fashion*. New Haven and London: Yale University Press, 2009.

Merceron, Dean. *Lanvin*. New York: Rizzoli, 2007.

Milliken, Roberta. *Ambiguous Locks: An Iconology of Hair in Medieval Art and Literature*. Jefferson, N.C.: McFarland and Company, 2012.

Money, Keith. *Fonteyn: The Making of a Legend*. New York: William Morrow and Company, 1974.

Nenola-Kallio, Aili. "Lucky Shoes or Weeping Shoes: Structural Analysis of Ingrain Shoeing Laments," in *Finnish Folkloristics*, vol. 1, Helsinki, 1974.

Newman, Alex, and Zakee Shariff, *Fashion A–Z: An Illustrated Dictionary*. London: Laurence King, 2009.

Ofek, Galia. *Representations of Hair in Victorian Literature and Culture*. Farnham, Surrey, UK, and Burlington, V.T.: Ashgate, 2009.

Orenstein, Catherine. *Little Red Riding Hood Uncloaked: Sex, Morality, and the Evolution of a Fairy Tale*. New York: Basic Books, 2002.

Ovenden, Graham (ed.). *The Illustrators of Alice in Wonderland and Through the Looking Glass*. New York: St. Martin's Press, 1972.

Page, Michael F., and Robert R. Ingpen, *Encyclopedia of Things That Never Were: Creatures, Places and People*. New York: Viking, 1987.

Postrel, Virginia. *The Power of Glamour: Longing and Art of Visual Persuasion*. New York: Simon and Schuster, 2013.

Prawer, S. S. *Comparative Literary Studies: An Introduction*. London: Duckworth, 1973.

Pushor, Jessica Ann. *From Folk to Fashionable: The Witch in Fashion from 1880 to 1930*. Master's thesis, Fashion Institute of Technology, 2013.

Ricci, Stefania (ed.). *The Amazing Shoemaker: Fairy Tales and Legends about Shoes and Shoemakers*. Milan: Skira, 2013.

Ritter, Gretchen. "Silver Slippers and a Golden Cap: L. Frank Baum's 'The Wonderful Wizard of Oz' and Historical Memory in American Politics," in *Journal of American Studies*, vol. 31, no. 2 (August 1997): 171–202.

Rudofsky, Bernard. *The Unfashionable Human Body*. Garden City, NY: Doubleday, 1971.

Sadler's Wells Ballet at Covent Garden: A Book of Photographs by Merlyn Severn. London: John Lane the Bodley Head, 1947.

Sayers, F. C. "Walt Disney Accused," in *The Horn Book Magazine* (December 1965).

Scala, Mark W. (ed.). *Fairy Tales, Monsters, and the Genetic Imagination*. Nashville, TN: Vanderbilt University Press, 2012.

Scholl, Tim. *Sleeping Beauty: A Legend in Progress*. New Haven and London: Yale University Press, 2004.

Scott, Carole. "Magical Dress: Clothing and Transformation in Folk Tales," in *Children's Literature Association Quarterly*, vol. 21, no. 4 (Winter 1996): 151–57.

Scott, Linda M. *Fresh Lipstick: Redressing Fashion and Feminism*. New York: Palgrave Macmillan, 2005.

Seifert, Lewis C. *Fairy Tales, Sexuality, and Gender in France, 1690–1715*. Cambridge: Cambridge University Press, 1996.

Sévigné, Marie de Rabutin-Chantal. *The Letters of Madame de Sévigné to her Daughters and Friends*. Boston: Little, Brown, 1900.

Shawcross, Rebecca. *Shoes: An Illustrated History*. London: Bloomsbury, 2014.

Sherlock. Alexandra. "Footwear: Transcending the Mind-Body Dualism in Fashion Theory," in Brownie, Barbara; Petican, Laura and Reponen, Johannes (eds). *Fashion: Exploring Critical Issues* [e-book]. Oxford: Interdisciplinary Press, 2011.

Sorley Walker, Katherine. *De Basil's Ballets Russes*. Alton, Hampshire, UK: Dance Books, Ltd., 1982.

Steele, Valerie (ed.). *Dance and Fashion*. New Haven and London: Yale University Press, 2014.

Stern, Jeffrey. "Lewis Carroll the Surrealist," in *Lewis Carroll: A Celebration*, Edward Guiliano (ed.). New York: Clarkson N. Potter, 1982.

Stewart, Susan. *On Longing*. Durham: Duke University Press, 1993.

Streatfeild, Noel. *Ballet Shoes*. London: Puffin 2011.

Tatar, Maria. *The Hard Facts of the Grimms' Fairy Tales*. Princeton: Princeton University Press, 1987.

Thelander, Dorothy R. "Mother Goose and Her Goslings: The France of Louis XIV as Seen through the Fairy Tale," in *The Journal of Modern History*, 54, no. 3 (September, 1982): 467–96.

Thomas, Hayley. "Undermining a Grimm Tale: A Feminist Reading of 'The Worn Out Dancing Shoes,'" in *Marvels and Tales Journal of Fairytale Studies*, vol. 13, no. 2 (1999).

Thomas, Rhys. *The Ruby Slippers of Oz*. Los Angeles: Tale Weaver Publishing, 1989.

Tresidder, Jack (ed.). *The Complete Dictionary of Symbols*. San Francisco: Chronicle Books, 2004.

Ussher, Arland, and Carl Von Metzradt. *Enter These Enchanted Woods: An Interpretation of Grimms' Fairy Tales*. Dublin: The Dolmen Press, 1957.

Vaclavik, Kiera. "Alice in Wonderland: The Making of a Style Icon." *Independent*. Accessed July 2015. http://www.independent.co.uk/arts-entertainment/books/features/alice-in-wonderland-the-making-of-a-style-icon-10128741.html.

—. "The Dress of the Book: Children's Literature, Fashion, and Fancy Dress." Proceedings of *Beyond the Book: Transforming Children's Literature* conference. Cambridge: Cambridge Scholars Publishing, 2012: 62–139.

—. "Dressing down the Rabbit Hole – How to Become Alice in Wonderland." *Conversation* (April 29, 2015). Accessed May 22, 2015. http://theconversation.com/dressing-down-the-rabbit-hole-how-to-become-alice-in-wonderland-40398.

Van Beirendonck, Walter. *Walter Van Beirendonck: Dream the World Awake*. Tielt, Belgium: Lannoo, 2011.

Vincent, Susan J. *The Anatomy of Fashion: Dressing the Body from the Renaissance to Today*. New York and Oxford: Berg, 2009.

Von Franz, Marie-Louise. *The Interpretation of Fairy Tales*. Boston and London: Shambhala, 1996.

Waelti-Walters, Jenny. "On Princesses: Fairy Tales, Sex Roles and Loss of Self," in *International Journal of Women's Studies*, vol. 2 (1981).

Warner, Marina. *From the Beast to the Blonde: On Fairy Tales and Their Tellers*. London: Random House, 1994.

—. *Once Upon a Time: A Short History of Fairy Tale*. Oxford: Oxford University Press, 2014.

Watt, Judith. *Alexander McQueen: The Life and Legacy*. New York: Harper Design, 2012.

Weber, Caroline. *Queen of Fashion: What Marie Antoinette Wore to the Revolution*. New York: Henry Holt and Company, 2006.

Weinstein, Amy. *Once Upon a Time*. New York: Princeton Architectural Press, 2005.

Weitzman, Erica. "The World in Pieces: Concepts of Anxiety in H. C. Andersen's 'The Snow Queen.'" *Modern Language Notes* (*MNL*), vol. 122, no. 5 (2007): 1105–23.

Whipple, Dorothy. *They Were Sisters*. London: Persephone, 2007.

White, Palmer. *Elsa Schiaparelli: Empress of Fashion*. New York: Rizzoli, 1986.

Wilcox, Claire (ed.). *The Golden Age of Couture: Paris and London, 1947–57*. London: V&A Publications, 2007.

Wiley, Roland John. *Tchaikovsky's Ballets: Swan Lake, Sleeping Beauty, Nutcracker*. Oxford, UK: Clarendon Press, 1985.

Williams, Gareth. *Telling Tales: Fantasy and Fear in Contemporary Design*. London: V&A Publishing, 2009.

Wilson, Elizabeth. *Adorned in Dreams: Fashion and Modernity*. Berkeley: University of California Press, 1985.

Wood, Christopher. *Fairies in Victorian Art*. Suffolk, UK: Antique Collectors Club, 2000.

Woolf, Jenny. *The Mystery of Lewis Carroll: Understanding the Author of "Alice's Adventures in Wonderland."* London: Haus, 2010.

Zipes, Jack. *Breaking the Magic Spell: Radical Theories of Folk and Fairy Tales*. Lexington, K.Y.: University Press of Kentucky, 2002.

—. *The Enchanted Screen: The Unknown History of Fairy-tale Films*. New York and London: Routledge, 2011.

—. *The Irresistible Fairy Tale: The Cultural and Social History of a Genre*. Princeton and Oxford: Princeton University Press, 2012.

—. (ed.). *The Oxford Companion to Fairy Tales*. Oxford: Oxford University Press, 2000.

—. "Spinning with Fate: Rumpelstiltskin and the Decline of Female Productivity." *Western Folklore* v. 52, no. 1 (January 1993): 43–60.

—. *When Dreams Came True: Classical Fairy Tales and Their Tradition*. New York: Routledge, 2007.

Acknowledgements

Fairy Tale Fashion has been one of the most interesting – and challenging – projects of my career so far, and I am indebted to the many people who provided encouragement along the way. I would first like to thank Dr. Joyce Brown, the president of The Fashion Institute of Technology, for her ongoing support of The Museum at FIT and its efforts. I am also incredibly grateful to the members of the museum's Couture Council, who are among our biggest champions. I look forward to sharing this project with them. I would also like to give a tremendous thanks to Ward Mintz, the executive director of The Coby Foundation, as well as to the Foundation's Board, for their generous support of this book and the exhibition.

This project would have been impossible without the encouragement of Dr. Valerie Steele, the director and chief curator of The Museum at FIT. Valerie has always been a brilliant and generous mentor, who encourages me to achieve greater things. Likewise, I am forever indebted to Patricia Mears, MFIT's deputy director, who not only contributed a wonderful essay to this book, but who also helped me get my start in museum work. I am grateful to have worked alongside Patricia for nearly a decade, and she has always served as my role model. I am also thankful to Fred Dennis, the museum's senior curator, whose advice, humor, and vast knowledge of fashion has always kept me on the right path.

Julian Clark, the museum's publications coordinator, was the first to work on this text, and his early understanding of my somewhat experimental ideas was incredibly encouraging. Few writers can say they have fun at meetings with their editors, and I count myself among them. I'd also like to extend my gratitude to

Eileen Costa, who took many incredibly beautiful photographs for this book and who prepared other images for publication as well. *Fairy Tale Fashion* proved to be a tremendous amount of work, but her enthusiasm never waned.

A curator's work is nothing without the support of her colleagues, and I am humbled to work with such an outstanding group of people. Thanks especially to Vanessa Vasquez, Nateer Cirino, and Theresa Rinere of the Director's Office; Ann Coppinger, the museum's senior conservator, as well as Nicole Bloomfield and Marjorie Jonas of the Conservation Department; the assistant curator Ariele Elia, the curatorial assistant Elizabeth Way, Lynn Sallaberry, and Thomas Synnamon of the Costume Department; the curator of education Tanya Melendez and the associate curator of education Melissa Marra; Tamsen Young, the museum digital media and strategic initiatives manager, and Mindy Meissen of the Media Department; Sonia Dingilian, Jill Hemingway, and Laura Gawron of the Registrars Department; and Michael Goitia, Ryan Wolfe, and Kenneth Wiesinger of the Exhibitions Department. Kate Bishop and Nancy MacDonnell, graduate students at FIT, and Neil Wu, a graduate student at Parsons, provided invaluable research assistance.

A special thanks goes to the architect Kimberly Ackert and the graphic designer Matthias Kern, whose immense talents bring *Fairy Tale Fashion* to life.

Also from the Fashion Institute of Technology, I would like to thank Cheri Fein and Ivana Cepeda, both from the Office of Communications and External Relations, for their work in promoting the museum's exhibitions.

From FIT Library Special Collections and FIT Archives, I give a heartfelt thanks to Karen Cannell and April Calahan, who are both knowledgeable and a pleasure to work with.

Ellen Sampson and Kiera Vaclavik, two scholars in the United Kingdom, provided fascinating essays for this book that enhance and expand upon my own work. This project has afforded me the delightful opportunity to become acquainted with and work with these wonderful women.

Working with Yale University Press – and in particular with the incomparable editor Gillian Malpass – is always a fantastic experience. The beauty and quality of the books overseen by Gillian and designed by Paul Sloman never cease to amaze me. Their indefatigable efforts are very much appreciated.

Finally, I would like to thank my family for their ongoing support of my work: my mother, Jane, my father, Ross, and my sister, Devon. And to my love and soon-to-be-husband, Christopher Howard, who has stuck by me through the completion of three books, and who has also provided valuable editorial insight – as well as many laughs. Thank you.